Urban Exploration Photography

GUIDE TO CREATING AND EDITING IMAGES OF ABANDONED PLACES

Todd Sipes

Urban Exploration Photography
A Guide to Creating and Editing Images of Abandoned Places

Todd Sipes

Peachpit Press
www.peachpit.com

To report errors, please send a note to: errata@peachpit.com
Peachpit Press is a division of Pearson Education

Acquisitions Editor: Ted Waitt
Project Editor: Nancy Peterson
Development Editor: Bob Lindstrom
Copyeditor: Scout Festa
Proofreader: Darren Meiss
Senior Production Editor: Lisa Brazieal
Interior Design and Composition: Kim Scott, Bumpy Design
Indexer: Karin Arrigoni
Cover Designer: Aren Straiger
Cover Image: Todd Sipes

ISBN 13: 978-0-134-00792-2
ISBN 10: 0-134-00792-1

9 8 7 6 5 4 3 2 1

Printed and bound in the United States of America

This book is dedicated to a number of people, but first and foremost to my beautiful wife for letting me sneak out before dawn so that I could find and photograph dangerous places. I love you, Jay.

To Mom, Dad, and Laurel for always supporting the crazy things I've tried throughout my life. To all my friends who have joined me on my explorations and helped me grow as a photographer: Adam Heckaman, Nick McCoy, Stefan Roumell, Jason Bodenheimer, Jesse Krieger, Amy Heiden, Quenton Hamlin, Brian Matiash, Dan Hughes, Michael Rosati, Scott Haefner, Jonathan Haeber, Stephen Freskos, Nate Johnson, Chelsea Barada, Nicky Pedroia, Gary Utley, Colby Brown, and Michael Bonocore. You are all amazing and I can't thank you enough.

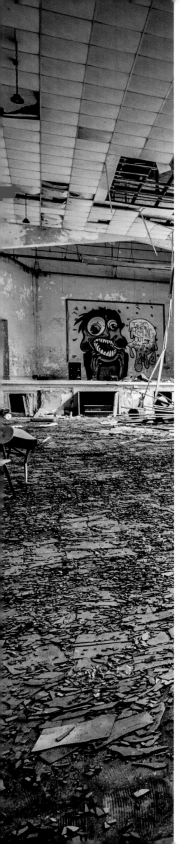

CONTENTS

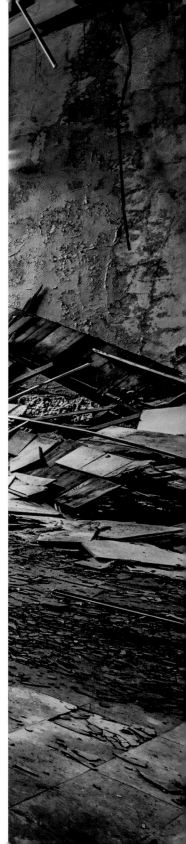

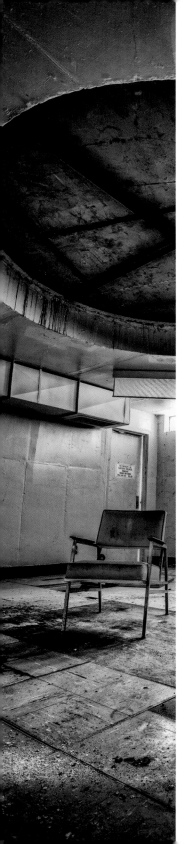

PART 2 EDITING

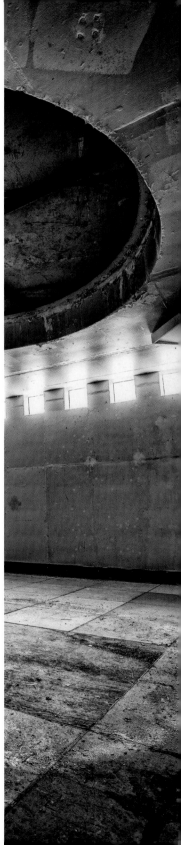

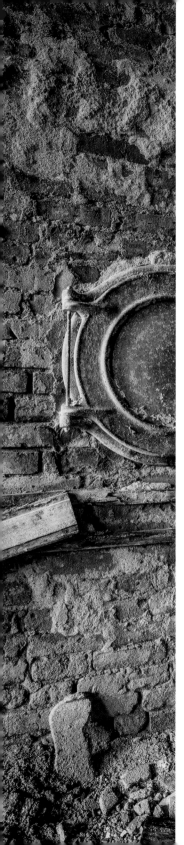

About the Author

Todd Sipes is an award-winning photographer who resides in the San Francisco Bay Area. He specializes in urban exploration and concert photography, and has explored and photographed countless abandoned structures, beginning at 10 years old while growing up in Colonial Williamsburg, Virginia.

With a deep-seated interest in history, he earned his BA degree in American History at the University of California in Santa Cruz, and then pursued his MBA degree at the University of San Francisco. When Sipes isn't getting his hands dirty exploring, he plays drums, loves to travel, snowboards in Lake Tahoe, and spends time with his wife, Harasyn. Find out more about Sipes and his work at www.toddsipes.net.

INTRODUCTION

The term "urban exploration"—aka UrbEx and UE—sounds like it should be pretty self-explanatory. The term, however, has morphed and mutated from its literal meaning. Today, it represents a community of people who like to explore and photograph man-made structures that have been abandoned or are off-limits to the general public.

Despite varied definitions, nine times out of ten when people mention urban exploration, they are talking about entering abandoned buildings to take pictures. Other popular activities that fall under the UrbEx definition are draining (exploring drains), craning (climbing cranes), and infiltration (exploring active buildings). My expertise resides with abandoned buildings, so this book focuses on that subject matter.

About This Book

For photographers, abandoned and derelict structures provide an abundance of interesting subject matter to shoot, but they're not for everyone. I view urban exploration as the "heavy metal" of the photography world. It's aggressive, difficult to execute, and often misunderstood. It's a genre that most photographers don't attempt because most people pick up a camera and only want to take pictures of their kids, flowers, landscapes, food, etc. (ya' know, normal stuff). It takes much more commitment to gather the extra gear, locate an abandoned building, figure out how to get inside without hurting yourself, and then take photos while battling multiple photographic variables. For me, it's one of the few photographic

genres that gets my blood pumping, and it's certainly the only genre that will get me out of bed at 4 a.m. so that I can be ready to shoot at sunrise.

I'm writing this because I've never seen a how-to guide specifically catering to urban exploration photography. And because it's a unique genre of photography, I think it deserves its own book. Keep in mind that numerous fantastic UE photographers probably have their own tips and tricks. While this guide is purely based upon my personal experience, I think it can truly help anyone improve their UrbEx photography.

In terms of the information you'll find in this book, I'm the type of person who just likes to know the essentials on how to get from point A to point B. I don't like to dig through tons of extraneous information to get a job done. With that said, I'm going to take you through the essentials for every step along the UrbEx way.

Is there more you could learn? Absolutely. I'm going to let you decide the topics for which you want more information and seek it out for yourself instead of covering everything there is to know about every facet of photography in this book. I don't want you to become distracted or discouraged by providing too much information; I want to give you the essentials so that you can get a head start with the UE genre or fill in the gaps for specific topics if you're already a seasoned photographer.

- **Disclaimer 1:** This is not a how-to guide for urban exploration, itself. For that, there's a much more comprehensive guide called *Access All Areas* by Ninjalicious. This book covers every aspect of UE photography, so there's no point in reproducing something that's already been done so well. Instead, while I do touch upon some preparation tips, this book is all about photography. The only thing I'll reiterate is this: "Take only pictures, leave only footprints." Respecting locations means that other people get to enjoy them the same way you did. Don't steal. Don't vandalize.

- **Disclaimer 2:** I'm writing this under the assumption that you understand basic camera functions and also have a solid grasp on the exposure triangle. If you ever get confused, you can easily find more information on any of the photography terms used in this book by searching online.

- **Disclaimer 3:** Urban Exploration may entail risks of all sorts—including some which can be both illegal and lethal—and this book in no way encourages illegal or dangerous activity of any kind! Urbex can also be completely legal and safe. So take all that into account and use good judgment and caution when considering where you go to explore and shoot.

Downloadable Content

This book uses a few files in some of the tutorials and walkthroughs in the book. These files are available for you to download.

Please visit www.peachpit.com/register and follow the instructions for registering this book in order to download that additional content.

PART 1 **SHOOTING**

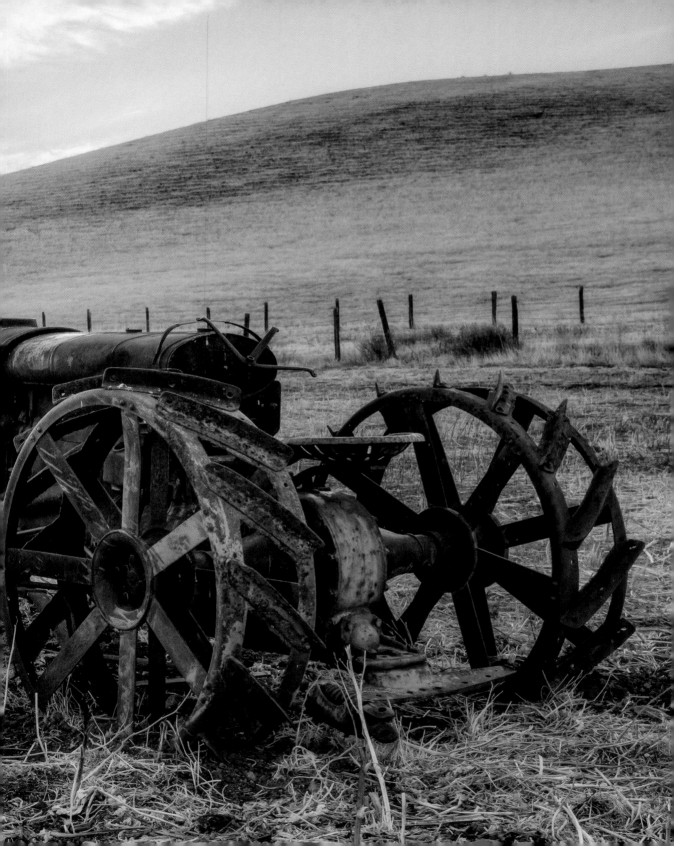

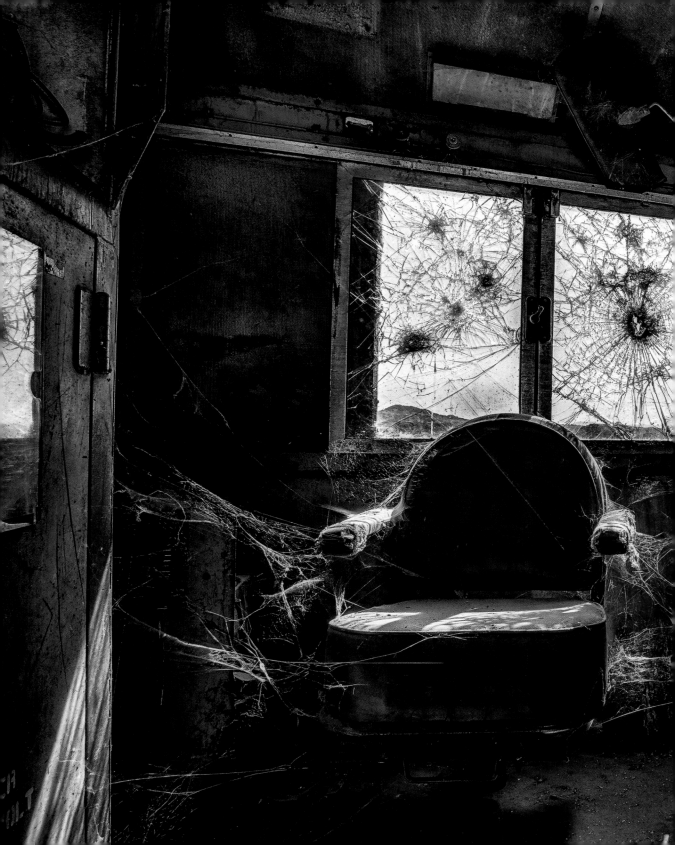

ONE
BEFORE YOU SHOOT

As much as I enjoy just getting in my car and driving to a location, I've learned that I always walk away from a shoot with better photos when I take the time to plan my adventure. By doing some research, checking my gear, and preparing mentally, I can make the most efficient use of my time while on location. You wouldn't go skydiving without checking your pack and knowing the location of your drop zone, would you?

Urban exploration isn't always life and death, but you are usually pressed for time due to weather, security hazards, and other variables that are out of your control. This chapter will help ensure you have everything you need in order to use your time efficiently.

Be Prepared

Without getting too much into the details of "how to" urban explore, you should prepare thoroughly based on advance knowledge of where you're going. Here are some tips that will help you maximize your shooting time and also keep you safe:

Having an offline map of your location can help you when inside and outside a location, especially when you don't have cell service.

- Using Google Maps, save an offline map of the location to your phone. Do it now, because you might not have cell service when you get to your location. Knowing the geography of your target and its surrounding areas can be immensely helpful.

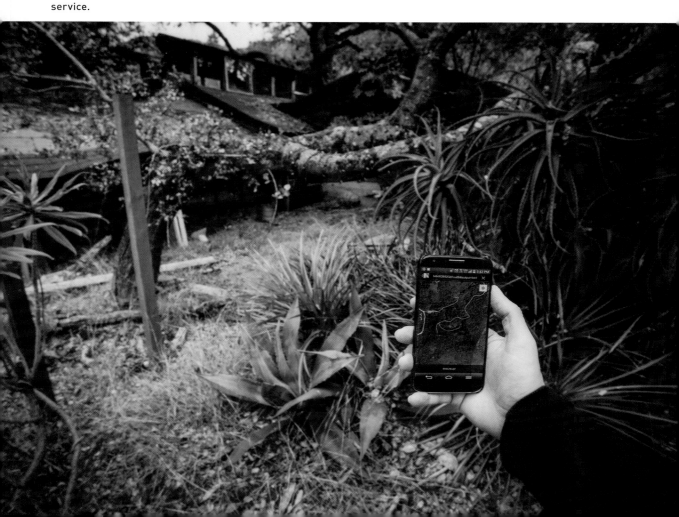

- Tell someone where you're going and how long you plan to be there. I've heard horror stories of explorers getting lost or injured, sometimes with tragic results.

- Wear appropriate clothing for the location. (For example, don't wear shorts if you're going to encounter barbed wire. I learned this the hard way.) I like to wear long pants and long sleeves no matter what the situation may be. Just be smart and wear comfortable clothing that will keep you well protected.

- Don't go alone if you can avoid it. Exploring is always more fun with friends, and having an extra hand can be extremely helpful if problems occur.

- If you've been to a location previously, plan your shots ahead of time. I've visited some sites repeatedly and I know them like the back of my hand. However, that doesn't mean I've always been able to photograph certain features to my satisfaction. I make a note of the shots I want to retry so that I'm not just wandering around looking for things to shoot.

- Have your bag ready to go. This should be an obvious tip, but I've even caught myself ignoring it sometimes. I charge my batteries, clear my memory cards, and make sure my pack is ready the night before I go out. I do this for two main reasons:

 1. I usually go shooting very early in the morning and I don't trust my half-asleep brain to remember everything at 4 a.m. There's nothing worse than successfully getting into a location only to realize that your batteries are dead.

 2. When I get to a location, I want to be able to just grab my bag and concentrate on getting inside the location. My chances of being seen increase exponentially if I spend 20 minutes fumbling with my bag in a parked car in front of or near a place I shouldn't be.

What to Bring: The Bare Essentials

Don't bring every lens you own because you fear missing out on that one amazing shot. Resist temptation! Pack as light as possible because you don't know what feats you'll have to perform to get from point A to point B, nor do you know how long you'll be at the location. I usually stick to a "two lens" policy, which keeps my bag relatively light. Here is my "bare essentials" list of things to pack:

The contents of my bag are minimal compared to most professional photographers: just enough to get the job done properly.

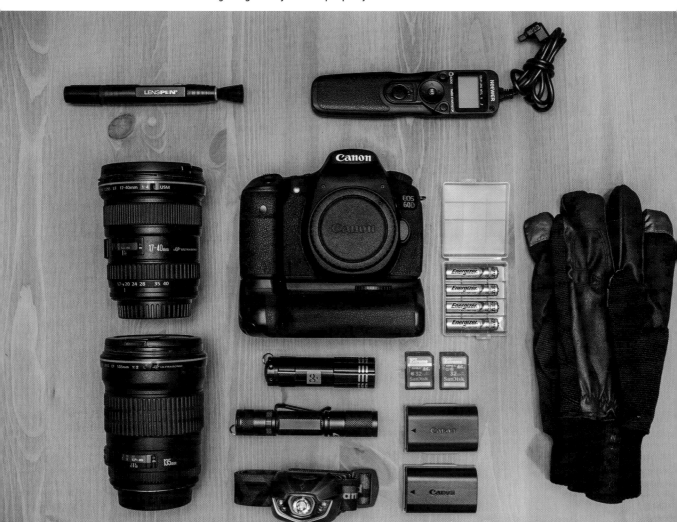

Photography-related essentials

- Tripod
- Camera body
- Wide-angle lens and telephoto lens
- Blank memory cards
- Charged camera battery, extra camera batteries
- Intervalometer and batteries
- Lens pen/cloth
- Business cards that state you're a photographer, which can help if you run into anyone "troublesome"

Apparel and accessories

- Gloves
- Headlamp
- Flashlight
- Extra flashlight
- Laser pointer
- Water
- Snack
- Respirator (optional)

Why Are You Shooting?

Are you shooting as a *documentarian* or as an *artist*? When I was first getting into UrbEx photography, I felt that I needed to capture every nook and cranny of a location. After a while, I began to analyze the photos I was taking and came to the conclusion that I didn't even want to post-process 90 percent of them.

(right) Documentarian shot: I took this picture of a laundry chute in a psychiatric hospital slated to be demolished in the near future. I'd never seen laundry chutes built into the wall like this, and it grabbed my attention. I knew that this wasn't going to be a very artistic shot. I just wanted to document it to preserve my memory of the place.

(opposite) Artistic shot: This angle of the laundry chute had better lighting, and the scene itself was more interesting to me. So I took my time and shot from two different angles. What you see is the result after some light post-processing.

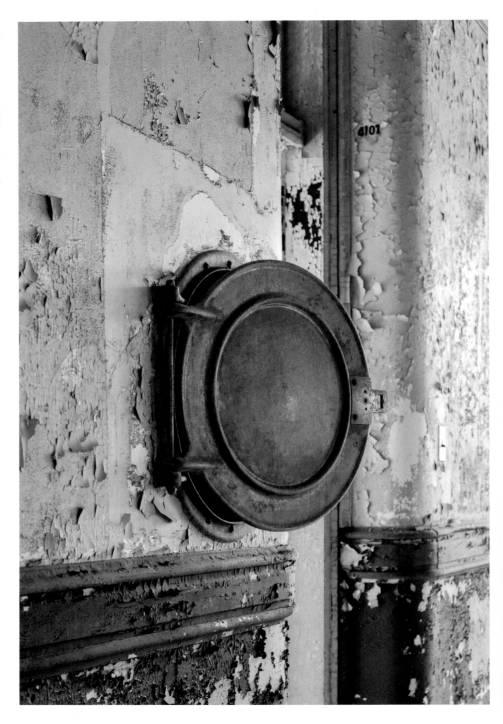

The question you must ask yourself is, "What is your goal?" Are you shooting to document what a place looked like for *historical value* (perhaps because it's being demolished soon), or are you shooting to get a few *artistic shots*? I've moved from the former to the latter, and I've been much more satisfied with the shots I walk away with.

There's absolutely nothing wrong with taking tons of photos so your viewers can get a sense of how the place felt when you were there. I'd say that most fellow explorers prefer the documentarian shots, whereas non-explorers prefer the artistic shots. If you've got the time or permission to be there, document as much as you want! If you're in a time crunch, pick your shots carefully but execute quickly. It's a personal choice—just be cognizant of what you're shooting and why.

Make the Best Use of Your Time

Shooting mentality aside, you'll be better off if you have a shooting strategy before you get into a location. I have a very practical order to how I shoot:

1. Scout the premises to decide what I want to shoot.

2. Go through the premises and take all my wide-angle shots.

3. Go through the premises again and take all my detail shots.

I'll explain the difference between wide-angle and detail shots later, but keep this strategy in mind as you're shooting. When following it, you won't be changing lenses in every room you want to shoot. I don't know about you, but I'd rather not crack open my bag and potentially introduce dust onto my camera's sensor every five minutes. This method may involve more walking, as you're going through the building three times, but I've found it to be the most efficient shooting order.

You can also tuck your bag somewhere safe in a room that's close to your entrance/exit so you're not lugging it around everywhere. In the unfortunate event that you need to make a quick getaway, you won't be bogged down by your gear, and your bag will be a quick pit stop on the way out. I also keep a spare memory card, battery, and Lens Pen in my pocket so I don't have any reason to run back to my bag until I'm finished shooting.

TWO
HOW TO SHOOT

The elements that produce a great photo include composition, shooting style, camera settings, and lighting. How you choose to use these elements can make or break a fantastic shot. Memorizing the basics can seem tedious, but once you have a solid grasp of the concepts behind these elements, they will become invaluable tools at your disposal.

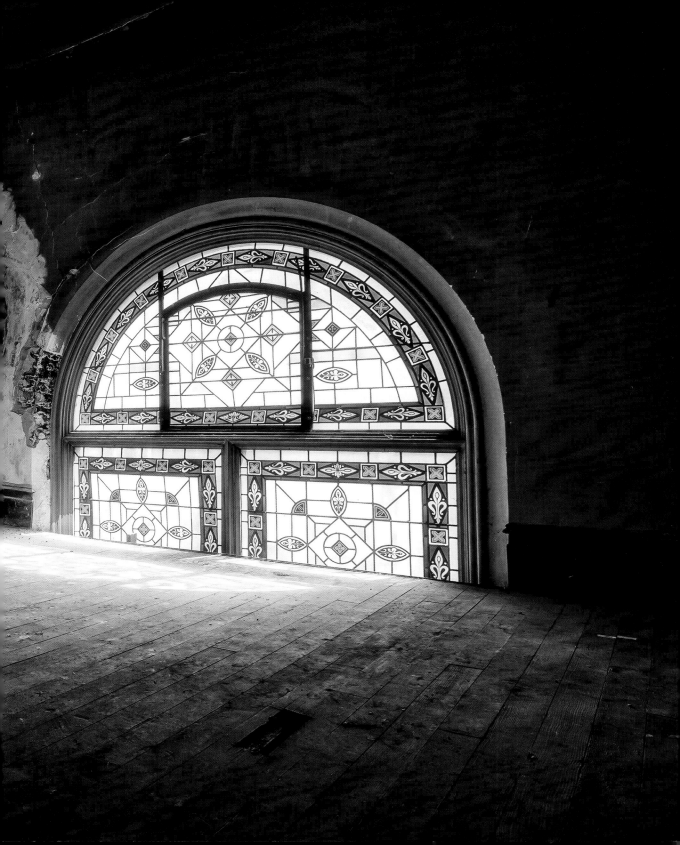

Composition

Composition is the only manual element of photography that will exist in the future. Cameras are advancing at an incredible rate, along with all of our modern devices.

Today, anybody can pick up a camera and take a great photograph using Auto mode and dumb luck. The difference between a "photographer" and a "person who takes pictures" comes down to composition. We could go through a slew of other variables photographers can control, such as lighting and manual settings, but those factors simply contribute to the final composition.

We're getting to a point where we can use post-processing software to control almost every possible adjustment of the look and feel of a photo, but we can't create what we didn't capture in our original composition.

So let's go over the generally accepted rules of composition that will set you ahead of the pack for urban exploration photography. Why use the following composition rules? Because photos with their subjects aligned dead center are boring (most of the time). A photo composed with these rules allows your viewers' eyes to wander around the scene, picking out the important parts. These rules enable you to create photos as scenes, not just photos of things.

With that said, rules are meant to be broken. In urban exploration, we often don't have the luxury of moving our subjects like models; we have to adapt and find the right composition for the scene we are offered.

Rule of Thirds

This is the most common rule in photographic theory. Simply divide your frame into thirds using two parallel and two horizontal lines. Most cameras have this function built into the Live View function to make it even easier. Use this grid, and align the interesting features of your photo where the lines intersect.

You can use the other intersecting points to display other interesting subjects or you can use them as a frame, as I've done in this photo.

The Golden Compositions

To keep it simple, the golden compositions all stem from the golden mean, which is a mathematical formula that, when applied correctly, creates aesthetically pleasing photos. We have a few golden mean–inspired compositions to choose from: the golden ratio, the golden spiral, and the golden triangle.

Golden ratio

The golden ratio is basically just a tighter rule of thirds. To use it, follow the same premise as the rule of thirds: line up your subjects along the intersecting points.

This shot was taken exactly as I found it. I turned a corner to find the teddy bear like this. It was so big, I thought it was a person. "Startled" is an understatement.

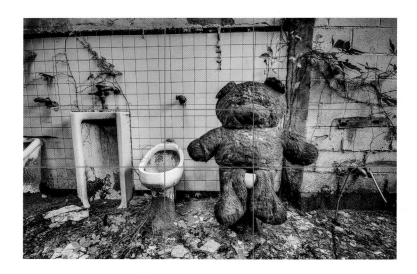

Golden spiral

The basic principle behind the golden spiral is that you want some elements to sweep around the composition, gradually leading your viewer to a focal point (your subject). The elements don't need to be perfect leading lines, but they should gently show the viewer where to focus their attention after surveying the scene.

This stairwell obviously doesn't perfectly align to the golden spiral overlay, but it's easy to understand how the railing leads your eye to the lower floors.

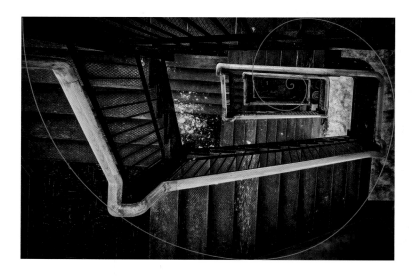

Golden triangle

Diagonal angles always make for interesting scenes because you can often use strong leading lines to push the viewer's eye toward your subject. Strong leading lines can force the viewer to catch your focal point faster than the golden spiral because their eyes don't need to wander around the scene to get there.

To use it, place three subjects of approximately equal size in these triangles. For best results, frame your shot so that your subject fills one of the three triangles. It doesn't need to be perfect. This is one of those situations where "close enough" works just fine.

Centered

But Todd, didn't you say that centered photos are boring? Yes, I did. But that typically applies only when you're shooting objects. If you have a scene that offers interesting symmetry, by all means capture it. The key is to make sure you are perfectly centered both vertically and horizontally. You'll want to use Live View, check your in-camera level, check the level bubbles on your tripod, and so on. You can do some amazing things in Lightroom and Photoshop to correct imperfections, but you're always better off nailing it in-camera. Even a perfectly centered composition doesn't guarantee that the final product will be interesting, but don't shy away from centered compositions, because some of them turn out amazing.

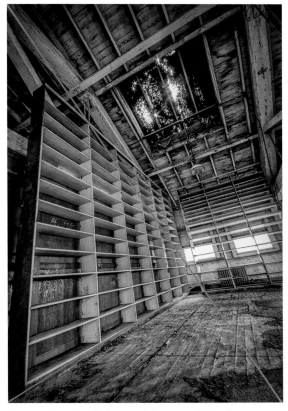

The golden triangle is one of the more difficult compositions, in my opinion. This shot was one of those "happy accident" moments when the composition was nearly perfect for the golden triangle.

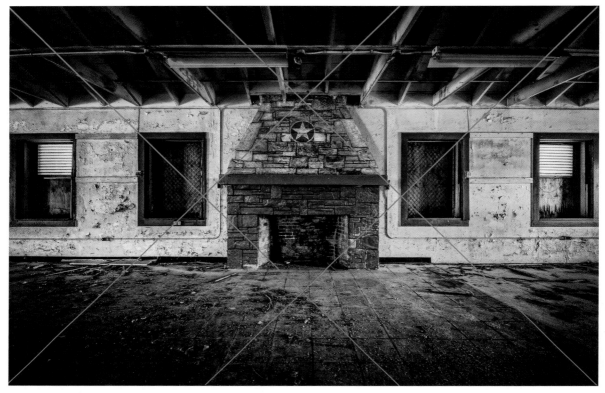

Before shooting a centered composition, check features around the room to see if they line up. In this shot, I used the mantel, the window frames, and the floor/wall intersection to make sure I was as centered as possible.

Dutch Angle

(opposite) The Dutch angle can be applied almost anywhere. I use it for scenes that look really great in person but are hard to capture using traditional compositions.

The Dutch angle is a composition theory that adds drama to a scene. Throwing your subject on a 45-degree angle as opposed to a traditional 90-degree angle induces a mild sense of vertigo in the viewer. It's used quite a bit in concert photography and for modeling, but you can also use it to turn an otherwise boring hallway into a more interesting composition.

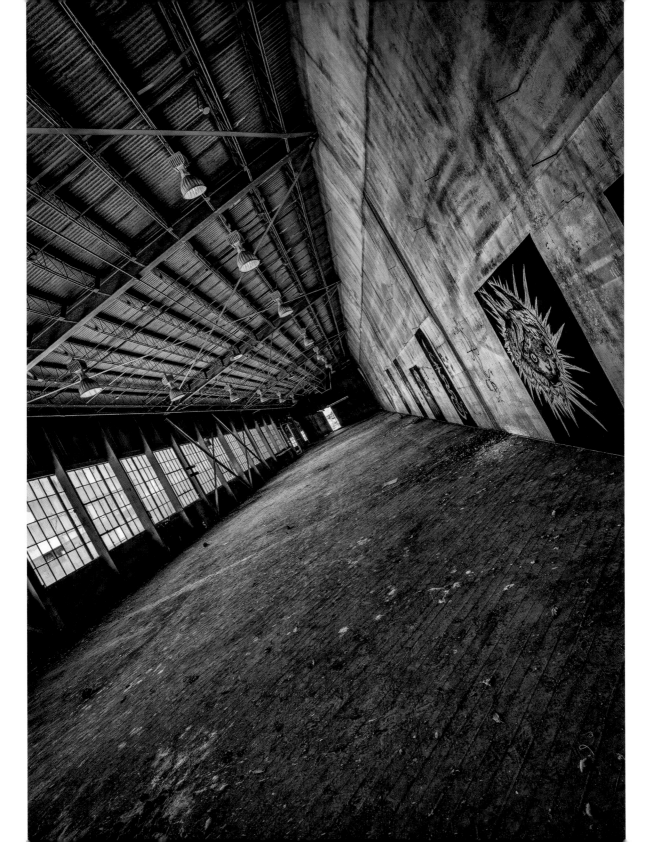

Other Facets of Composition

There are a plethora of other compositional theories I could drag on about, but I'll keep the rambling to a minimum and tell you some of the other compositional elements I think are crucial.

Counterpoints

Counterpoints are a great way to add a sense a balance to your composition. They round out a scene in a way that really completes your final image. Viewers will have more than one thing to look at within the scene, which creates a much more dynamic photo. These counterpoints can't really be forced in an urban exploration setting, but keep your eye out for locations that offer them. You don't want to add counterpoints if they distract your viewer from focusing on your subject; you only want a counterpoint if it complements (and doesn't compete with) your subject.

Depth

A sense of depth is critical for urban exploration photography. Your viewers want to feel that sense of scale. This can be achieved in a variety of ways (bokeh, lens distortion, vantage point). Just keep in mind that adding depth can also create leading lines that can be used in coordination with the Dutch angle and golden triangle compositions. Depth can also be used to further highlight your subject by pushing away elements that you don't want to be prevalent in your scene.

The graffiti behind the stage and the light pouring in from the ceiling served as great counterpoints to my main subject, the chair.

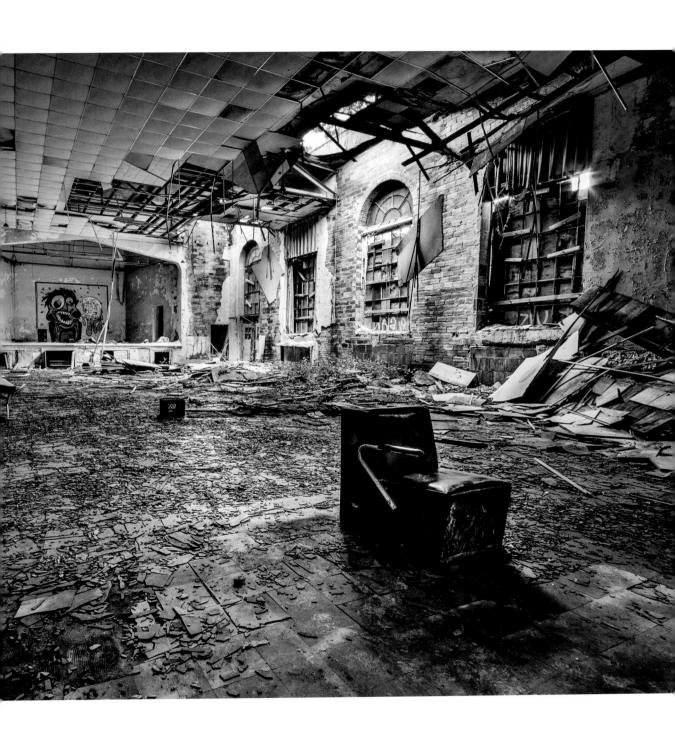

Even though you can't see the detail behind the first few hooks, you still get a sense of how deep this room is. I could have easily maintained all the detail had I not shot at a high aperture, but it would have detracted from my subject.

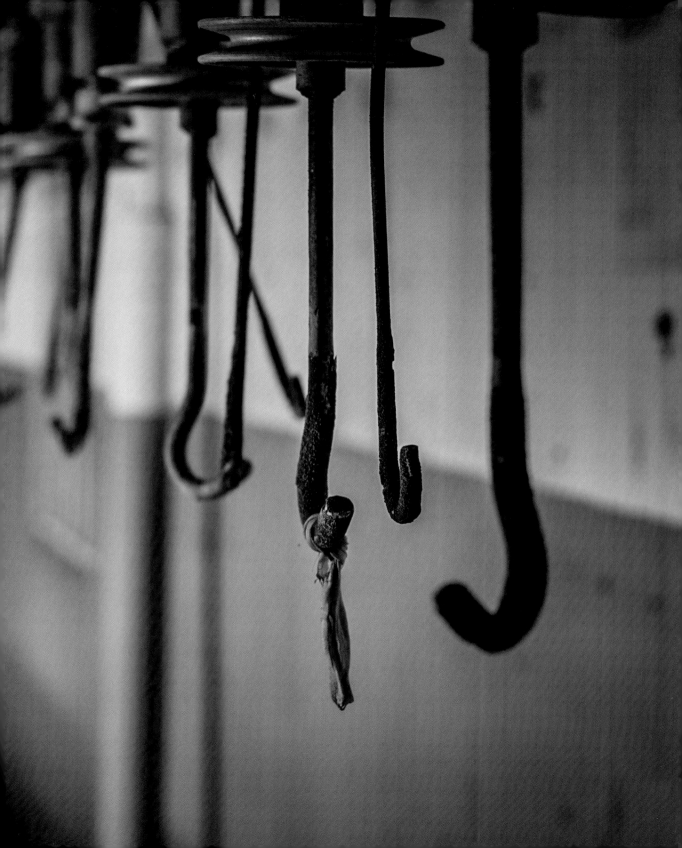

Perspective

How high is my tripod? Which side should I shoot this from? How is the light falling on it? These are the three things you should be asking yourself after you've chosen something you want to shoot. The key is to experiment. Don't waste your time taking pictures at all heights and sides. Walk

I've tried to capture this incredible room in an abandoned commune more times than I can count. Here is an example of one day when I walked around the room while trying different angles. I settled on the third shot as my favorite. The compositional elements simply didn't align to my satisfaction in the first two.

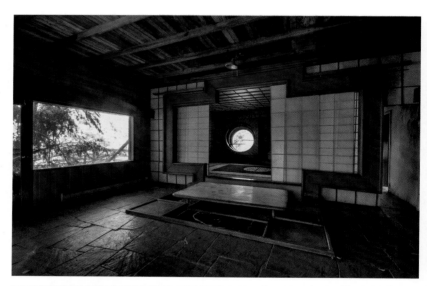

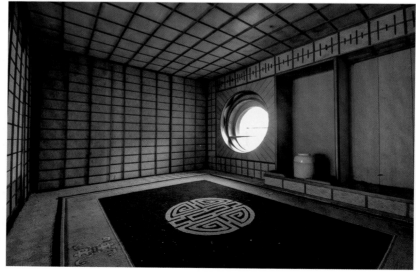

around your subject with a discerning eye. Imagine what your photo would look like while crouching down or standing on something. After you do this for a while, you'll have that "aha!" moment when you walk into a room and visualize exactly how you want to frame your subject.

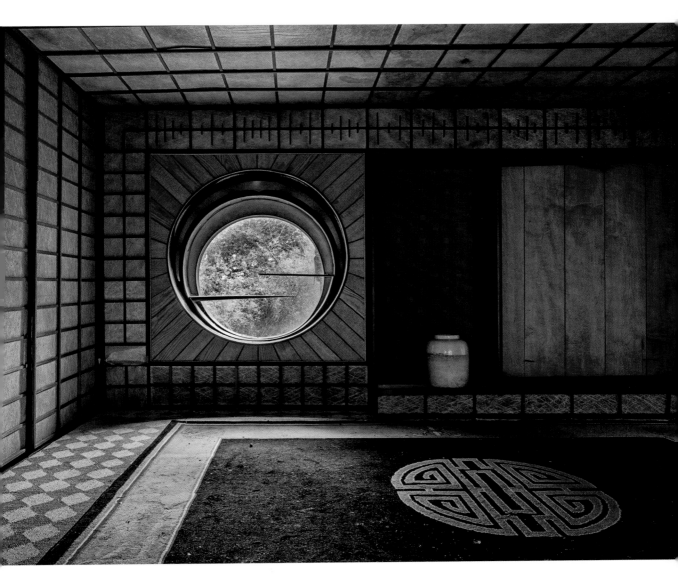

The Three Major Shots

No matter the location, photos from any abandonment usually fall into one of three categories:

- **Wide shot:** A wide-angle shot that captures all the detail of a room, from wall to wall
- **Detail shot:** A zoomed-in shot that captures a specific object or texture within the room
- **Exterior shot:** A shot of the outside of the building(s)

All three of these styles are taken directly from real-estate photography. We're obviously going for a much grungier, darker feel than the perfect, well-lit photos of real estate, but the principles are identical. To make the best use of your time, remember to take all your shots in the order listed above.

The wide shot

When you're shooting a wide shot, you obviously use your widest lens. If you have a fisheye lens, it's even better! But use the fisheye in moderation—in situations where you simply can't capture the scene without it. You can also use a fisheye lens to create interesting lines and angles, because of the lens's distortion. You can also use a normal wide-angle lens's distortion to your advantage. By setting up your tripod very low and angled toward the ceiling, you can create a very cool elongated effect.

(opposite) A fisheye lens enables you to catch a huge area within one shot. The trick is to make it work compositionally. In this shot, I thought the stairs served as a great leading element through the image.

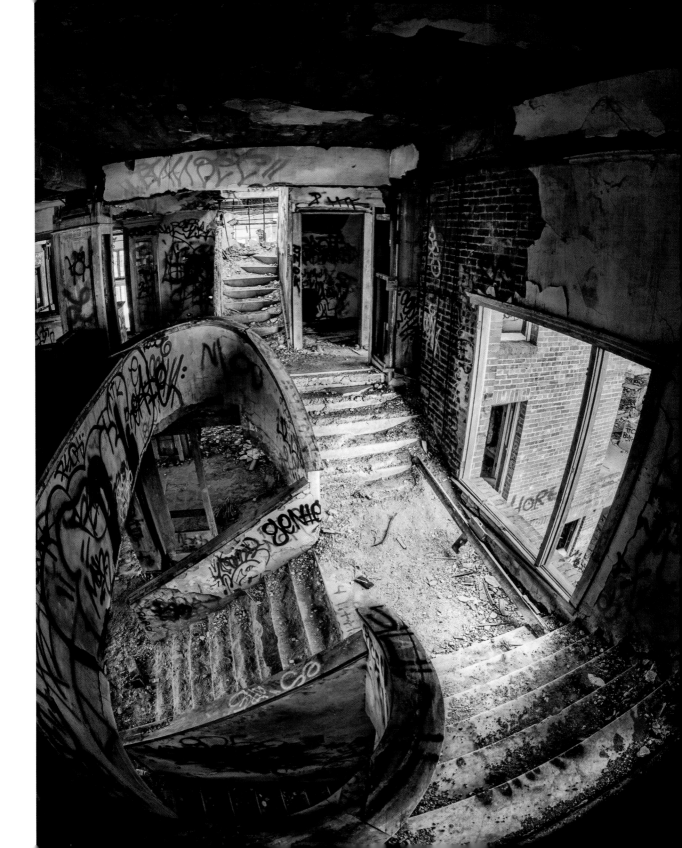

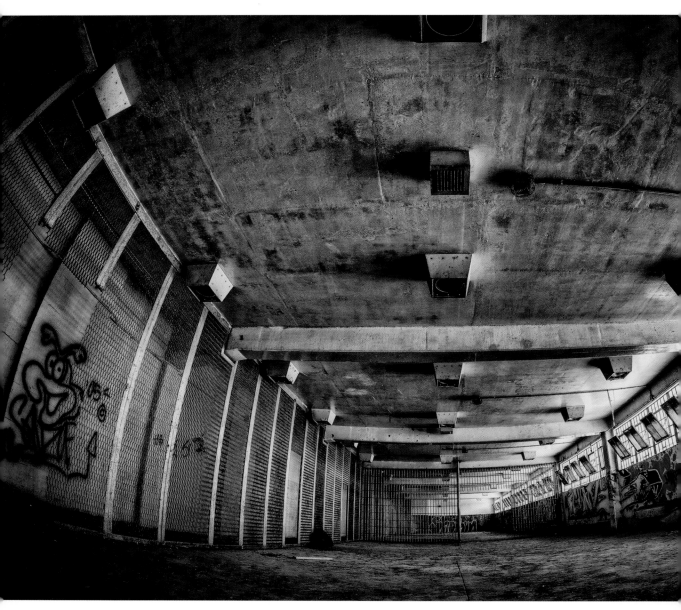

This shot is a perfect example of how you can use wide-angle distortion to your advantage. Just set up your camera very low and angle up to the ceiling to get the elongated effect.

The detail shot

Details can be shot using just about any lens at a high aperture. I usually look for unique items that help tell the story of the place I'm in. Old family photos in abandoned houses, official documents in military structures, and medical supplies in hospitals all help my viewers understand the kind of abandonment they're looking at and also give them a sense of how old the abandonment is.

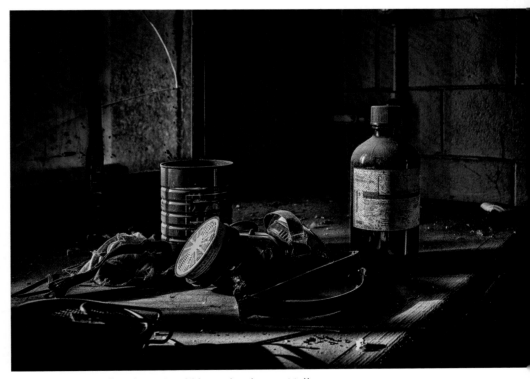

Sometimes the smaller elements within an abandonment tell a better story than do the elements of a wide shot.

The exterior shot

Some urban explorers are wary of taking exterior shots because they don't want to give away the location of the abandonment to taggers and scrappers. I think it's generally very difficult to find abandoned buildings based upon their exterior appearance alone, so I don't shy away from shooting exteriors. However, I do like spending most of my time in the interiors, and I'll generally only get the exterior shot if the lighting is right. That's my personal preference, but if you're shooting as a documentarian, I say go for it!

Blue hour at this psychiatric hospital came and went very quickly. Within 5 minutes of this shot, it was pitch black and we had to stumble to our car using only moonlight. Of course, we had flashlights but it was too risky to use them.

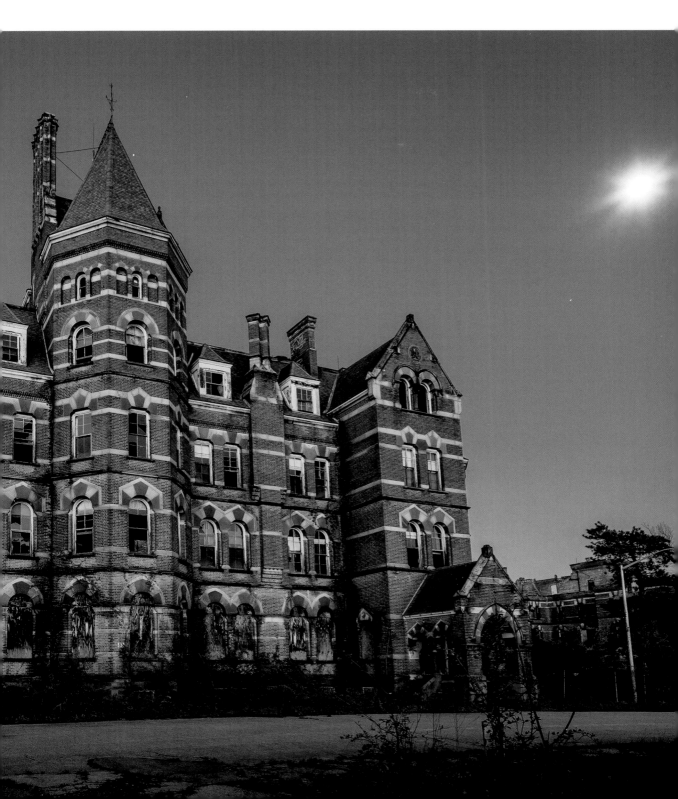

Raw, Aperture, ISO, Lenses, and More

I'm going to offer you some general guidelines for settings and gear, but they can absolutely be ignored based on your unique situation. These are simply baseline settings that I use in any situation and that have offered the best results for me if the conditions are right. But even if they aren't, I have to make only minor adjustments.

Raw or JPEG

Since the advent of digital photography, cameras have been able to save in different file formats. The most prevalent file formats today are raw (.cr2, .NEF, .dng) and JPEG (.jpeg, .jpg).

Raw files are lossless images that are essentially data files taken straight from your camera's sensor. They require special software to view them (such as Adobe Lightroom) and look pretty flat upon first glance because the camera is recording only data; the computer chip inside the camera isn't applying saturation, contrast, color tone, or sharpness settings to the image, which makes it look pretty dull. Your camera probably has settings such as Auto Lighting Optimizer or Picture Style (Portrait, Landscape, Neutral, Faithful, and so on); raw file formats ignore these settings and deliver a pure image to your memory card.

JPEG, on the other hand, applies saturation, contrast, color tone, and sharpness settings to deliver a compressed (not lossless) image that your camera thinks looks best. The problem with this format is that your camera doesn't always know best. Some people prefer JPEG files because they are smaller and take up less room on a memory card and on a computer. The reason that these files are smaller is that the camera applies these settings and then discards all of the "extra" data.

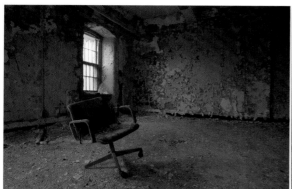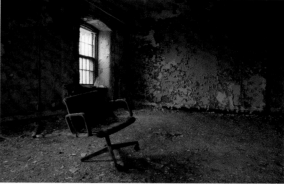

On the left, a raw image with no post-processing applied. On the right is a JPEG with no post-processing other than the in-camera automatic functions.

So what does this all mean?

To boil it down to the simplest explanation, raw files will let you make more corrections to your images than JPEG files will. Because raw files retain all the data from the sensor, you have much more latitude when making adjustments. JPEG files discard the "extra" data after applying the camera's settings, so you have much less data to manipulate.

JPEG files can look great straight out of the camera with minimal adjustments needed. Raw files look pretty bad straight out of the camera and usually require more adjustments. I prefer having the flexibility to edit the raw files on my own because UrbEx shots are difficult to shoot and cameras aren't sophisticated enough to know how I want my images to look.

Some cameras can save both raw and JPEG at the same time so that when you get the photos onto your computer, you can decide if the JPEG is good enough and not worry about dealing with the raw version. I typically don't bother saving both, because I know that I'm going to need the raw file to create my final image. My best advice is to shoot raw; a majority of the post-processing I talk about later in the book is dependent upon it.

Mode

I shoot in Aperture Priority mode 95 percent of the time, so I don't need to worry about shutter speed. I recommend you do the same simply because it will save you time. Seasoned photographers may balk at the notion, but we're after the best results with minimal time and effort.

ISO

I shoot at ISO 100 whenever possible. If I can't get a shot without going over ISO 400, I break out the intervalometer or I opt to light-paint with a flashlight. I hate the feeling of getting home only to find out that my favorite shot is plagued with noise that can't be fully corrected in post-processing. You'll learn about shooting options in greater detail later in the book.

Lens

For wide shots and exterior shots, I use a 17–40mm f/4 lens. For detail shots, I use a 24–105mm f/4, a 135mm f/2, or a 50mm f/1.8. I prefer prime lenses for detail shots because they tend to be sharper than zoom lenses. If you have an unlimited budget, you have a plethora of other choices, such as fisheyes and tilt-shift lenses, but the basic lenses offer the performance I need without requiring me to eat ramen noodles for every dinner.

Aperture

I shoot between f/5.6 and f/16 for wide shots and exterior shots. When you drop below f/5.6, you run the risk of having the corners of your photo blurred due to depth-of-field limitations. If you shoot any higher than f/16, your lens may actually decrease in sharpness due to lens diffraction.

Some photographers recommend shooting wide compositions in the highest f-stop possible so that *everything* is in focus. While that works, all lenses have a "sweet spot" where the lens performs at its sharpest.

Usually, the sweet spot is one to two stops below your lens's widest aperture. For example, the sweet spot on my Canon 17–40mm f/4 is f/5.6. The farther away from that you go, the less sharp your shot will be.

The trade-off is for depth of field (DOF). You need to sacrifice overall sharpness for the DOF of your composition. That's why I usually shoot in the f/8 to f/11 range for wide shots. Doing so offers the best trade-off of DOF and sharpness so that my entire shot is in focus while maintaining the highest level of sharpness that my lens has to offer.

For detail shots, I shoot between f/2.2 and f/5.6. Most of the time I want to completely wash out the background of my subject with bokeh, but sometimes the background offers an interesting counterpoint that I want to keep slightly in focus. Remember to keep compositional rules in mind when shooting detail shots. It's easy to see something interesting, line it up in the center of your frame, and fire away. The hard part is making that object or texture interesting and placing it within the larger context of your abandoned scene.

TIP Getting great bokeh involves a combination of low f-stop and the distance between your subject and its background. The farther away your subject is from its background, the blurrier your background will be.

The key here is to know your gear. Try shooting the same scene at three different apertures so you can see the difference when you get home. For your sharpest shots, make a note of which aperture you used so that you can hone in on your own favorite aperture range for future shoots.

Bracketing Your Shots

Bracketing is a simple way to ensure that you get a proper exposure of your scene. Sure, you can rely on your in-camera histogram to tell you if you've achieved the perfect exposure. But I've surprised myself in the past when I've liked the overexposed or underexposed shot better than the proper exposure. So I always like to have the flexibility to make that choice after I've imported my photos to my computer. I also bracket shots so that I can have more flexibility when it's time to post-process a final image.

What Is Bracketing?

Bracketing your photos simply means taking the same photo numerous times at different exposure levels. Using your camera's built-in exposure compensation, you can capture scenes that are dramatically overexposed and underexposed. I typically capture seven shots ranging from −6 to +6 in increments of 2. I primarily do this because I create high dynamic range (HDR) photos out of most of my shots. (We'll explore HDR later in the book.)

Even if you have no interest in creating HDR images, I still encourage you to take a couple of bracketed shots so that you have a variety of exposures to choose from when you get the photos to your computer. Sometimes a single exposure simply looks better than the HDR result; other times, having a shot that's just a tad brighter or darker helps convey the scene better than a proper exposure. Hard drive storage is so cheap these days that there's no reason not to bracket your shots unless you're in a hurry while shooting.

How to Bracket

Bracketing your photos is very easy. I'll show you how it works on my camera (a Canon 6D; sorry, Nikon shooters), but consult your camera's manual to figure out how best to do it.

First, you need to tell your camera how many exposures you want to shoot:

1. Press the Menu button.

2. Find the Custom Function menu, and press the Set button to get into it.

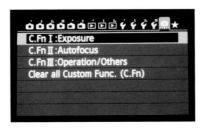

The Custom Function menu

Here you can choose between two, three, five, and seven shots. Some cameras can go up to nine, but some are limited to three.

3. To get three exposures, select 3 shots and press Set. (The same goes for 5 and 7 shots.)

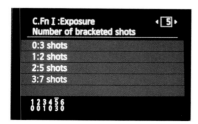

4. Once you've selected your shots, you can press the Quick Control button on the back of your camera. It's the Q button.

5. Use your directional buttons to get to the Exposure comp./AEB setting.

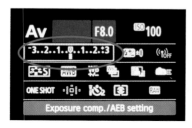

6. With the AEB setting highlighted, turn the wheel on top of your camera to the right to add additional exposures.

7. You should now see three dots, indicating that your camera will take shots at +2, –2, and 0.

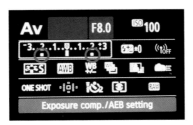

If you selected five shots in the Custom Function menu, you'll have five dots.

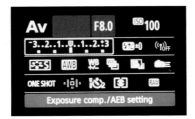

And if you selected seven shots, your AEB section will look like this:

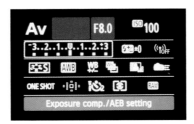

8. Set your camera to shoot with a two- or ten-second timer, and press the shutter button. Your camera should take all your shots in succession. If you don't use a two-second timer, when you press the shutter it will take only one bracketed shot. The next time you press the shutter, it will take another bracketed shot, and so on until you've taken the number of exposures you've selected.

If you're taking seven shots and you've still got blown-out highlights in your darkest exposure, do the following:

1. Select five or seven shots in the Custom Function menu.

2. Go back to the AEB option.

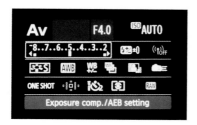

3. Use the wheel on top of your camera to bring your bracket all the way to the left. The range looks like it stops at –8, but it really goes all the way down to –14. In this configuration, you camera will take shots at –14, –11, –8, –5, –2, and +1. That should be more than enough to get the dark shot you need to fix those highlights.

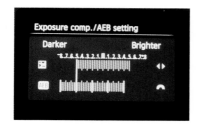

4. Shoot away!

TIP Firmware that can be used with select Canon cameras, called Magic Lantern (www.magiclantern.fm), has options to take as many as nine exposures (the last time I checked), and it can even auto-bracket. Auto-bracketing will take as many exposures as necessary to effectively capture the entire dynamic range of your scene. I should warn you that using Magic Lantern may have some adverse effects on your camera. I have had no problems with it, but as with any custom firmware, you use it at your own risk.

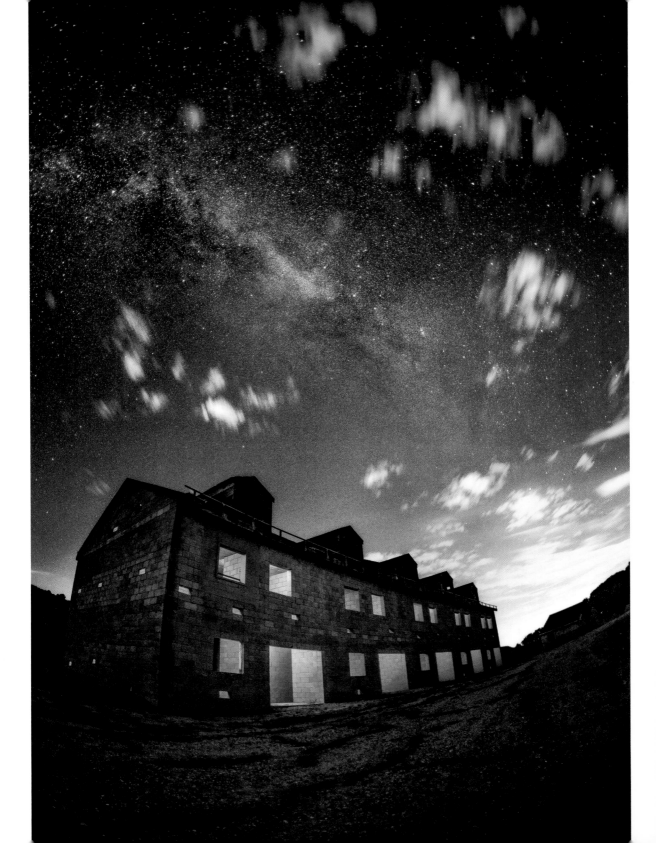

Shooting in the Dark

This is perhaps the most difficult aspect of shooting UrbEx. More often than not, we are in very dark places, which are notoriously difficult to capture effectively. Tripods are typically mandatory, so we have a few choices in terms of capturing a scene. Keeping yourself safe in these places is hard enough, so I'm going to give you the quick and dirty guide to getting great shots. I've tried all these methods. There's no "right way," but there is certainly a best way given your environment and time restrictions.

Focusing

One of the most difficult aspects of shooting in very dark places is focusing. Your camera's autofocus will keep adjusting back and forth if it can't measure the light. Some cameras are equipped with an autofocus assist beam that will shoot a small beam of light in the direction you're shooting. My camera is not equipped with this feature, so I've had to pick up some tricks to compensate.

It's not really a problem if I have permission to shoot an abandoned building, because I can just turn on my flashlight and use autofocus. If I am in an abandoned building without permission and have some security concerns, focusing gets a little more difficult, because turning on my flashlight means that somebody could see the light from the outside.

You could try to focus manually, but I have had very limited success doing so, and it's usually a huge waste of time.

This is my go-to flashlight for focusing if I'm not in danger of being seen. It's a Fenix PD35 with 850 lumens, more than enough to get the job done (and potentially blind your exploring buddy).

TIP Experiment whenever you have opportunities to shoot in dark rooms. You can even practice in your own home: just turn the lights off and shoot away!

Instead of using a flashlight to focus, you could use a laser pointer so you don't draw attention to yourself. Just point the beam at your subject, and autofocus works like a charm. Some laser pointers come with attachments that create little images with the laser beam, which works even better than one laser beam because your autofocus has more than one point to use as a focal reference.

You could also place your cell phone where your subject is (with the screen on) to get autofocus to work. If you're exploring with a friend, you can have them stand where your subject is while holding their hand over a flashlight (letting just a little bit of light shine through). You have many different ways to get autofocus to work in dark conditions; I find that the laser pointer is fastest and easiest, so I carry one with me at all times.

Three Choices: Light Painting, Small F-stop/High ISO, Intervalometer

We can artificially light the shot, we can sacrifice picture quality, or we can sacrifice our time. Lighting your shots artificially can ruin a scene's natural ambience but can also add a cool effect in a time crunch. Compensating for the darkness by shooting at a low f-stop and high ISO is by far the most efficient method to capturing a scene if you're limited for time, but you're going to sacrifice picture quality. Using an intervalometer is the best way to capture a scene with its natural ambience and in the highest quality possible, but I recommend this method only if time is no concern.

Light painting

Pros: Relatively fast
Cons: Sacrifice ambiance and authenticity, flat-looking images, some experimentation necessary

Light painting is the easiest way to get a shot in the dark if you're pressed for time. It can also be a great way to add some interesting effects to a scene. Purists may cringe at the thought of using colored flashlights, but when executed properly, light painting can make your shot unique.

A flashlight (or "torch" for my European brethren) is something you should be carrying with you no matter what, so you don't need to haul any extra gear to light a room. Light painting always requires some experimentation because variables such as room size, flashlight power, and ambient light all play a role in a proper exposure. Here are my steps to nailing an exposure:

TIP You can also buy a multi-colored flashlight so you can light paint different parts of the room with different colors.

1. Set your camera to f/8, ISO 400, and 30 seconds in Manual mode.

2. Point your flashlight at your subject and focus accordingly.

3. Switch your lens to manual focus so you don't lose focus when pressing the shutter button. You can avoid this by assigning a Back-Button Auto Focus. (Google it.)

4. Press your shutter button.

5. Now you have two choices while the shutter is open:

 a. Wave your flashlight around the room quickly in uniform strokes (up and down, then side to side) for the full 30 seconds.

 b. Point the flashlight at a wall or ceiling behind you and hold it steady for the full 30 seconds.

 Choice A will light the room better, but it will look flat because you will effectively illuminate all the shadows. Choice B will give you some good shadows, but your exposure will be much darker (so you'll need to compensate with a stronger flashlight or use the intervalometer method described later).

6. When the shutter closes, check your exposure. If it looks too bright, cut the ISO to 200. If it looks too dark, you can bump the ISO higher, lower the aperture to f/5.6, or use the intervalometer method. If you have time, use an intervalometer. I'll tell you why shortly.

7. Repeat steps 1–6 with adjustments.

You can also use a flash to illuminate your scene, but to be blunt, you shouldn't ever use your camera's built-in flash for UrbEx photography. It kills all ambient light and makes the scene look too artificial. I'll just leave it at that and accept the hate mail later.

However, you can absolutely use off-camera flash units to light up particularly dark areas within your frame. Assuming your camera is on a tripod (I can't imagine why it wouldn't be), follow the same steps as in the flashlight instructions as a starting point. With the exposure time at 30 seconds, you can run around the scene and manually pop off your flash without your camera capturing you in the image. Make sure to keep the flash pointed away from you, and also cover any little lights on the flash unit itself (like the ready/pilot light, illuminated screen, and so on) because your camera will undoubtedly pick those up as light trails as you run around.

This photo was taken by pointing my flashlight at the ceiling of an abandoned military bunker, then running down the hallway as far as I could go.

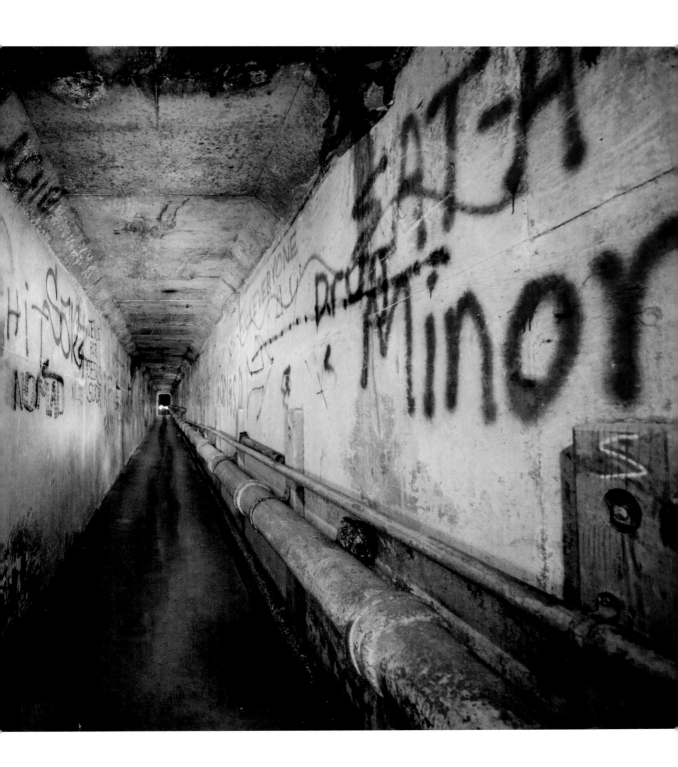

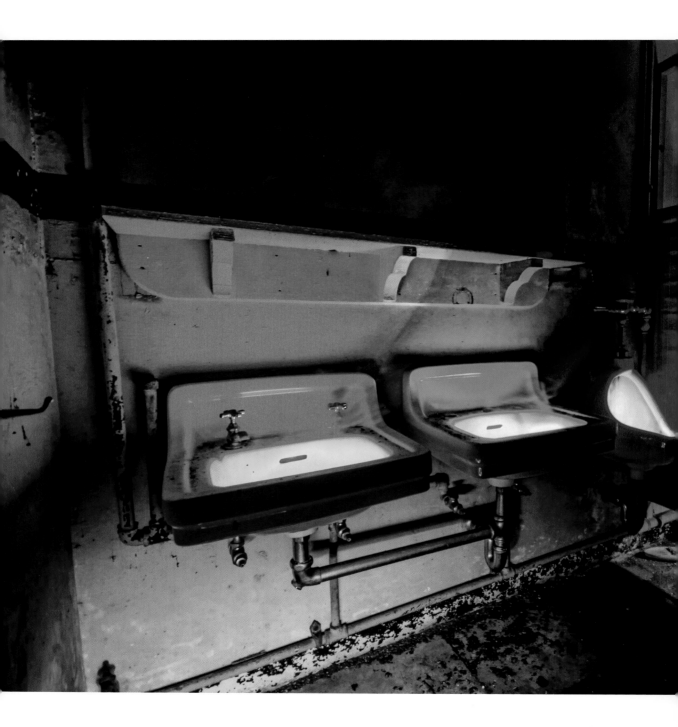

Gels can also be used with your off-camera flash. They're little pieces of colored plastic that can be placed over your flash to give off colored flashes of light. I like to put gels between my flash and its diffuser so they are locked in place. Use a gel-covered flash just as you would a regular flash. When you start to colorize a composition with flashes and flashlights, you're shooting with an artistic purpose. You're not trying to maintain the authenticity of the scene, so enjoy it and experiment until you're happy with the results.

TIP Make sure that your flash never faces the camera itself. You always want to bounce the light off surfaces. Also, make sure your flash is pointed away from your face; otherwise, you'll show up as a ghost in the final image.

A multi-colored flashlight lets you create very dynamic scenes with minimal extra gear.

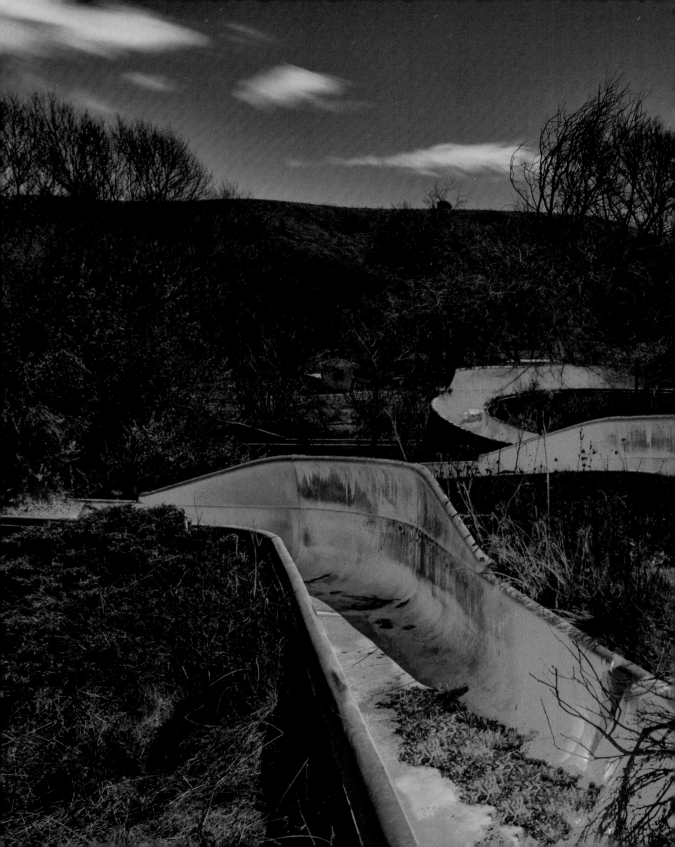

To nail this shot of an abandoned water park, I needed to have an exploring buddy run down the other slides to set off gel-covered flashes. I was setting off flashes while running along the closest slide.

Small f-stop/high ISO

Pros: Fastest option
Cons: Sacrifice image quality (higher noise and shallow DOF)

Your second option for lighting dark places is to lower your f-stop and raise your ISO. This is my least favorite option because it sacrifices image quality for time. If you're going to go to the trouble of getting into an abandoned building, you might as well walk away with shots that you're proud of and shots that are printable. Because you don't always have all the time in the world while you're in a location, however, here's how to use this technique when you have to:

1. Set your camera to f/4 and 30 seconds in Manual mode.

2. Point your flashlight at your subject and focus accordingly.

3. Switch your lens to manual focus.

4. Turn your flashlight off and check your light meter in your view-finder by pressing your shutter button halfway down.

5. Adjust your ISO until your light meter gives a proper exposure at 0.

6. Fire away!

Your ISO could end up at 5000 or higher to get a proper exposure. When an ISO is this high, I find the images to be practically unusable. The ISO noise is simply too great to maintain a sharp image. This is my personal preference, however. Obviously other factors come into play, such as your camera's ISO handling, in-camera noise reduction, and the application of noise reduction software in post-processing. Some of the new mirrorless DSLRs have incredible ISO noise handling and can create usable images at very high ISOs. If you're like me, you probably don't have thousands of dollars to spend on a new camera at any given moment, so you'll have to make do with what you have. My best advice is to experiment with your own gear and decide for yourself.

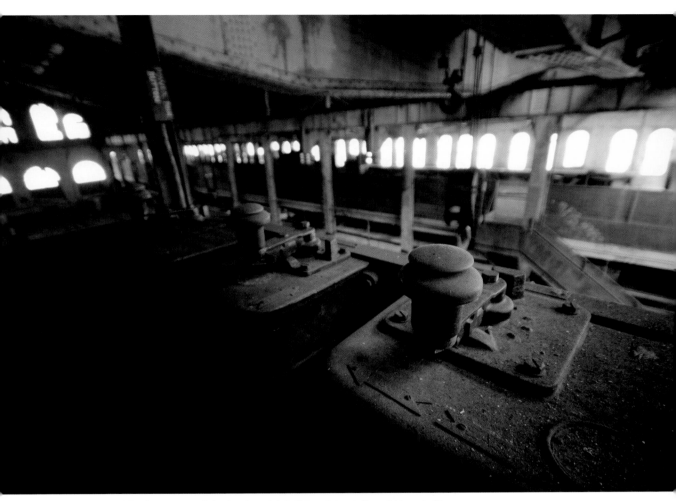

The space for this shot was so tight that I couldn't fit in a tripod. (I could barely fit myself.) My only choice was to shoot these crane controls while holding my camera. The small f-stop/high ISO method was my only option given the circumstances.

Intervalometer

Pros: Highest image quality, natural ambience
Cons: Sacrifice time

Now for the best option: the intervalometer. Using an intervalometer is a tad more complicated and time consuming, but the payoff is worth it. If you're new to an intervalometer, it is an external device that lets you take exposures longer than the 30 seconds your camera is restricted to. If you don't have an intervalometer, both Apple and Android have intervalometer apps that require only a cable with which to hook the mobile device to your DSLR.

The difficult aspect of this technique is figuring out exactly how much time is required to get a perfect exposure. Most people dial in their aperture and ISO, and then just guess and adjust from there. I've got an easy way for you to skip all of the guessing. I call it the "Amy method." My friend (and amazing photographer) Amy Heiden taught it to me while we were exploring an old military base. Other people may have come up with this method, but it was new to me so I'm giving her the credit. Here's what you do:

1. Make sure your intervalometer is plugged in and ready to go.

2. Switch your camera to Aperture Priority mode.

3. Set your f-stop between f/8 and f/11, and set your ISO as high as necessary for a proper exposure on your light meter. I set mine at about 10,000 because it's a nice even number to work with, and you'll learn why in a moment.

4. Point your flashlight at your subject and focus accordingly.

5. Turn your flashlight off and switch your lens to manual focus.

6. Half-press your shutter, and make a note of the suggested exposure time either in your viewfinder or in the top-panel LCD display.

7. Fire a test shot.

8. If your test shot looks good, you now have some calculations to do. If the test shot required a shutter speed of 10 seconds at ISO 12,800 for a correct exposure, *divide* the ISO in half while *doubling* the shutter speed to get down to an image what won't be plagued with ISO noise. The handy chart in **Table 2.1** illustrates the Amy method.

TABLE 2.1 Some simple math gets us to a proper exposure: 640 seconds on the intervalometer (roughly 11 minutes) and an ISO of 200.

SECONDS	ISO
10	12800
20	6400
40	3200
80	1600
160	800
320	400
640	200

9. Switch your camera to Bulb mode, enter 11 minutes into your intervalometer, and set your ISO to 200.

10. Trigger your shutter with your intervalometer.

11. Keep exploring your location and start planning other shots while you wait for your exposure to finish.

As I said, you'll be sacrificing time using this method, but it will undoubtedly get you the highest quality shot. I did some sample shots in an abandoned military bunker to illustrate this. The first has been light painted with a flashlight pointed at the wall behind the camera, the second one was shot at a high ISO, and the third was shot using an intervalometer. These haven't been edited at all; they're straight out of the camera.

Shot using a flashlight. I captured all the elements of the scene, but it's fairly boring.

17mm, 30 sec., f/8, ISO 100

Although our shot may not have natural light, it has virtually no noise.

Shot at a high ISO, this scene is a little more interesting because of the light pouring into the room. But upon closer inspection, you can see that I've introduced a lot of noise into the final image.

17mm, 30 sec., f/8, ISO 2000

Examine the lettering on the cans and the detail in the shadows. You can see just how much noise was introduced. Noise reduction software can work wonders, but only to a certain extent.

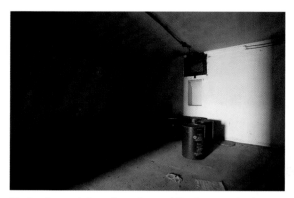

Shot using an intervalometer and the Amy method, I've captured the great light coming into the room and I haven't introduced unnecessary noise.

17mm, 478 sec., f/8, ISO 100

The best of both worlds: natural light with minimal noise. However, it took eight minutes to shoot it. Use the intervalometer only when you've got time to spare.

Shooting with Stars

Shooting at night can be another way to get creative with your abandoned location photography. Since we typically shoot these places in the dark, why not add some natural characteristics to your shots, such as stars? If you're in an abandoned place that's far enough away from city lights (and it's not a full moon), you should be able to get some great photos with stars in them.

All you need is:

- Camera
- Tripod
- Intervalometer
- Fast lens (such as an f/1.4, f/2.8, or f/4)

Star Trails or No Star Trails?

Once you're in the middle of nowhere with bright stars overhead, you need to decide how you'd like to capture those stars with your abandoned subject in the foreground. No matter which method you choose, you can light paint your abandoned subject in the foreground using any of the methods I've previously described.

No star trails (the 500 rule)

The "500 rule" is a simple calculation you can use to avoid having star trails in your shots. There's nothing wrong with having streaks of stars in your long exposure, but sometimes you might have the opportunity to produce a crisp image using the Milky Way.

The traditional rule uses 600 instead of 500, but 500 has produced star trails for me in the past so I prefer to err on the side of caution. What is the rule? It says that the maximum exposure time of a photo that doesn't generate star streaks is achieved by dividing 500 by the effective focal length of the lens.

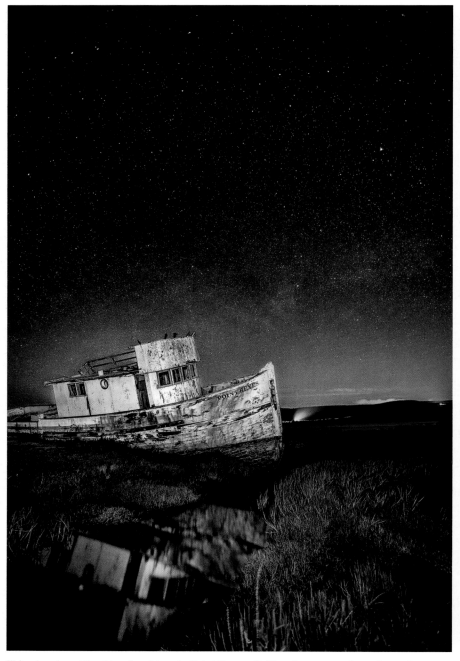

This abandoned boat is a local icon in Point Reyes, California, near my hometown. I've driven past it for most of my life, and I never took a photo of it until last year. This shot was created using two exposures: one was for the boat, which was light painted with a cheap headlamp (not worrying about the exposure of the stars), and one was a proper exposure of the stars using the 500 rule (see previous page) in which I didn't light paint at all. I simply blended the two together with Adobe Photoshop.

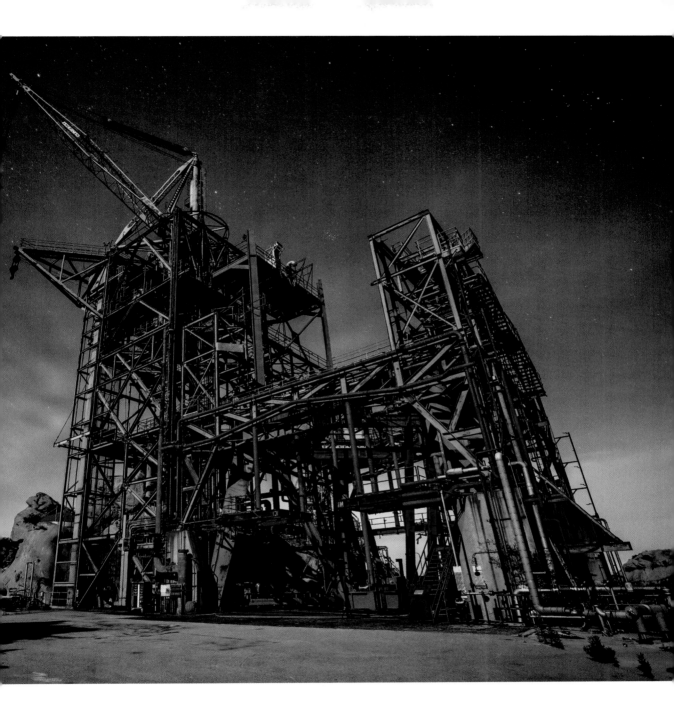

Let's say you're using a 50mm lens on a full-frame camera. All you have to do is divide 500 by 50 to determine that you get 10 seconds of exposure before streaks are noticeable. If you're using a crop sensor (such as Canon's common 1.6x sensor), all you do is multiply that exposure time by 0.6. That same 50mm lens on a 1.6 crop factor camera would allow only six seconds of exposure. Once you have that time dialed in, use your ISO as the variable to get a correct exposure. Here is a step-by-step guide for you to use in the field, with the photo of the Point Reyes boat as the example.

1. Open your lens to the widest focal length. My wide-angle lens was 17mm at its widest.

2. Use the 500 rule to calculate exposure time. Using 17mm, my calculation came to 29 seconds. To be extra safe, I set my camera's exposure time to 25 seconds.

3. In Manual mode, set your camera to its lowest f-stop and input the exposure time. My wide-angle lens's highest aperture was f/4.

4. Look at the light meter in your viewfinder as you raise your ISO from 100. Keep raising until the light meter reads 0. My light meter told me that a proper exposure was at ISO 5000.

5. Shoot.

6. Adjust ISO lower or higher depending on results, and reshoot until you've got a proper exposure.

Star trails

Having star trails in your shot is much easier to execute and can provide you with some unique shots. You can get star trails in one of two ways:

- **One *really* long exposure**

 To capture star trails using one long exposure, you need to let as much light into your camera as possible for the stars to show up in your image. The best way to do this is to use a fast lens, preferably a lens that can open up to f/2.8, although most wide-angle lenses can only go up to f/4.

 In terms of shooting conditions, it's best to shoot during a new moon so that the light doesn't interfere. You can get away with a waxing or waning crescent moon, but a new moon is optimal. If you have anything more than a crescent, your exposure will be limited to less than 10 minutes because the moonlight will cause your image to become overexposed before your camera can capture decent star trails. For this kind of photography, darkness is your best friend.

 Lower your ISO to 100 and use the previously described intervalometer method to get an exposure time that is higher than the results of the 500 rule. Plug that time into your intervalometer and shoot away. Make sure you do a few test shots at higher ISOs so you don't waste time on

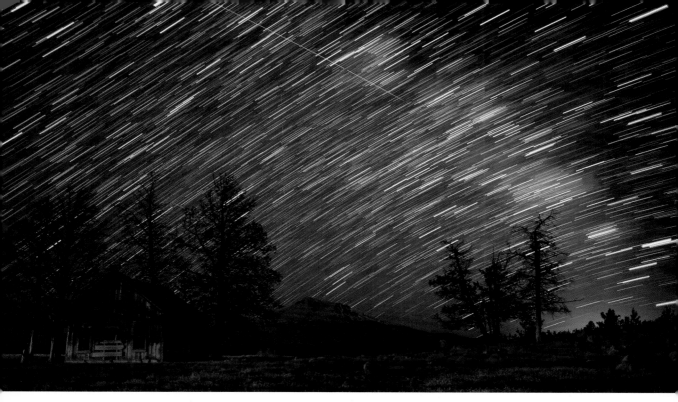

This photo of star trails is brought to you by my good friend and amazing photographer Michael Bonocore (www.michaelbonocore.com).

exposures that aren't perfect. This can take a few minutes or a few hours, depending on your scene (and your patience).

- **Numerous short exposures**

 You can take a series of shorter shots and then blend them together in post-processing using software like ImageStacker, DeepSky-Stacker, or Adobe Photoshop. For this method, I've had the best results with shots that are between 30 and 40 seconds (just enough to produce little star trails). Most intervalometers have a setting in which you can tell it to sequentially take a set number of photos (mine goes up to 999 photos). After a couple of hours, you'll have hundreds of photos to stack together, but you can get away with about 50 shots if you're in a hurry. Then all you need is one light-painted photo of your abandoned subject to mask into your shot using Photoshop.

Shooting Panoramas

Panoramas are great for gigantic scenes where a wide-angle shot just won't cut it. If want to convey the enormousness of a location, sometimes you need to shoot numerous images and stitch them together in post-production. Here's a simple guide for shooting a panorama:

1. Set up your camera *vertically* on your tripod.

2. Choose Aperture Priority mode on your camera.

3. Choose a proper aperture for your scene—f/8 to f/10 is usually a good starting point.

4. Focus on your subject and determine proper exposure time using your light meter (just as with the intervalometer method).

5. After you've dialed in your focus, set your camera to Manual mode and manual focus.

6. Take your first shot.

7. Inspect your first shot to make sure it looks good.

8. With Live View on, loosen the head of your tripod and swivel to the left or right (depending on which way you want to shoot).

9. Swivel your camera so it has at least 30 percent overlap from the first image you shot. Keep your eye on Live View to make sure you don't go too far.

10. Keep swiveling and shooting until you've fully captured the scene.

After you've done a full pass of your scene, you can tilt your camera up or down and do another pass to get even more of the scene into your panorama. Just keep in mind that the more photos you shoot, the more difficult it will be to align them in post-processing.

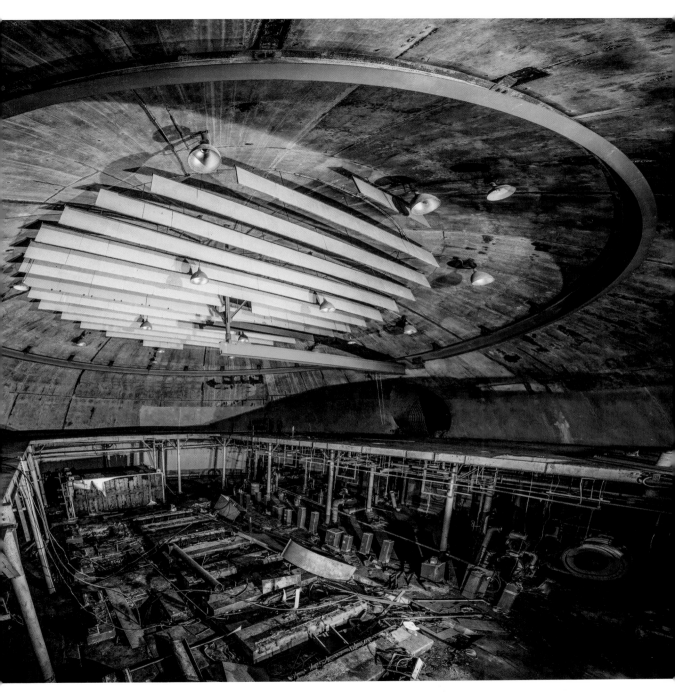

This shot of a power station in an underground Titan missile silo actually comprises
16 images shot with a 17mm tilt-shift lens.

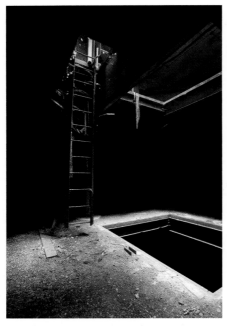

Here is the first shot in a simple two-shot panorama.

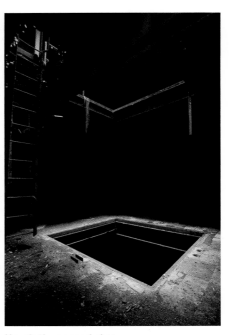

Here's the second shot.

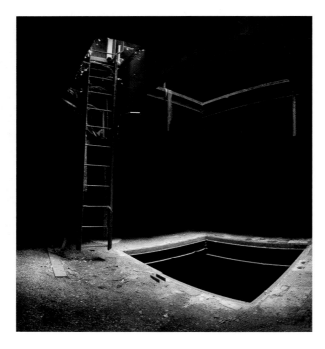

The image after stitching the photos together. Now I get to have the full scene in one image. It just didn't feel complete without the giant hole in the floor and the ladder together.

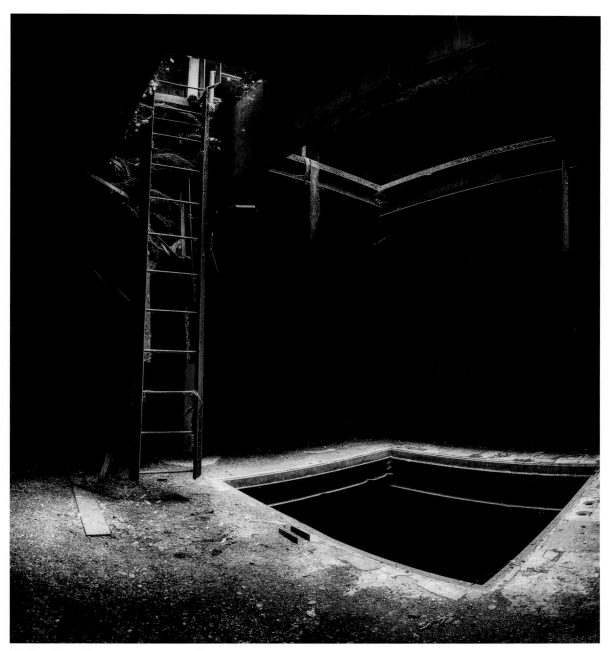

Final product after some post-processing.

THREE
WHAT TO SHOOT

Now that we've covered how to compose and shoot your photos, let's chat about what to put in those photos. Urban exploration is a unique genre because it involves static scenes that, as a photographer, you have to make interesting. You're not shooting amazing landscapes like the Golden Gate Bridge at sunset, where the scene speaks for itself.

Your job is to capture beauty in unforgiving photographic circumstances. My experience with UrbEx has taught me that combinations of organic and synthetic elements create our scenes. It's up to you to decide how to capture these elements.

This mysterious hatch was shot in the early morning light. I consider this shot a perfect balance of organic and synthetic elements.

Shooting Organic Elements

The organic elements in UrbEx photography are the most difficult to work with because they're usually out of your control. With that said, these are often the most important elements for creating a dramatic photo. Over time, abandoned places are reclaimed by nature. By timing your explorations, you can capture some dramatic scenes that truly highlight the balance between nature and your location's man-made structures.

Light Beams

Depending on the location, you can use harsh light to your advantage. Exceptionally dusty places will have natural light beams flowing through windows, collapsing ceilings, or even decaying walls. Light beams are really visible only when the light particles bounce off something in the air. If there's nothing to bounce off, you can give those particles something to bounce off! If you can see light beaming in but are having a hard time capturing light beams in-camera, here are six steps to help you:

1. Make sure you're wearing a respirator.

2. Set your camera on a 10-second timer or use a wireless trigger.

3. Run into your frame where the light beams are pouring in.

4. Kick up dirt and dust from the ground.

5. Run out of the frame.

6. Take your shot.

TIP I highly recommend that you wear a respirator because a majority of abandoned places were built during a time when asbestos was commonly used. As these buildings decay, that asbestos falls from the ceiling to the ground. The same can be said for a bunch of other nasty chemicals that you certainly don't want to be breathing. Additionally, check the floor before you start kicking around. If the floor feels unsafe to be walking on, you definitely don't want to push your luck by stomping and kicking around on it.

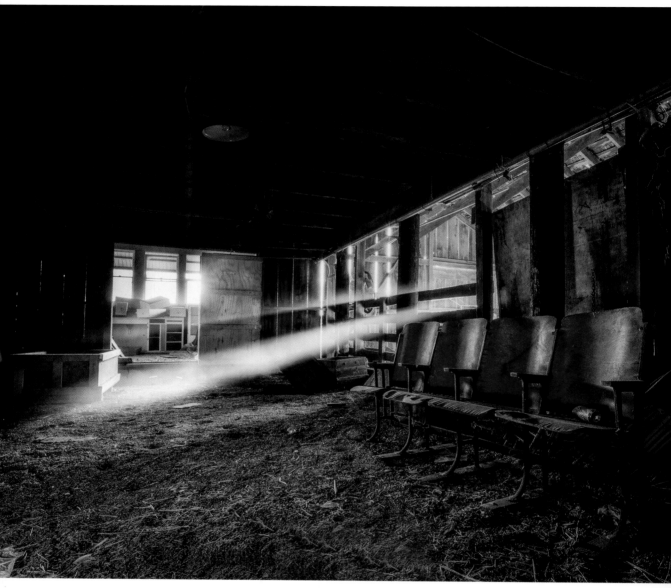

(above) I used the method described here to accentuate the light beams that were already visible in this abandoned barn.

(right) Sometimes you get lucky and nature does the work for you. Fog was rolling into this historic psych ward just as the sun was coming out. I didn't have to kick up dirt at all. I just set up my tripod and shot as many different angles as I could.

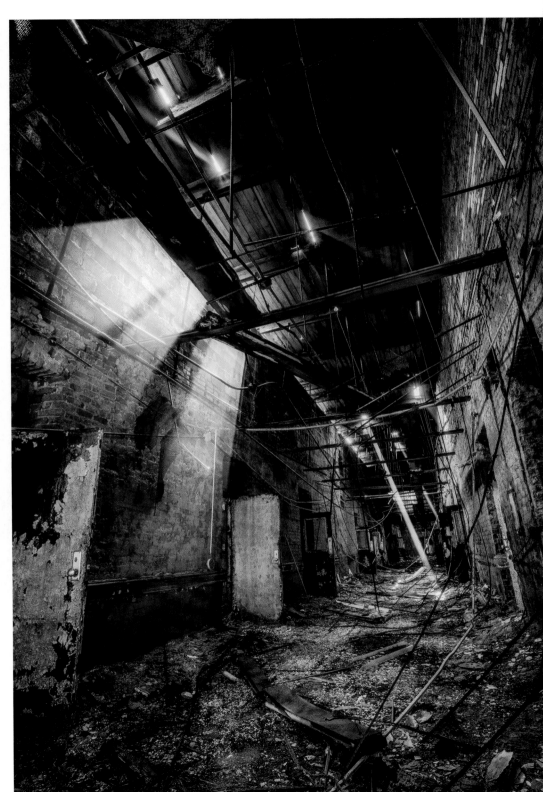

Overgrowth

Depending on the age of the location, there's a chance you'll have some plant life growing out of the floor, coming in the windows, or draping through the ceiling. Use that foliage to your advantage! Plants that grow naturally within a building are one of the unique aspects of UrbEx photography. The lives of natural organisms that are "reclaiming their territory" serve as a great symbolic offset to the death and decay of a man-made structure. Very few genres of photography are able to capture such a condition, especially on the grand scale of entire buildings.

How many other photographers can say they've had the opportunity to photograph plants growing out of the floor of a building?

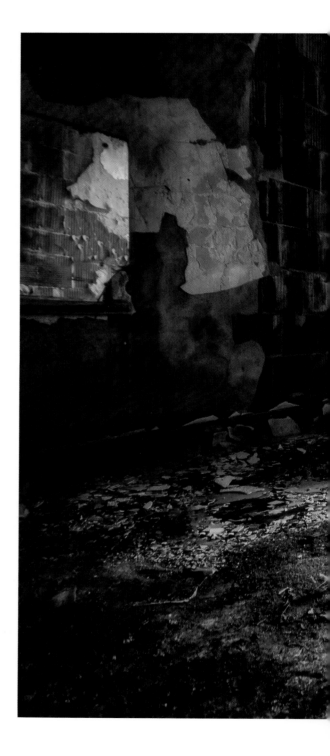

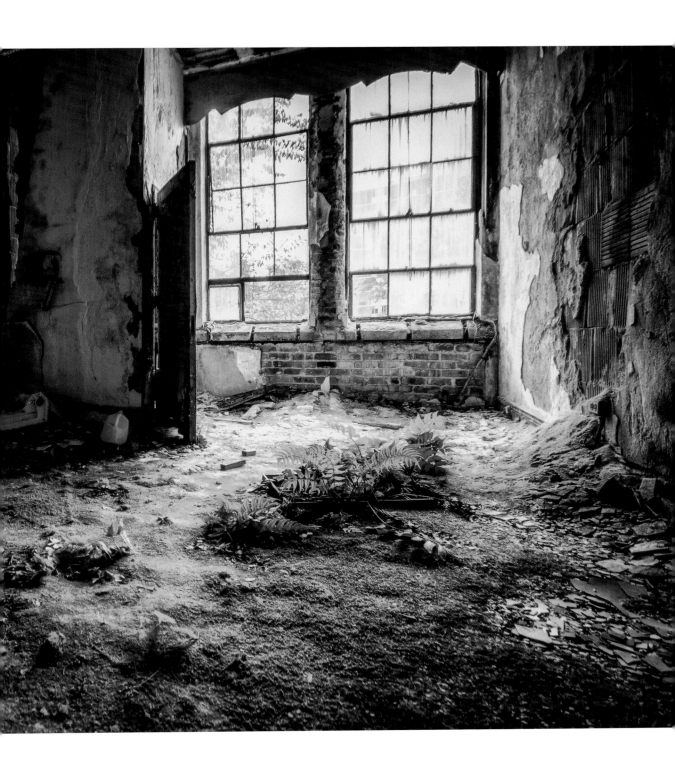

Capturing Synthetic Elements

The synthetic elements found in abandoned places can be easier to work with than organic elements because they can sometimes be moved around and relocated for a better composition. These elements typically give viewers a better sense of how the structure was used and the types of people who used to inhabit it.

While some of the larger synthetic elements cannot be moved and may even be built into the structure, they can still serve as a great photo subject. In my personal adventures, reoccurring elements like artifacts, chairs, graffiti, windows, peeling paint, and machinery have all made excellent subjects. If you see something in an abandoned place that doesn't fit within these categories, however, shoot it! The more unique, the better!

Artifacts

Personally, I think artifacts are the most interesting things to photograph in an abandoned location. Items that were left behind and remained undisturbed since a location's closure truly tell the story of that place's history. They encourage your viewers to put themselves in the scene and understand the age of the location. Not only do I find them some of the most interesting elements of urban exploration, artifacts become more and more difficult to find as the locations get older.

When I'm exploring a structure, artifacts are the first things I look for because they help me piece together the types of activities that occurred there. Items such as calendars, small machinery, documents, clothing, furniture, and commercial goods will serve as interesting subjects for your photos.

I found this bowl sitting perfectly in the hallway of an abandoned hospital. All I had to do was wait a few minutes for the sunbeam to hit it. A benefit of shooting at sunrise is that the light changes so quickly that you don't have to wait around for hours for the light to be right.

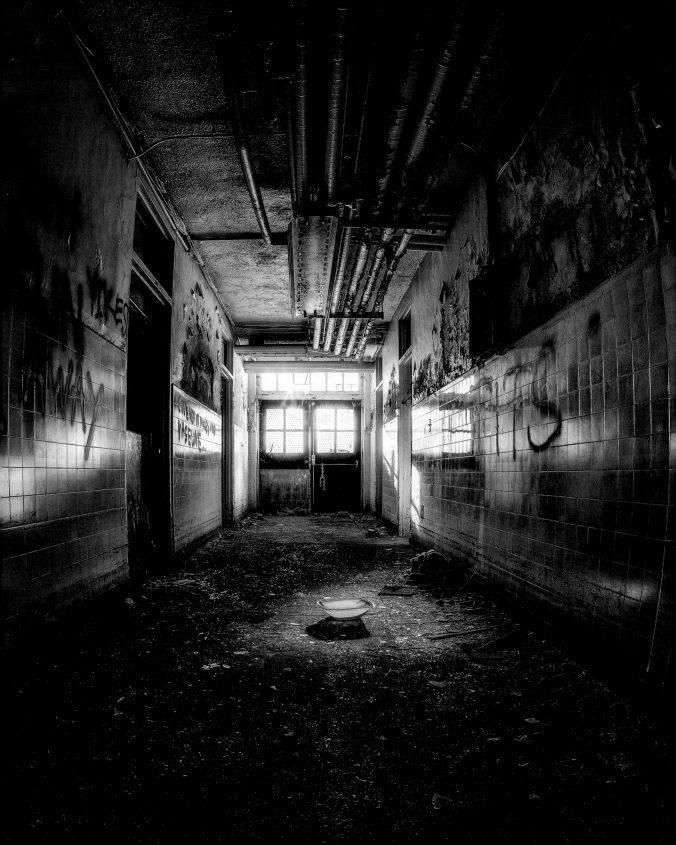

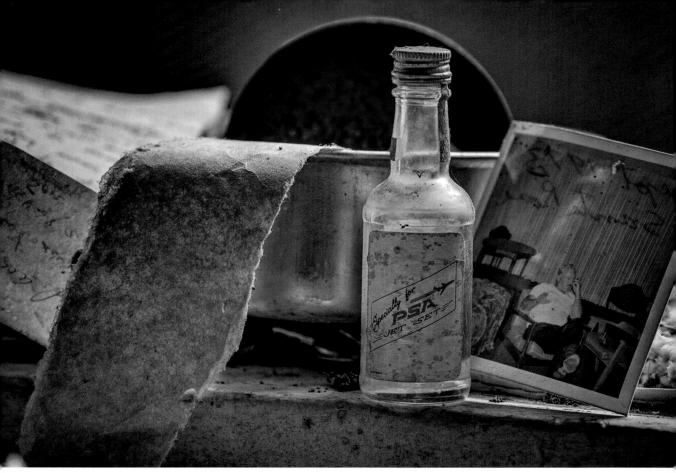

Photographs and papers in this abandoned house told
an extensive story about the people who once lived here.
There were even pictures dating to the 1940s depicting the
construction of the house itself.

One old psychiatric hospital had a pile of combs in front of its sinks. I
was told that before vandals ripped the medicine cabinets off the walls,
you could even find old toothbrushes and assorted toiletries. To non-
explorers, this must sound absolutely insane; but for the explorers, these
items are treasure just waiting to be photographed. The basement of this
place was a room that consisted of three collapsed floors' worth of arti-
facts. I could've spent a week there.

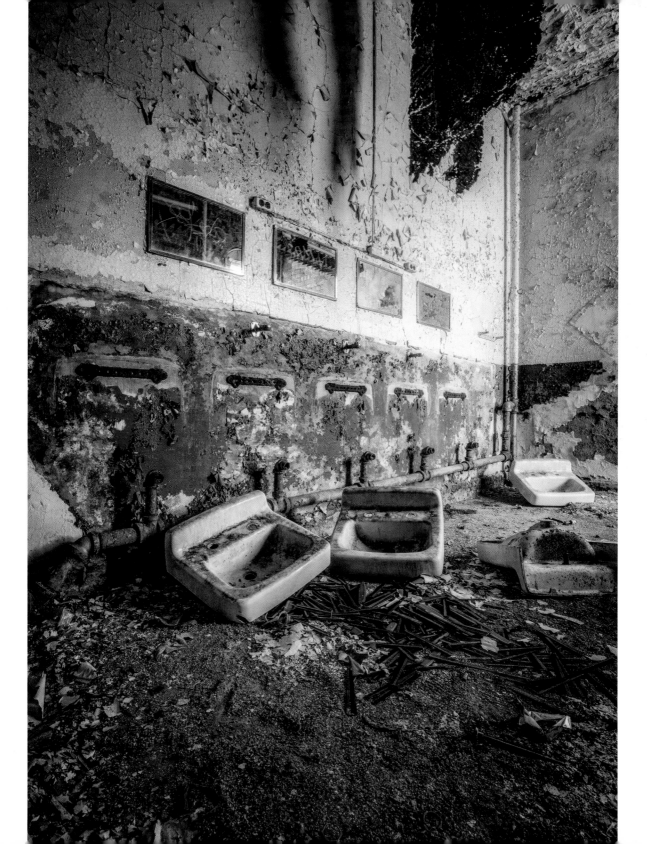

Chairs

Almost every time I go exploring, I find a chair sitting in an abandoned place. The location may have been completely scrapped and destroyed, but without fail, a lone chair remains. This phenomenon is so prevalent in the exploring world that there are Facebook pages and Google+ communities dedicated to it.

(below and opposite) I took the first shot in a naval administration building, the second in a military weapons facility, and the third in a water treatment plant. Chairs reside in almost every abandoned place I've visited.

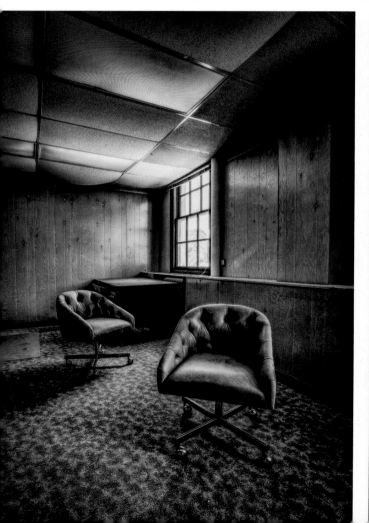

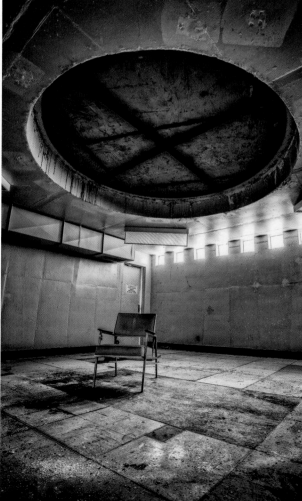

Because they are so abundant, chairs serve as great counterpoints for compositions. Nothing is more boring than a big empty room. No matter how much awesome peeling paint and decay you have in your frame, it will still feel empty and bland. A chair is a great compositional element that will really round out your shot. Chairs also give the viewer an idea of when the location was in use, because chair design is usually indicative of an era. There's an unmistakable difference between a 1970s La-Z-Boy and a classroom chair from the 1990s.

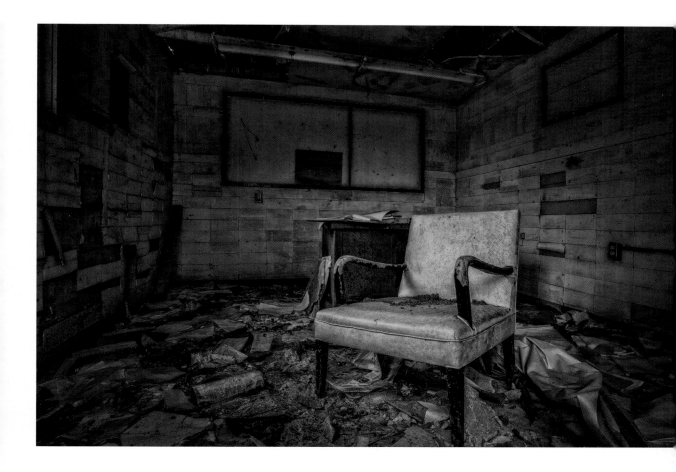

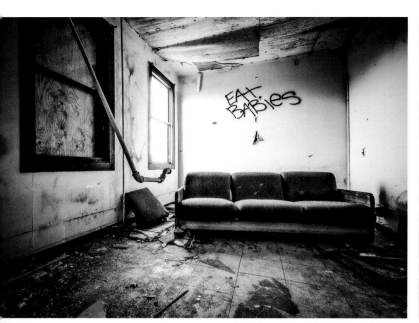

Graffiti

Graffiti is a hotly debated topic within the UrbEx community. Some photographers love it because it adds character to an otherwise boring old building. Other photographers hate it because graffiti can ruin amazing historical architecture.

I subscribe to the latter opinion—most of the time. I'm a historian at heart and I hate seeing historically significant buildings marred by unintelligible scribble. Having said that, I can absolutely appreciate graffiti artists who are good at their craft. I would just prefer that they don't further destroy property, regardless of how destroyed it was when they found it. The three ways that I use graffiti are as follows:

- **Graffiti wisdom:** Interesting quips or quotes, not just tags, *do* add to the character of a scene. They can even be the subject of your composition. I call this "graffiti wisdom." When I run across some graffiti that makes me chuckle, I'll take a shot of it but I always try to round out the composition with another element. Otherwise, I'm just a graffiti documentarian.

- **Texture:** Graffiti can add great texture to a scene, but pay close attention to your subject. Bright spray paint can create a horrible distraction in your overall composition. Most of it can be fixed in post-processing, but there's no sense in giving yourself extra work, right? What you're really looking for is graffiti that can contribute to the mood of your scene without detracting from your subject.

- **Mood:** Another use for graffiti is to serve as colorful bokeh. If you're shooting close-up detail shots, try shooting between f/2 and f/5.6 so that the graffiti adds moody color to the room without directly competing with your subject.

Some people like to shoot big, colorful pieces of graffiti. I don't think it leaves much room for other subjects in a photo, so I try to shoot more subdued forms of graffiti.

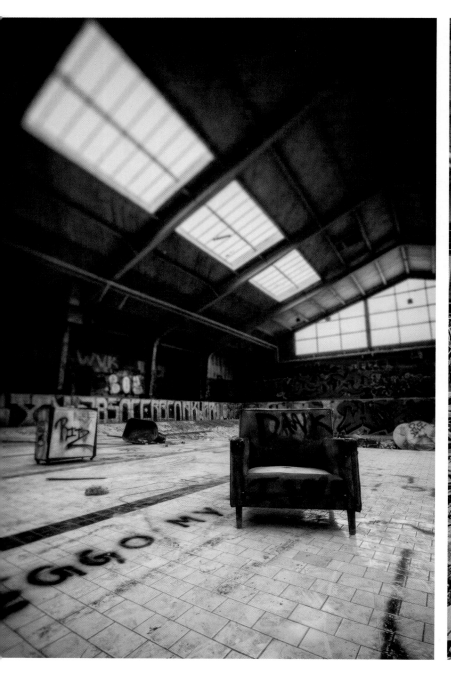
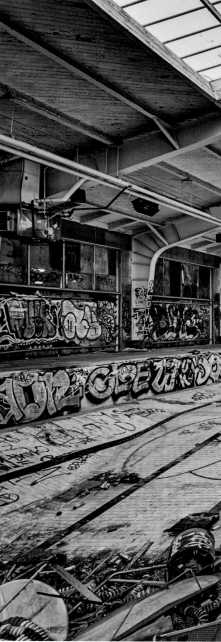

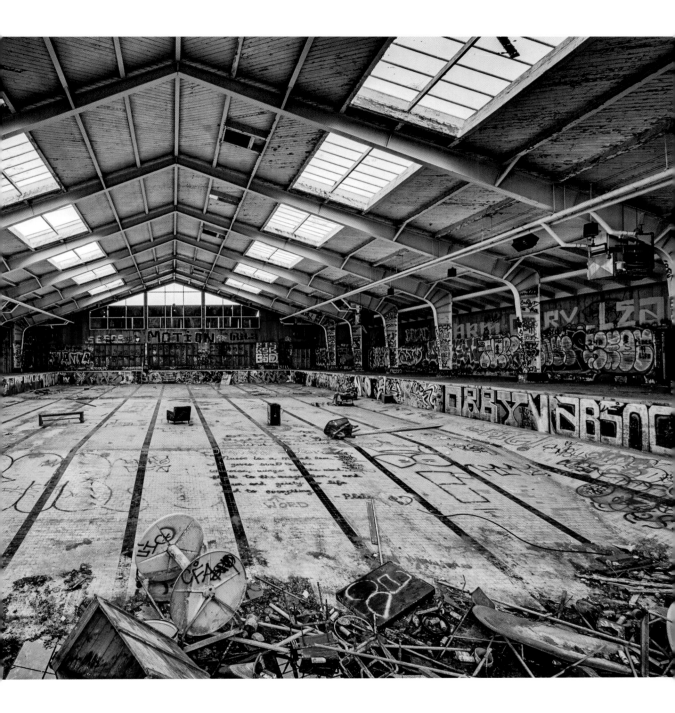

Windows

TIP If windows are not the focus of your composition, try to avoid having them around the edges of your shot. They can be terribly distracting because they are typically so much brighter than your subject (depending on the time of day that you're shooting). Nothing will catch your viewer's eye faster than a bright white light around the frame of your photo.

Windows can serve as great compositional elements as long as they have light coming through them. If no dramatic contrast is provided by the windows, they don't offer themselves as interesting subjects. I particularly try to use them for natural light beams. If interesting subjects are outside the windows, by all means try to capture them. If not, I suggest using windows as a counterpoint for other compositional elements.

The windows and the light coming through them are clearly the focus of this shot. Although this room in a former military administration building is interesting in a historical sense, it didn't offer much to shoot because the building had been cleared out.

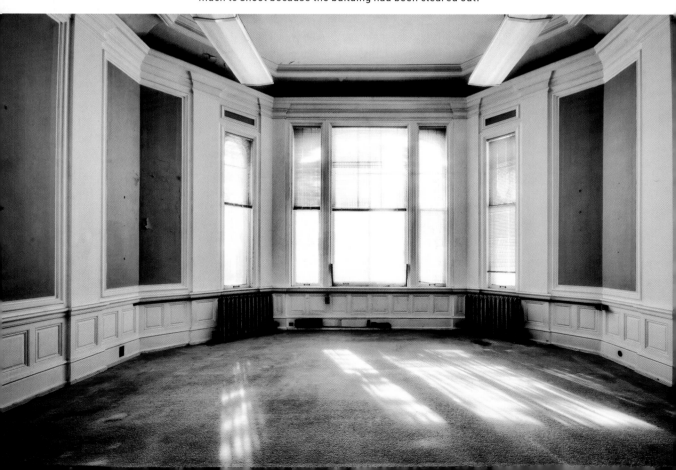

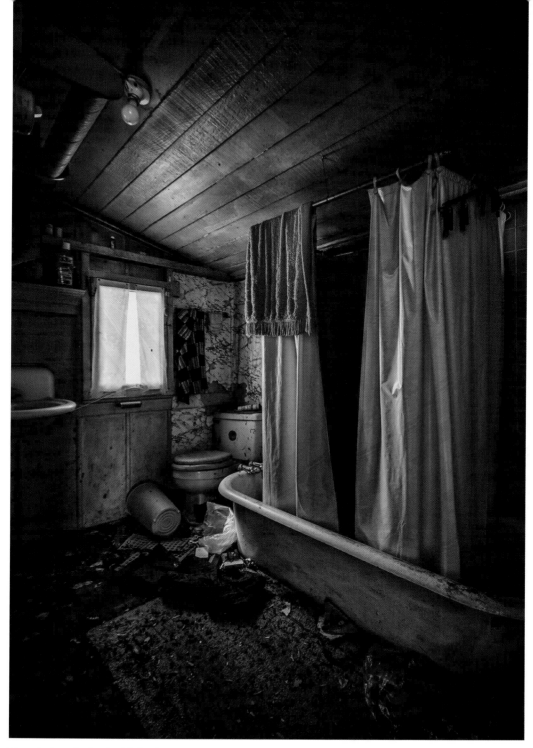

The window shades in this bathroom had a slight blue tint that gave the room a great color and served as an ideal counterpoint to the pink shower curtain.

Peeling Paint

(opposite) This military facility was built in the mid-1800s, and the peeling paint is evidence of that. The level of decay provides a context for the building—otherwise, this shot would just be a broom in a basement.

In my opinion, the most interesting texture for UrbEx photos is peeling paint. It's the quintessential representation of age, wear, and decay. Peeling paint usually indicates that a place has been undisturbed for quite some time. For both photography and general interest, "the older the better" is my motto. Peeling paint not only gives viewers an idea of your location's age but also provides amazing textural design. Some people like rust and some people brickwork; I prefer peeling paint over any other texture. Rarely, it can be the lone subject in a wide-angle shot, but it can certainly serve as a great subject in a close-up detail shot.

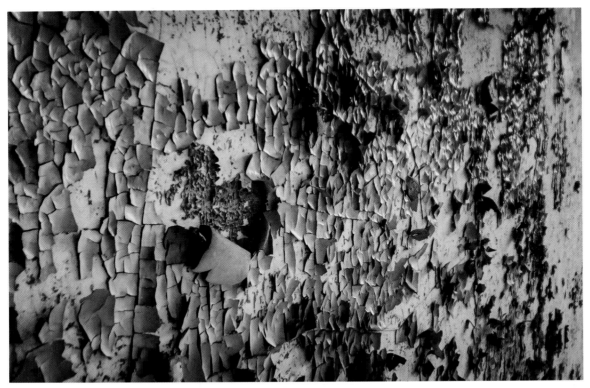

This abandoned elementary school had great peeling paint throughout the entire building. The patterns that formed are interesting in themselves. As you can see, sometimes traditional subjects aren't necessary.

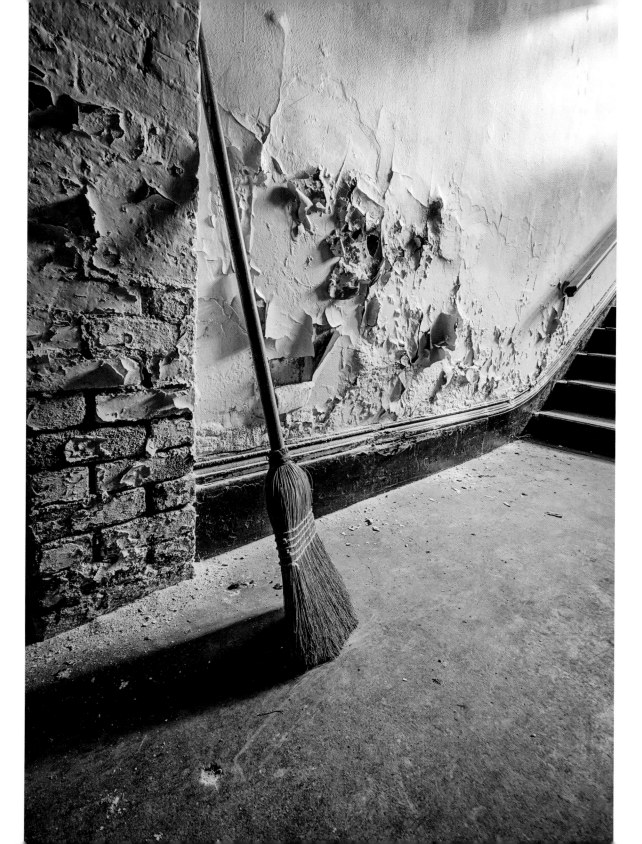

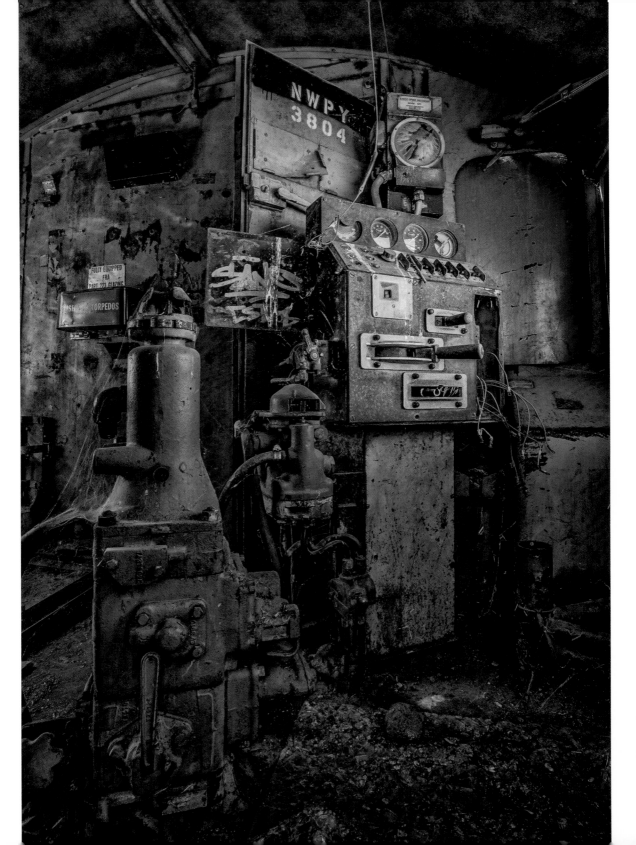

Machinery

Machinery, when available, is my first choice for a compositional element. Depending on where I am, figuring out a machine's purpose is usually guesswork because I'm no engineer. Does that mean I can't take a great photo of it? Absolutely not! I've come across giant control panels, massive cranes, and other pieces of machinery that are almost too big to shoot. Almost.

It's always a challenge to understand how an old factory worked based on the machinery you find, but it's an even bigger challenge to fit these pieces of machinery into a decent composition. It may not be the size of the machinery that's the problem—it may be the very tight space you're limited to for capturing the shot. This is where a fisheye lens can really make the difference for a wide shot. At times I've had to accept defeat and settle for detail shots so that my viewers could still understand the place without any good wide shots.

These conductor controls hadn't been used in a very, very long time. In fact, wasps had taken up residence in the ceiling, so I had only one chance to nail this shot before I became a target.

FOUR
WHEN TO SHOOT

Light is the key to every photograph. Photography itself is technically just the art of capturing light. Within the genre of UrbEx photography, *when* you choose to capture light will directly correlate with the quality of your final photo. Whether you're shooting at blue hour, at golden hour, in broad daylight, or under a full moon, the quality of light can make or break a great composition.

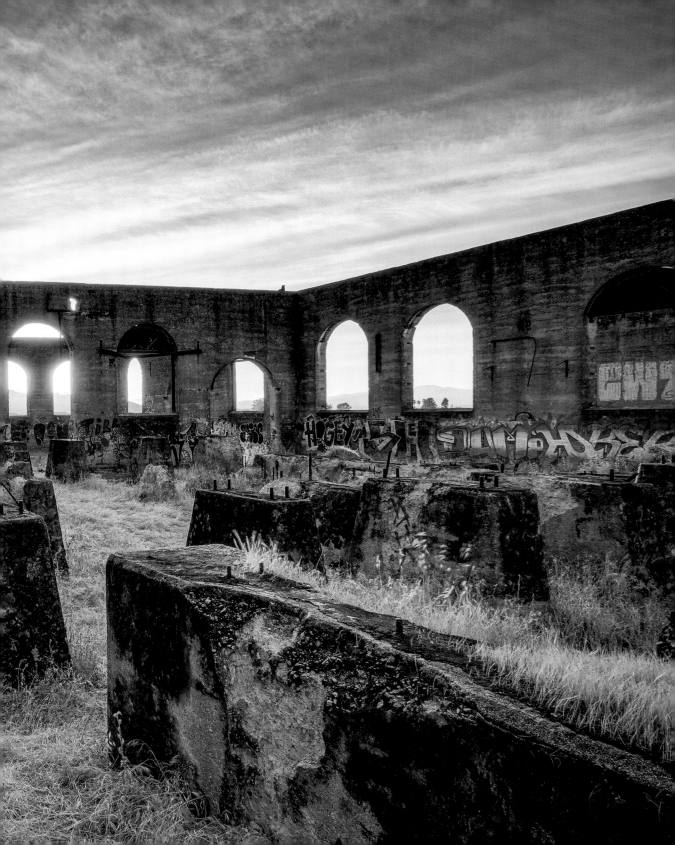

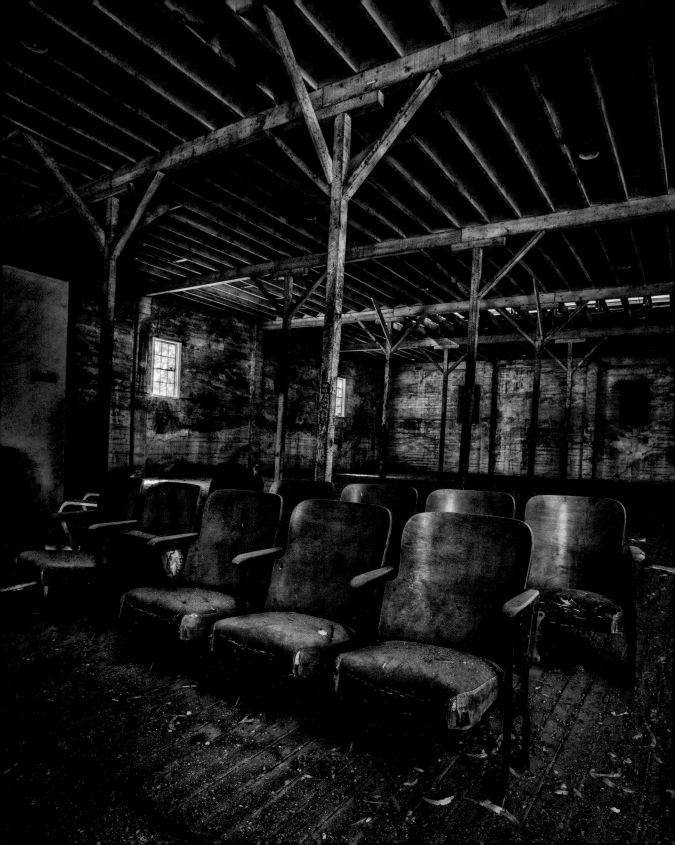

You don't always have the luxury of shooting when you want to, because of security and permissions, work schedules, weather, and so on. When you obtain permission to shoot an abandoned location, most owners don't want to wake up for blue hour, so you just have to make do with what you're offered. As the saying goes, "Never look a gift horse in the mouth." However, if I'm going somewhere without full credentials, I always find that blue hour makes it particularly difficult to be seen by other people. That's a win-win in my book. Even if you're not going to wake up early to shoot, there are specific phases of light you should be aware of to help plan your trip.

This shot would have been much less dramatic if it had been shot in the harsh midday sun. Thankfully, I got to this site early in the morning to catch the soft light while it was still available.

Here's the schedule of the light phases according to the elevation of the sun:

- Nighttime (below −18°)
- Morning twilights (−18° to 0°)
 - Astronomical twilight (−18° to −12°)
 - Nautical twilight (−12° to −6°)
 - Civil twilight (−6° to 0°)
- Morning magic hours
 - Blue hour (−6° to −4°)
 - Golden hour (−4° to 6°)
- Daytime (6°)
- Evening magic hours
 - Golden hour (6° to −4°)
 - Blue hour (−4° to −6°)
- Evening twilights (0° to −18°)
 - Civil twilight (0° to −6°)
 - Nautical twilight (−6° to −12°)
 - Astronomical twilight (−12° to −18°)

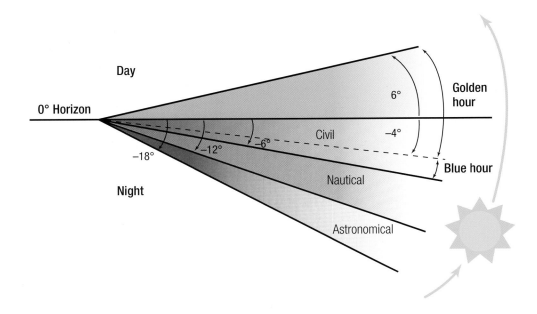

You can see that the magic hours and twilights occur twice in one day, but it's worth noting that they might not offer the same quality of light due to weather, pollution, and other variables.

We're primarily interested in the twilights and magic hours, but night-time can offer spectacular shots, as you learned in Chapter 2.

TIP Numerous apps available for iPhone and Android will show you the times of all the phases based upon your location. I currently use the Photographer's Ephemeris (TPE) for Android to plan my explorations so I know exactly when I need to leave the house in order to arrive on time at the site.

Twilights

I consider nautical twilight to be the perfect time to get into a location. Depending on the difficulty of entering that location, you should be able to get in and set up for shooting by blue hour. During nautical twilight, you won't be able to see objects around you clearly and you'll most likely need a flashlight. You should be using a red light to preserve your eye's sensitivity to light. Red light also doesn't travel as far as white light, so it can't be seen as well from a distance. Nautical twilight can offer great shots as well, but you'll need to use long exposures and the light changes very quickly. If you're set up for a five-minute exposure during nautical twilight, you may find yourself in civil twilight's blue hour with an over-exposed shot and not enough time to recompose or reshoot with the beautiful blue hour light.

I prefer to sacrifice nautical twilight to get set up for blue hour. As you transition from nautical to civil twilight, you'll get enough natural light to start distinguishing objects around you, but you'll probably still need to use long exposures to get decent shots.

Blue Hour

Blue hour is when I get some of my best shots. If you're not a morning person, know that the magic hours both occur at sundown as well. But I think it's less risky to be at a location first thing in the morning. You're less likely to run into scrappers, vandals, and authority figures because everyone likes to sleep in. It's a worthy sacrifice in my eyes.

Blue hour also contributes to the uniqueness of UrbEx photos; not only do most people not get to see the places that we go, but they're especially not used to seeing these places shot at blue hour, because it is typically used only by landscape photographers. I can't stress enough how great blue hour is. If you haven't shot during this phase, try it now!

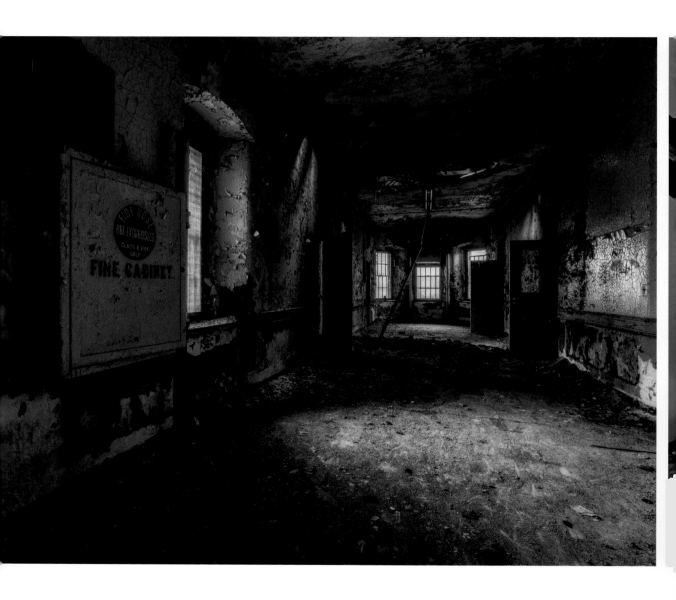

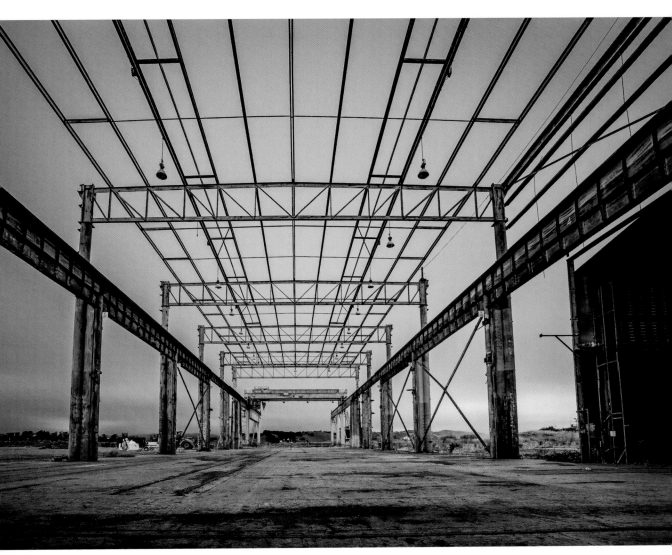

This shot of an abandoned pipe factory was caught right between blue hour and golden hour.

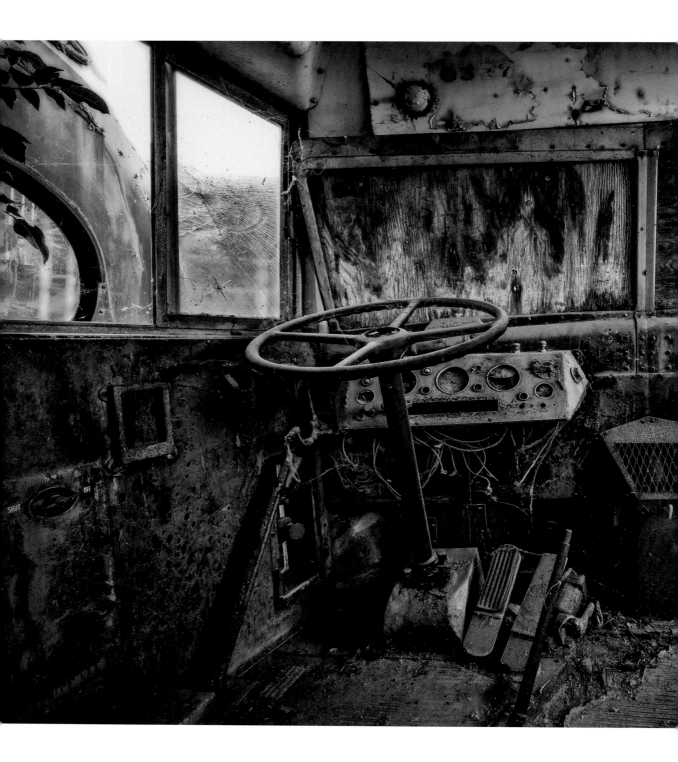

Golden Hour

Golden hour is the prized possession of photographers in any genre. This is the window in the morning when just about everything looks fantastic. It's really hard to get bad shots during golden hour if you've got a good subject, you're composing correctly, and you're properly calculating your exposures. I often like to shoot abandoned places during golden hour because the light is warm and beautiful, which contrasts with the darkness and decay of the locations.

One thing to keep in mind is to shoot frequently during golden hour. The light changes incredibly fast, and the difference between a good shot and a great shot can be a matter of minutes. Obviously, shooting at golden hour won't make you the best photographer in the world, but it will certainly help you create better photos than the people who shoot only during the day. I know that statement can be argued forever, but just trust me when I say that waking up incredibly early is worth it if your goal is to create dramatic photos.

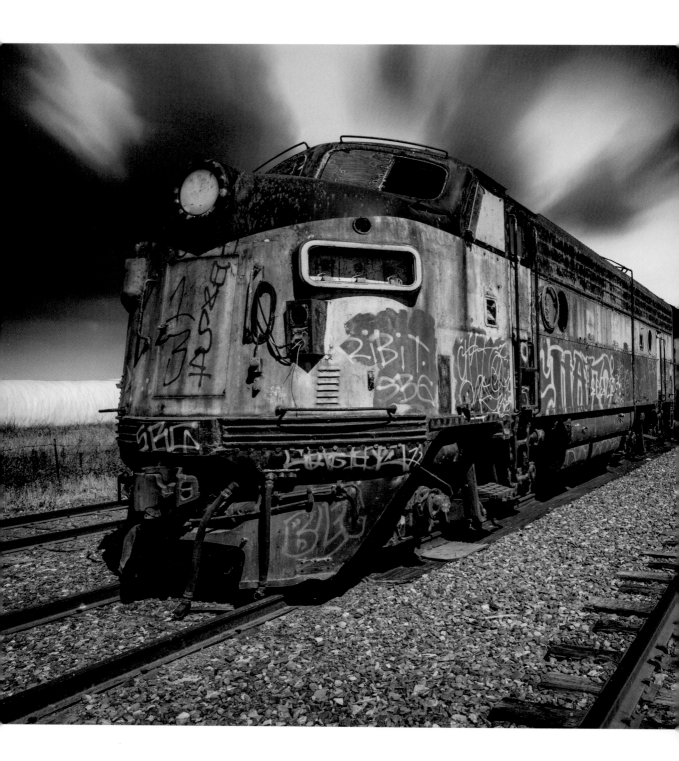

Daytime

Shooting from 10 a.m. to 6 p.m. is typically the "bleh" window when you'll face harsh highlights and be stuck trying to make your shots dramatic during post-processing.

There is obviously a difference in time zones, so a good rule of thumb is not to shoot between lunch and dinner. Still, I break this rule all the time out of necessity. We don't get to choose the times that we have access to particular sites, and there's no reason not to shoot a site if you're there; but at times I have looked at various scenes within a location and chosen not to shoot them because I knew that the light would ruin the shots.

I've gotten pickier over the years, and I know what will make a good photo; shooting in the right light makes all the difference. I find that if I'm stuck shooting in the "bleh" window, I focus more on shooting close-ups. They don't require the dynamic light of wide-angle shots, and they can turn out pretty well if you avoid harsh highlights in your frame. Since we are typically shooting indoors, you can get away with shooting during the "bleh" window, but your shots will always turn out better if you avoid it.

I shot this in broad daylight with a Formatt-Hitech 10-stop ND filter. It's a filter I usually use for landscape shots, but the light was pretty bad and I decided that this shot would be more dramatic with stretched clouds and black and white instead of a boring blue sky.

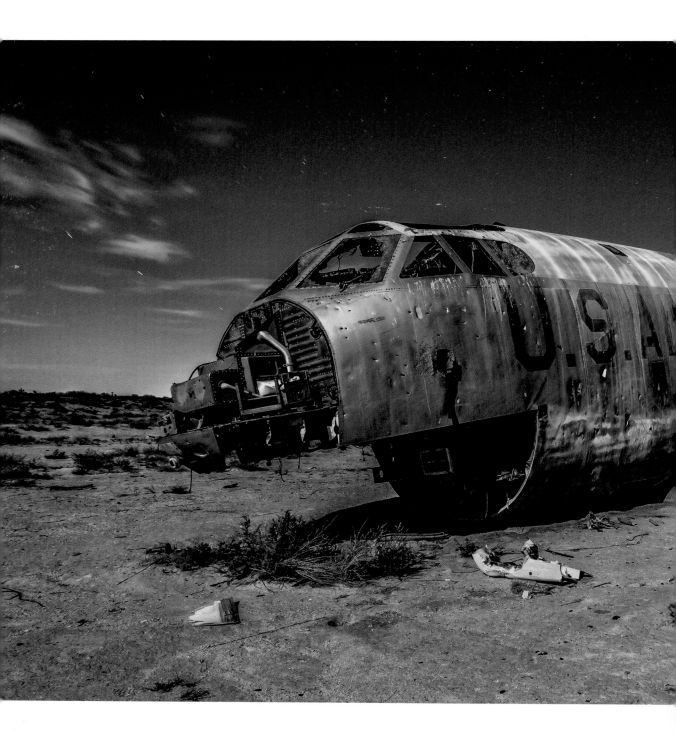

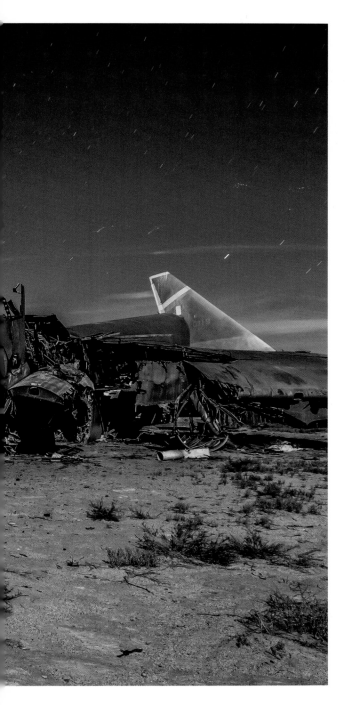

Nighttime

Shooting under a full moon or the Milky Way can also produce amazing results. This is the preferred time to shoot for a lot of well-known UrbEx photographers. There's just something about the full moon that produces remarkable photos with fairly little effort and much less risk than shooting in broad daylight.

Photos that are produced under the full moon look deceptively like daytime shots. The main giveaways are that you won't see harsh highlights and stars can usually be seen somewhere in the scene. If you're in a particularly dark location, which you often are, it can feel as if you're shooting at night, so the same shooting techniques apply.

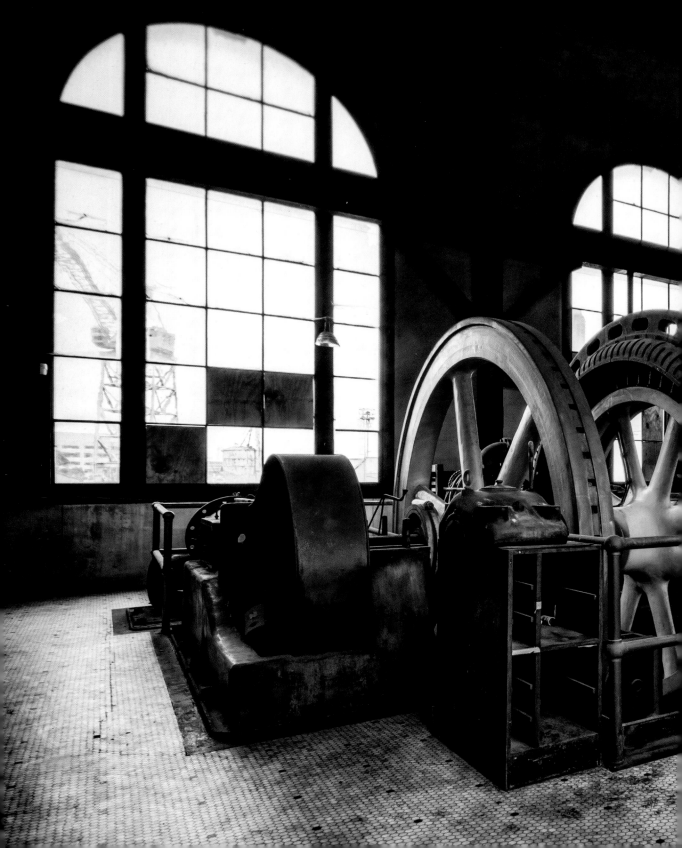

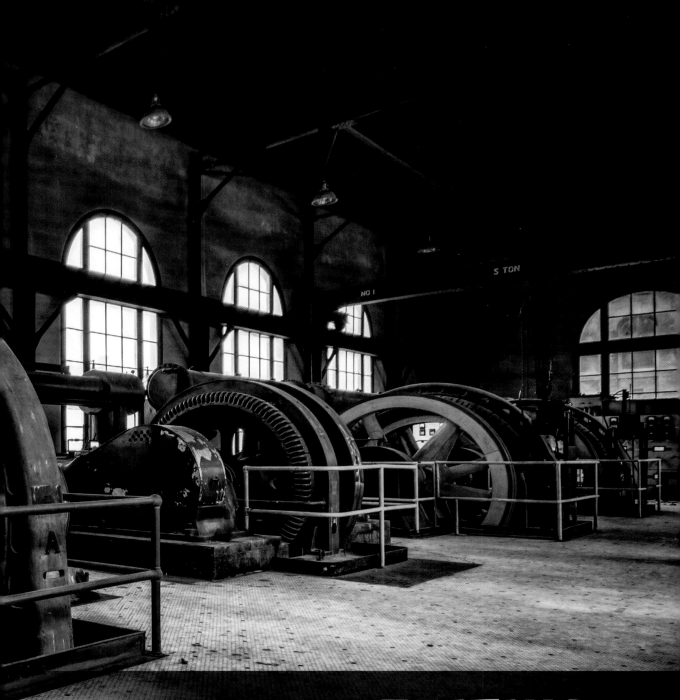

PART 2 **EDITING**

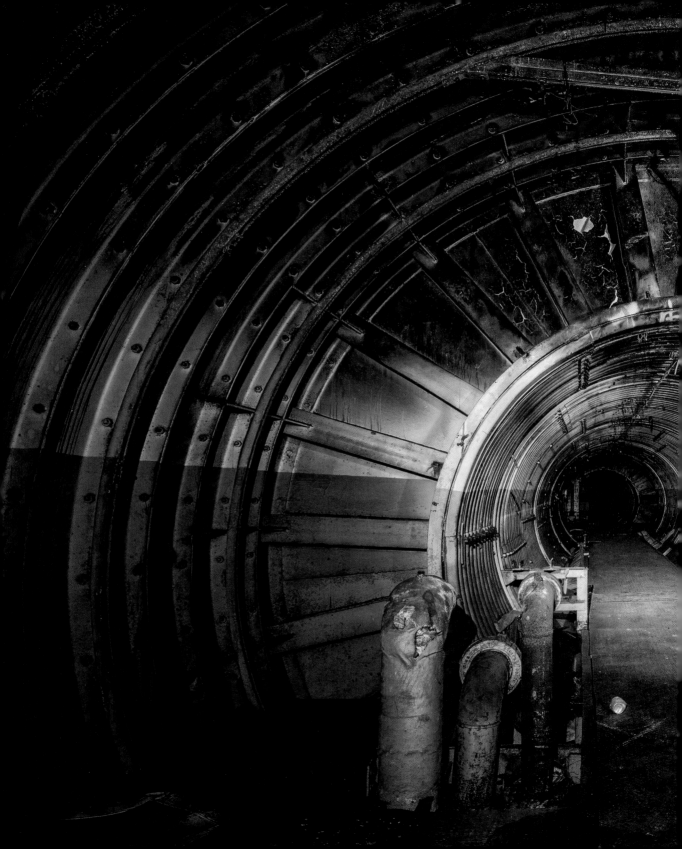

FIVE

BUILDING YOUR
SOFTWARE TOOLBOX

Hundreds of applications are available for correcting or enhancing your photos. I've used a wide selection of them, and I'll discuss the ones that I use on a daily basis. If your favorite piece of software isn't on this list, fret not; if something works well for you, use it. These are merely the tools that I find essential based upon their effectiveness and ease of use. They are categorized according to how I use them, and not necessarily according to their features.

Making Corrections with Photoshop

In my opinion, Adobe Photoshop Lightroom is an imperative piece of software for photographers. Anyone can create incredible images using Lightroom alone. It's easy to use and incredibly robust, and it's the starting point for every photo I've ever shot.

Adobe Photoshop Lightroom

I'm actually doing this application a disservice by describing it as merely a "correction" app. In reality, I use it to import photos, organize them by date and location, perform initial corrections, add finishing touches, edit metadata, and publish them to social networks and my website. I'll go through my workflow later in the book, so you'll see how crucial Lightroom is to my process. If you don't have Lightroom, I suggest picking it up now, because it is the foundation for almost everything else we'll explore in this book (www.adobe.com/products/photoshop-lightroom.html).

Adobe Photoshop

Before Lightroom hit the market, in 2007, Adobe Photoshop was the essential software for every photographer, and Photoshop is still the gold standard for digital image editing worldwide. It can do everything that Lightroom does in terms of correction and post-processing, but it can do so much more. I use Photoshop for more advanced post-processing, and I also use it as a platform from which to launch filter and effect plug-ins.

NOTE Although Adobe Bridge is supposed to serve as a bridge between Photoshop and Lightroom to keep your photo catalogs organized, Lightroom's organizing abilities are so advanced that I've never had a use for Bridge.

So why don't I (and everyone else) just use Photoshop? Because Lightroom is incredibly easy to use and can address 90 percent of your post-processing needs. Photoshop also cannot organize or publish your photos.

Photoshop has so many features and capabilities that it takes people years to learn how to use it fully. This is the program that I dabbled with way back in high school, but I didn't learn how to *really* use it until I became a photographer (www.adobe.com/products/photoshop.html).

Using HDR Tools

You'll learn more about high dynamic range (HDR) photography in the next chapter, so if this section doesn't make sense to you, don't worry. You can always skip this part and come back to it. There are a plethora of HDR tools out there, but here are the applications that give the best results without all the frills that come with some HDR suites.

LR/Enfuse

LR/Enfuse is an option that confuses some photographers. It has a clunky installation and has an incredibly barebones user interface. Nevertheless, it's one of the best plug-ins for creating HDR images. It seamlessly integrates with Lightroom, it's very fast, and it merges your exposures without any of the bells and whistles that sometimes confuse HDR newcomers. The only downside is that it can process only 16-bit TIFF files, as opposed to 32-bit files. Most of the time, 16-bit resolutions will suffice, so LR/Enfuse is a great place to start if you want a dead-simple way to create HDR images (www.photographers-toolbox.com/products/lrenfuse.php).

HDR Pro

HDR Pro is built in to Photoshop. I use it exclusively to create 32-bit HDR images. Recently, Lightroom added the ability to work with 32-bit files, which has helped make the 32-bit option more popular. 32-bit images give you more data to work with once you bring the file back into Lightroom. HDRsoft (the maker of Photomatix Pro) also has a Lightroom plug-in called Merge to 32-bit HDR that makes it easy to create 32-bit HDR files straight from Lightroom; the only downside is that it costs $39. I'd rather just open up HDR Pro and get the same results at no additional cost.

Understanding Filters and Effects

Filters are all the rage right now. Instagram has brought the term *filter* into the mainstream by making it easy for the average consumer to apply artistic effects to cell phone shots.

Most non-photographers don't know that the term originated with the physical filters that photographers place over a camera's lens. However, the physical filters don't have much practical use in UrbEx photography, because you're often shooting in dark places and you also want to keep your gear as light as possible. You can certainly use artistic filters while shooting abandoned places, but I prefer to apply those artistic effects afterwards. Remember, it's all about packing light and shooting fast.

I've experimented with using circular polarizing filters to cut down on bright light that's pouring in through windows or walls, but I've found the results unpredictable. Because I still need to bracket shots to get the highlights dark enough for an even exposure, using a circular polarizer doesn't save me any time. You can, however, take full advantage of the digital filters and effects available via Lightroom and Photoshop plug-ins.

Nik Collection

Purchased by Google in 2012, Nik Software offers some of the best filters available for any genre of photography. The Nik Collection consists of Analog Efex Pro, Color Efex Pro, Silver Efex Pro, Viveza, HDR Efex Pro, Sharpener Pro, and Dfine. All of these plug-ins (for Photoshop or Lightroom) have different purposes (www.google.com/nikcollection/). Here are the ones I primarily use.

Analog Efex Pro

Creates the effect of shooting with old cameras and various types of film and exposure processes. These effects can be pretty extreme, so I tend to use them in moderation. They are very similar to VSCO filters, except that

you have much more control over each aspect of the effect, such as film grain, light leak, bokeh, and so on.

Color Efex Pro

Of all the Nik Collection plug-ins, I use this one the most. With Color Efex Pro, you can apply a wide variety of color, texture, and detail effects. One of its best features is that you can use "control points" to tell the software exactly where you do and don't want to apply a particular filter within your image. Additionally, you can stack filters and create recipes for filters that you use frequently.

Viveza

Viveza is a plug-in that *only* uses control points. But instead of using control points to apply effects to specific parts of an image, you use its control points to apply basic corrections (brightness, color, contrast, and so on) to parts of an image. Viveza is fantastically useful and really fills in the gaps when Lightroom and Photoshop fall short.

OnOne Perfect Photo Suite

OnOne's Perfect Photo Suite is another plug-in bundle for Photoshop and Lightroom that I frequently use to enhance the color or texture of images. OnOne is really trying to market itself as an all-in-one photo-editing solution, but I use only a few core apps within the suite. The main app I use for editing UrbEx photos is Perfect Effects, although I dabble with the other apps for other photography genres (www.ononesoftware.com).

Perfect Effects

Within the Perfect Photo suite, Perfect Effects is the most useful app for editing UrbEx photos. It has a swath of stackable filters that enable you to give your photo a completely different look and feel. The best part about Perfect Effects is that you can control the strength of each filter you apply.

This is something that Nik Efex really needs to jump on. Both applications allow you to stack and edit filters easily, but Perfect Effects also lets you control the overall strength of each filter. Perfect Effects also has Masking Bug, which is OnOne's answer to Nik's control points.

Once upon a time, OnOne also had a great plug-in called FocalPoint. It is now built in to Perfect Effects, but I still use the old standalone plug-in because I think it's more powerful than the one that's built in to Perfect Effects. FocalPoint allows you to create faux-bokeh and depth of field effects that can help accentuate the subject of your abandoned scene (especially if you don't have the time to experiment while on site).

VSCO

Visual Supply Co., or VSCO, is a relatively new company (founded in 2011), but they've taken the photography industry by storm. Offering hundreds of filters for Lightroom and Photoshop, VSCO accurately mimics the look of various film types and their corresponding cameras. I only recently introduced VSCO into my arsenal of tools, but I've really enjoyed using it. Making your photos look as if they were taken a couple of decades ago can sometimes be a great complement to the fact that our UrbEx subjects haven't been used or seen in a couple of decades. Best of all, VSCO's filters sit in folders along with Lightroom's built-in presets, so they're only one click away from giving your image a vintage feel (http://vsco.co/).

Creating Panoramas

Shooting panoramas can be a lot of fun. Stitching the images together can be not so much fun. The more images that you shoot for a panorama, the higher the risk that one or more of them won't line up. Don't let that stop you from trying out panorama shots, because some great tools can help with those little inconsistencies.

Photomerge

Photomerge is another fantastic tool from Adobe that's built in to Photoshop. Plus, Lightroom has an export button called Merge to Panorama in Photoshop. Nine times out of ten, Photomerge can handle anything I throw at it without major errors.

Kolor Autopana Giga

For the ten percent of images that are giving you a particularly tough time, there's Autopana Giga, the most advanced panorama tool I've ever used. With it, you can correct almost any panorama that hasn't been shot correctly. It isn't the easiest piece of software to learn, but once you get a feel for it, it's incredible what you can do with it (www.kolor.com).

But What About Applications X, Y, and Z?

I'm sure I'll get flak for not using or talking about a few hugely popular contenders in the marketplace. I won't go into too much detail, but this section is here to mitigate the amount of hate mail I'm probably going to get.

HDRsoft Photomatix Pro

In the photography community, this application is widely considered to be the gold standard for HDR creation (www.hdrsoft.com). However, this is also the software that creates 99 percent of the bad HDR images that are published on the web. It was made popular by the "godfather of HDR," Trey Ratcliff, and was prominently featured in an HDR tutorial that he published around 2008.

If you search online for "HDR tutorial," his website, stuckincustoms.com, is the first that pops up. Trey's tutorial is how I got started with HDR and

is fantastic overall. With that said, Trey did not give a healthy warning about Photomatix abuse. This was the software responsible for *letting* me create terrible HDR images at the beginning of my photography career.

But let's be clear and fair. The software is not to blame—the user is. I created those images. Photomatix was merely the tool that made it so easy to go overboard with the exaggerated tones and saturation.

With that said, world-renowned photographer Colby Brown turned me on to LR/Enfuse a couple of years ago, and I haven't looked back. I know that Photomatix has only gotten better over the years, but I've simply found other tools I prefer, so I don't need to go back and relive my dark years as a Photomatix junkie.

At this point, some of you may say to yourselves "Just because *you* think something looks bad doesn't mean everyone does. Who are you to judge anyone's art?" Even though I'm talking about my own art, I'm going to continue to express my opinions on bad photos and bad techniques throughout the rest of the book, so brace yourselves. Yes, art is art and nobody should give their negative opinions about anyone else's artistic expressions. But let's face it, some art is just bad. Even my own.

GIMP

GIMP is often regarded as a robust alternative to Photoshop, in part because GIMP is free and open source. It doesn't have all the advanced features of Photoshop, but it is a fantastic option for those who don't have the cash to invest in Photoshop (www.gimp.org).

Topaz Labs

Topaz has a great collection of plug-ins, including Adjust, Clarity, ReStyle, and ReMask. However, I've found that I can accomplish the same things (and more) with the Nik Collection and OnOne software. Why use three toolsets when I can achieve identical results with two? All in all, I've found that Nik and OnOne deliver results more quickly and easily than the Topaz options (www.topazlabs.com).

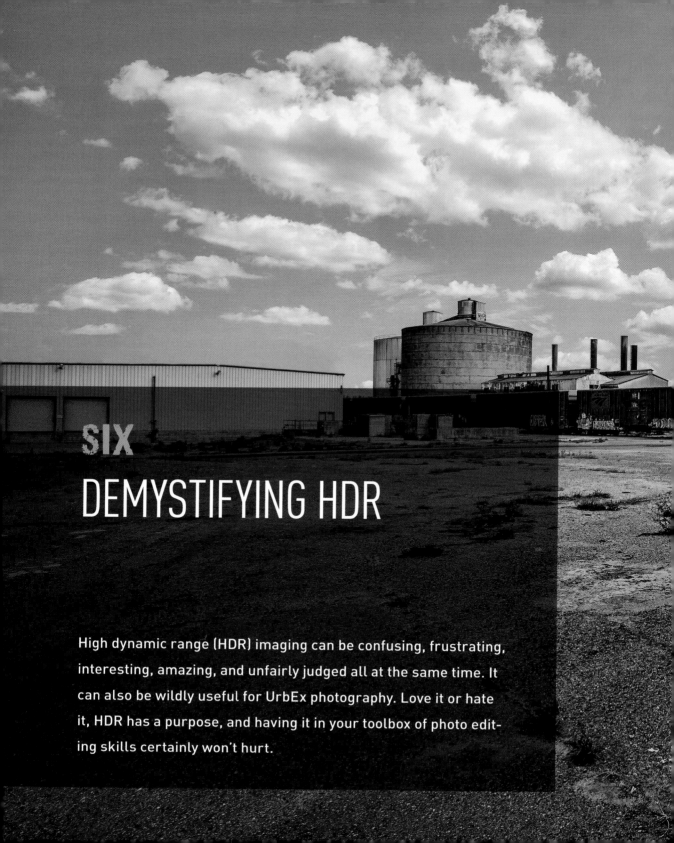

SIX

DEMYSTIFYING HDR

High dynamic range (HDR) imaging can be confusing, frustrating, interesting, amazing, and unfairly judged all at the same time. It can also be wildly useful for UrbEx photography. Love it or hate it, HDR has a purpose, and having it in your toolbox of photo editing skills certainly won't hurt.

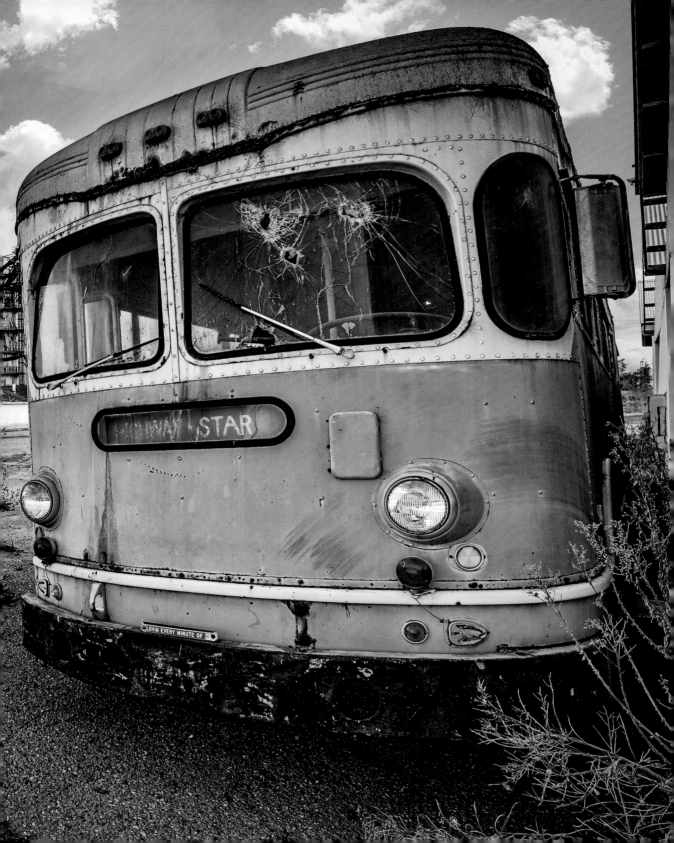

What Is HDR?

In its most basic form, HDR is a post-processing technique used to enhance the detail in the shadows and highlights of an image.

NOTE I don't claim to know everything about HDR. The aspects that are covered in this book are based on my personal experiences. If you'd like to learn everything you would ever want to know about HDR, do yourself a favor and pick up Christian Bloch's *The HDRI Handbook 2.0*. It has over 600 pages of technical descriptions, software comparisons, and processing techniques.

The objective of HDR is to create an image that captures the dynamic range of a scene as you saw it in real life (or as close to it as possible). HDR is sometimes necessary because the contrast ratio (or dynamic range) of a scene exceeds the single-shot capability of your camera's sensor. Some people think that HDR is just "reducing the contrast of an image," when in reality, it's about capturing the wide dynamic range of a scene in one 8-bit image.

Creating an HDR is achieved by taking the same photo at various exposure levels (see "Bracketing Your Shots" in Chapter 2) and then combining those exposures to create one large file.

You may be wondering, "Why do I have to bother?" The answer is you don't, unless you want or need to overcome some of the limitations of your photographic equipment to capture a particular scene. A typical DSLR camera can capture approximately 8 to 11 stops of light in a single raw file. However, the human eye can see about 20 stops because our eyes can adapt to changing light conditions. By utilizing HDR, you can create images that more accurately represent what you see in real life.

Why Is HDR So Prevalent in UrbEx Photography?

In UrbEx photography we typically deal with extremely wide dynamic ranges, because we often shoot in very dark rooms with bright windows or doors. When you use only a single exposure, you are forced to choose whether you want highlights to be overexposed or shadows to be underexposed. Using HDR enables you to overcome that choice by letting you capture proper exposure levels throughout all dimensions of the photo.

Unfortunately, this flexibility has led some UrbEx photographers to feel as if they need to use HDR for every shot. This is simply not true. HDR should be used as a tool to enhance photos of scenes that need it, not as a crutch to make bad photos look more interesting. You can absolutely leave your highlights blown out or your shadows underexposed—that's an artistic choice for you to make. But personally, I like having HDR in my toolbox to use when I need it.

When to Use HDR

HDR is best employed when your scene has extreme contrast between dark and light areas. So if you're in a very dark room that has a couple of windows with bright light pouring through, you'd want to bracket your shots and use HDR to maintain detail throughout the photo. The following figures show some bracketed shots and the final image of a scene that was perfect for creating an HDR image.

On the next page is an appropriately exposed shot that accurately represents what a camera can capture, but underrepresents what the human eye could see in the scene.

In the two underexposed shots, the ivy vines and dew in the window panes are visible, but you can see very little detail in the fan.

In the two overexposed shots, you can see great detail around the fan and the ceiling, but details like the leaves of ivy in the window are blown out.

The HDR image includes equal detail in the windows and the fan, which creates a scene that is very close to what I saw in person.

You can boost the highlights and lower the shadows on a single Raw file, but only by about two stops. If you try to push any Raw file more than two stops, you'll be sacrificing quality and introducing noise into your image.

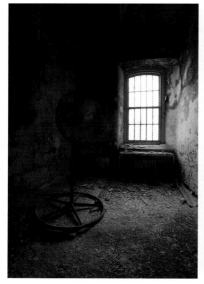

Proper exposure: 0

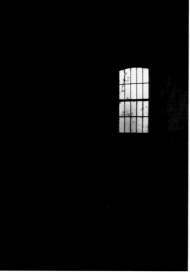

Underexposed: −4 stops

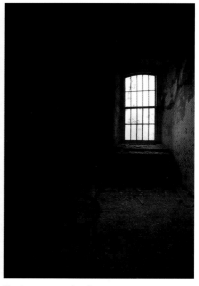

Underexposed: −2 stops

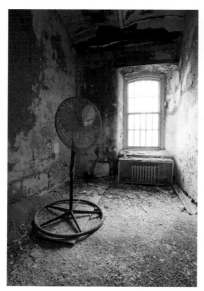

Overexposed: +2 stops

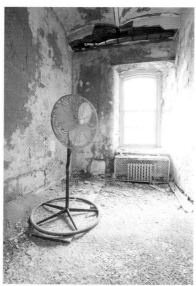

Overexposed: +4 stops

(opposite) 32-bit final HDR image

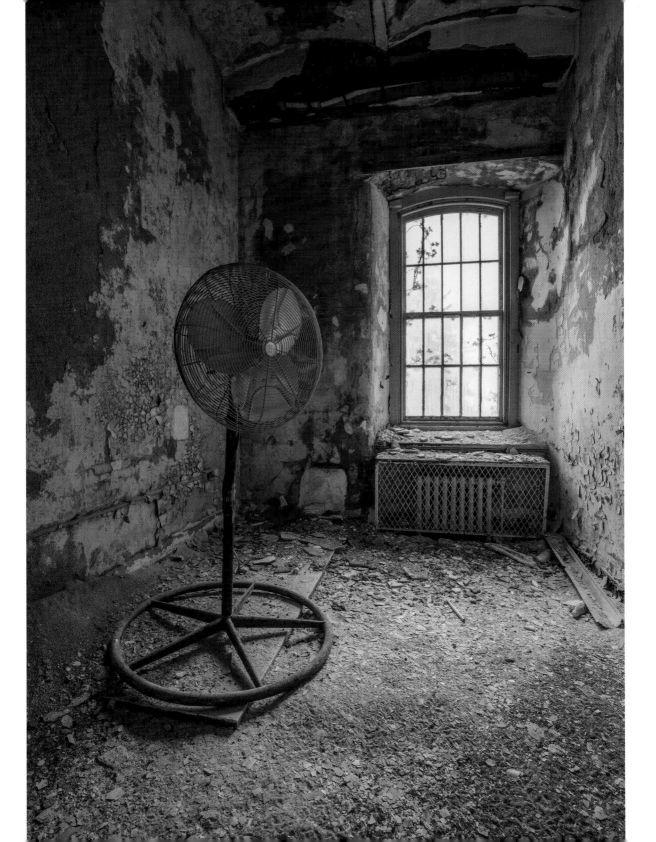

In the in-camera shot that was overexposed by four stops, you get all the detail with no noise.

If you try to get similar results by using a single raw file alone, the results aren't as desirable. The following figure shows what happens when the properly exposed photo is pushed up by four stops in Adobe Lightroom to enhance the detail in the shadows. Notice how much undesirable noise is introduced.

In the next shot, the properly exposed photo is pushed down by four stops in Lightroom to bring out the detail in the highlights. Notice how it turns into a dull gray color instead of the original bright white? It is also still lacking in definition.

Compare the previous photo to the in-camera shot that was underexposed by four stops. Now you can see the definition of the vines and even the dew on the window, and without any ugly gray light.

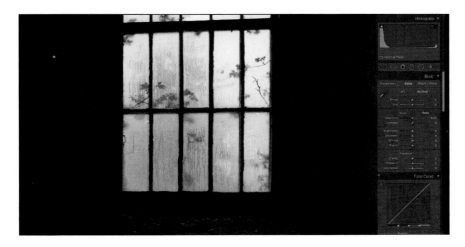

Raw files are really incredible in terms of how much data they can capture. Once you get comfortable with understanding how much you can push a Raw file's shadows and highlights, you'll be able to approach any scene in an abandoned building and know if you need to bracket your shots or not.

When Not to Use HDR

These images exemplify when and why you should be shooting with HDR. If you're shooting around blue hour or sunrise, you won't find yourself with a ton of shots that need HDR, because the light is softer and the sun does not create a harsh contrast that needs correction. For example, in this shot of castle ruins, I didn't need to use HDR to capture all the details

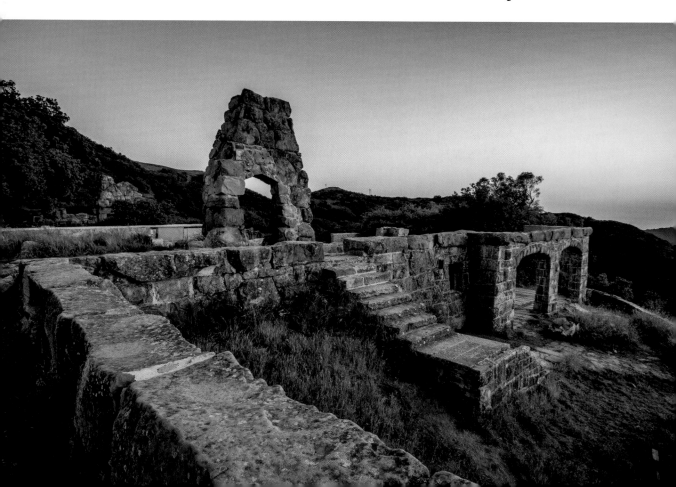

in the shadows in the grassy areas, nor did I need it to capture the highlights in the rocky areas or the sky.

Admittedly, this isn't my favorite shot. Having some clouds in the sky would have made it much more interesting, but I was on vacation and didn't have the luxury of returning to this place to try again. But it does illustrate that HDR doesn't need to be used at all times to get the detail you need.

Deciding when to use HDR is pretty simple. If a single exposure has enough detail in the shadows and in the highlights, don't bother using HDR to create your image.

It all boils down to artistic choice, but I will almost always bracket my images so I can make a choice later, and not when I'm hopping from room to room to avoid the security truck that's circling the building. In terms of actually generating an HDR, I really just decide if there's anything interesting in the highlights or shadows that I think will contribute to the image. If those details serve only as distractions from my subject, I will process my image using a single image instead of using HDR.

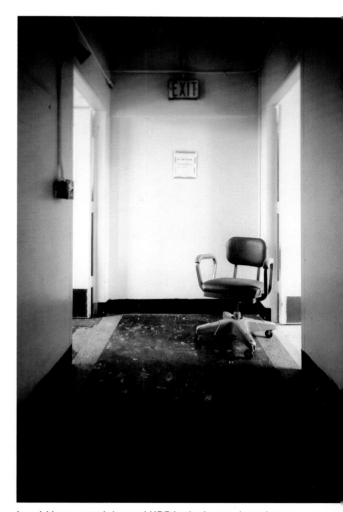

I could have certainly used HDR in the image, but what would it have contributed? Additional detail in the ugly floor? More texture in the door frame? Less contrast? No, thanks. I liked the intense contrast and even boosted it in post-processing. If I had used HDR in this photo, I think it really would have detracted from the overall simplicity of the subject.

Correcting HDR Misconceptions

Misconceptions about HDR have spread wildly within the photography community and outside of it. To the non-photographer, HDR-enhanced photos can be mind-blowingly awesome or just painful to look at. I hate to say it, but most HDR photos are not good. So misinformed viewers have come to associate HDR with "bad photos." (Some of my own early work has probably helped some people join the pitchfork-wielding mob against HDR.) I'm on a mission to banish those misconceptions, because HDR is a valuable tool when used in moderation.

All HDR Photos Are Bad Photos

This is perhaps the most common criticism I've read on the Internet and heard in person. But HDR photos are bad only when HDR is abused. It's easy to go overboard with the saturation when you're first attempting to use HDR. Photographers worldwide lovingly refer to overly enhanced HDR images as "clown vomit."

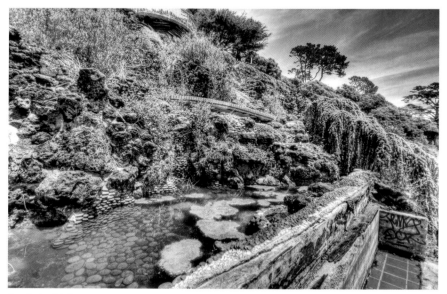

Don't do this!

An inability to avoid the vomit was my biggest pitfall when I started using HDR. At the time, I thought it looked really interesting and vibrant. I was so very wrong. As soon as I learned some new techniques and dialed back the saturation, my photos improved dramatically. Don't let anyone tell you that HDR is bad; HDR is only bad when a user abuses it.

On the previous page is one of my first HDR photos, taken three months after I got my first camera. If your photos look anything like this in terms of composition, start this book over. If your photos look anything like this in terms of color or contrast, keep reading.

HDR Is a New Gimmick

HDR has been around since the mid-1800s. Film photographers employed it by either stacking negatives together or simply dodging and burning photos in the darkroom; both methods have a similar effect. Heck, even Ansel Adams used a form of HDR. HDR has recently gained popularity because it's fairly easy to accomplish on digital cameras and comes as a preloaded setting on many cell phones.

HDR Looks Fake

This argument assumes that the problem with HDR is that it looks artificial by default. But in fact, the power is yours. You have full control over the final HDR image. My theory is that people have a perception of what photographs *should* look like based upon years and years of conditioning to limited dynamic range photos.

Altering images in a way that attempts to mimic the human eye's capability is not a familiar concept for many people. But the key take-away is that in the best HDR photos, you can't tell HDR was used. I like to push my images slightly past that point to make the viewer feel as though the abandoned places I visit are other-worldly. Whenever I enter an abandoned building, that's exactly how I feel: as if I had stepped into another dimension. I like my art to convey that, but each of you can decide for yourself what feels right.

[right] This is *not* an HDR image. This is a single long exposure in which the shadows and local contrast were boosted. When I first published this image online, I had swarms of people claiming that it was created using HDR or even CGI.

[opposite] This is the completed, unedited raw exposure. I have enough detail in the highlights at the top of the elevator shaft and enough detail in the dark ceiling to boost both in Lightroom without a severe detriment to image quality.

17mm, f/8, ISO 160, 150 sec.

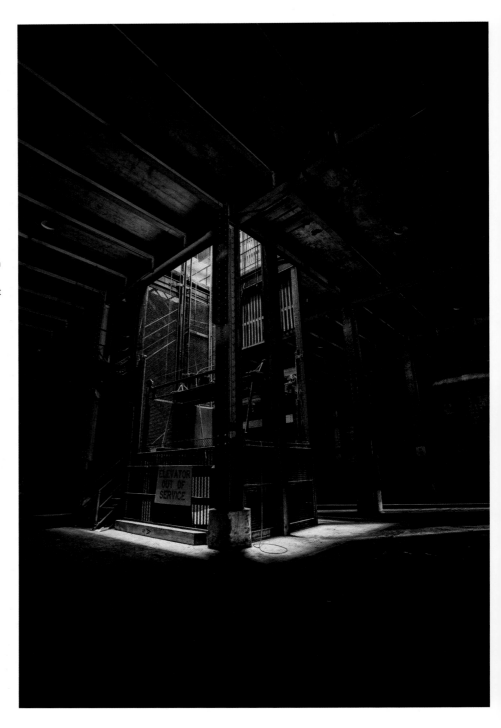

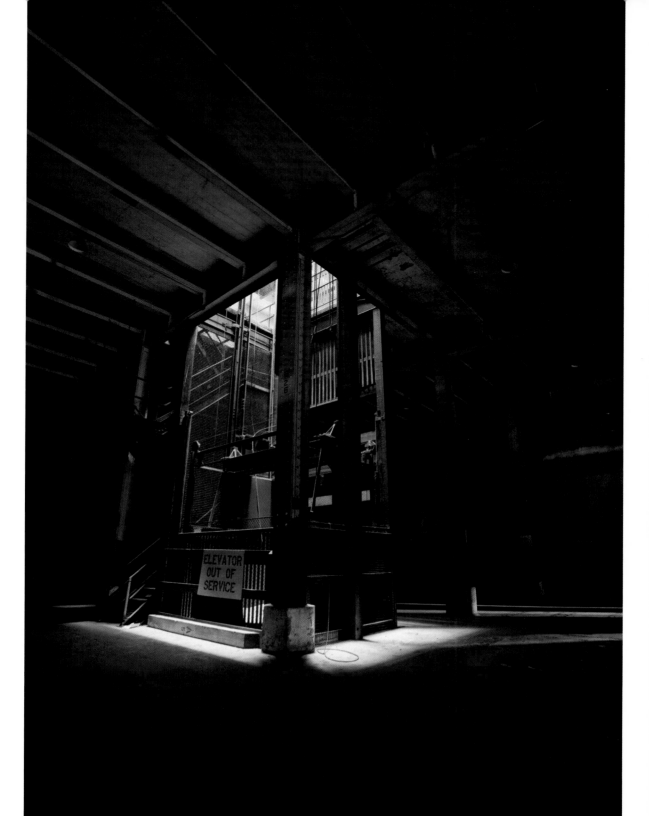

HDR = Tone Mapping

Long story short: Tone mapping may be used to generate an HDR image, but tone mapping alone does not increase the dynamic range of an image. This misconception has caused many people to use the two terms interchangeably. Tone mapping and HDR are two different beasts. Tone mapping is a procedure that reduced the dynamic range of a 32-bit HDR image to 16 or 8 bits to display the image on a monitor. A 32-bit file is not properly viewable on monitors so all image-editing programs tone map images down to 16 or 8 bits. You can tone map any image; it doesn't have to be an HDR image. Some people refer to a single exposure that has been tone mapped as a "pseudo-HDR" or "faux-HDR" image.

HDR Is the "Auto-Tune" of Photography

Photography purists often claim that HDR is just pressing a button on a computer—it doesn't take any skill. I don't see anything wrong with that, because I'm a fan of "work smarter, not harder." I *wish* churning out high-quality HDR images were that easy.

If you load your images into Photomatix and maintain all the default settings, your images will look horrible. Sure, you can create presets that speed up the process, but no two images are alike. Even if you stick with the same presets, you will always end up with wildly different HDR results. I can spend as little as two minutes or as much as two hours on an image, but I can guarantee that there is no magic button that generates a great HDR image.

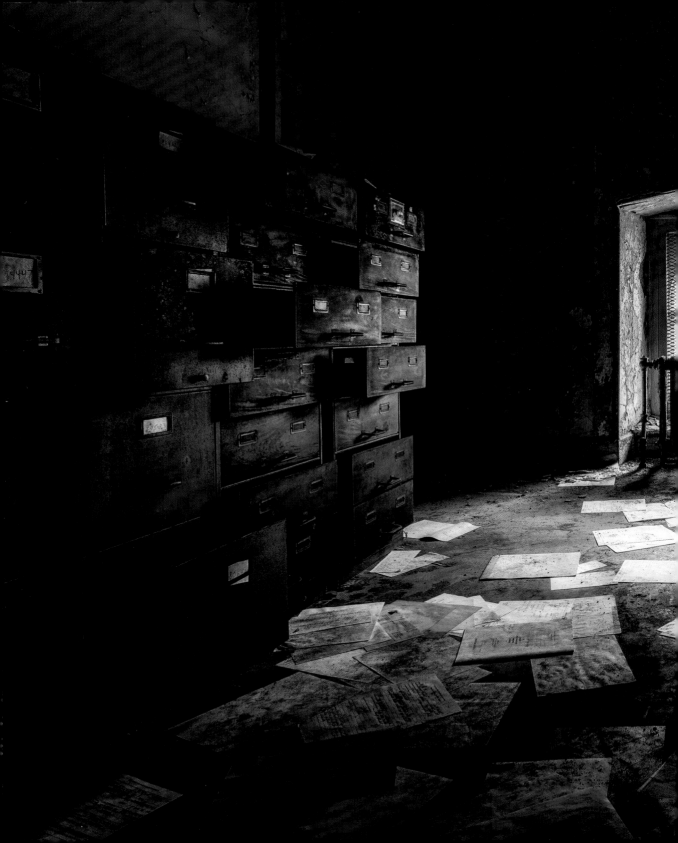

SEVEN
FINDING YOUR STYLE

All the great UrbEx photographers have a distinct style of editing photos. That doesn't mean you need to come up with one way to stylize your photos and stick with it forever; it simply means that you should clearly understand what looks good to you.

Your style will change over time. Almost all the great artists of history had defined periods of stylistic metamorphosis. Picasso, for example, had five to seven defined periods. The same will happen with you as you continue to expand your knowledge and hone your skills.

I didn't bother with the "find your style" phase when I first started, and my photos suffered greatly as a result. It wasn't until I saw other artists' amazing UrbEx photos that I really found a style and direction for my own work. Even if you've been shooting for years, I recommend trying to explain your style. If you think every one of your photos is unique, I'd be willing to bet they share stylistic similarities.

Places to Find Inspiration

What do you do if you don't know how to define your style? Simple: find inspiration from other great photographers. Any great artist is a melting pot of inspiration taken from artists that came before. There's absolutely nothing wrong with looking at a photo and saying to yourself, "I want to create that." You might not be able to take the same photo, but you can certainly try to replicate their post-processing style.

Seeking out inspirational images isn't an exercise in copying another photographer—it's an exercise in understanding the tools at your disposal to develop your own style. I'm constantly looking for new inspiration; thankfully, we have this great thing called the Internet, which is full of great resources.

Flickr.com

Flickr is one of the oldest photo sharing sites on the Internet. It's had its ups and downs in terms of quality, but it has always been a great source of stylistic inspiration. A quick search for "urbex" or "abandoned" will return some great results.

Unfortunately, some people tag their photos with "urbex" or "urban exploration" because they use the term in the literal sense. That is, they took a bunch of photos while walking around a city, added the keyword "urbex," and uploaded them. I can't blame them, because that is what the term means; they just don't understand that the term has taken on a new meaning for a large community of photographers and explorers.

500px.com

The website 500px encourages photographers to showcase their best work. Flickr tends to have photographers who upload ten variations of the same photo, which can really slow down your search for inspiration, but 500px typically has a phenomenal collection of top-notch photos. Not only will you find great photos of abandoned places, but you'll find a lot of abandoned location photos featuring models. A number of photographers like to use models to convey the duality of beauty and destruction. I'm personally happy depicting the destruction alone, but I'm certainly inspired by photographers who can convince beautiful women to pose in abandoned structures full of asbestos, mold, and pigeon droppings.

Google+

Google+ (G+) is Google's social media answer to Facebook. G+ gets a bad rap because it hasn't been widely adopted, but it's phenomenal for photographers. It displays photos in a beautiful lightbox, and it's very easy to find great UrbEx photographers there. I started a G+ community called simply Urban Exploration. We have about 25,000 members from all over the world. This community is a never-ending source of inspiration.

Reddit.com

Reddit is a collection of communities, or *subreddits*, for just about anything you can think of. Two great subreddits geared toward abandoned-location photography are /r/AbandonedPorn and /r/urbanexploration. Both have a good volume of activity and have supplied me with great inspiration. If you decide to post your own photos, though, prepare to thicken your skin, because some criticism can be less than constructive.

UrbEx Styles

You're now armed with several places to find stylistic inspiration, but how do you begin to analyze and describe those visual variations? In the following sections I've outlined the gamut of common UrbEx styles. Some photos and photographers certainly don't fit perfectly into these categories, but that tends to be a small percentage of UrbEx photographers.

Straight-out-of-Camera (SOOC)

Some photographers pride themselves on publishing SOOC photos, or those that have not had extra digital corrections applied. SOOC photos typically look a little flat and are prone to minor shooting mistakes. This style is typically practiced by two kinds of people: great photographers and people who like to brag about being great photographers.

SOOC photographers shoot JPEG images and will proudly tell you that their shots are SOOC. They regard themselves as better photographers than most because they nailed their settings in-camera and don't have a computer altering their images.

Yes, there's something to be said for getting the shot right in-camera, because it will save you time on the back end. However, these photographers overlook the fact that digital cameras *are* computers that apply contrast and saturation settings to every photo (when shooting in JPEG mode). It's a silly mindset, in my opinion, because every photo can benefit from some sort of digital correction (even if it's just sharpening or straightening). Film shooters have to make some of the same choices and corrections in the darkroom to optimize the final image. I just prefer to make those choices on a computer.

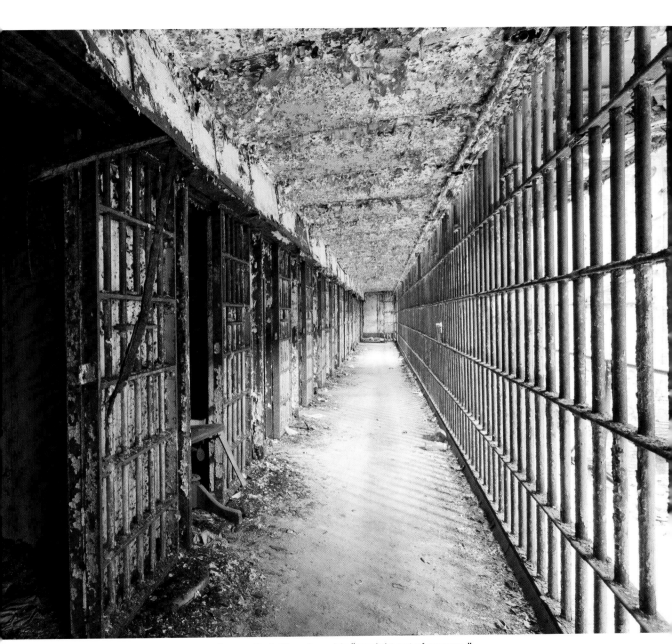

This shot has had no post-processing applied. Therefore, it's "straight out of camera."

Natural

Natural-style shooters are some of my favorite UrbEx photographers. Their photos are typically single exposures with minor digital corrections (such as saturation, straightening, shadow/highlight enhancement, and sharpening). Some natural shooters use HDR, but very minimally—to the point where you can't definitively tell whether HDR was actually used. Natural shooters focus on timing and composition to get the best light and don't need to apply too many corrections in post-processing.

Spending a few minutes in Lightroom adjusting the color, contrast, and clarity can make any photo more dramatic, while retaining a scene's natural qualities.

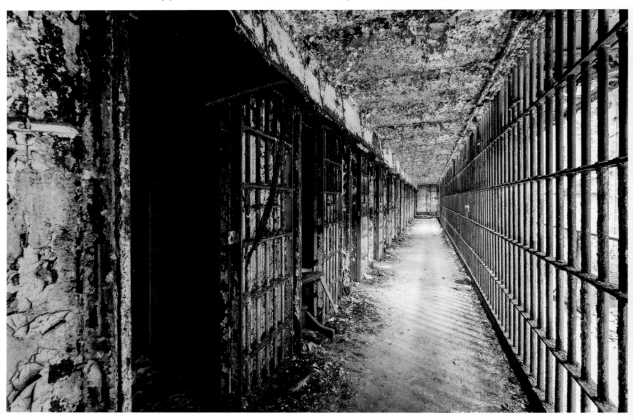

Detail-Enhanced

With a detail-enhanced style, the photo is enhanced to highlight the texture of a scene. Peeling paint looks more intense, lines are sharper, and you can see textures that you may not have noticed in person. This is my favorite style of UrbEx photography, and it's the one I'm constantly striving for. This style can be described as somewhat surrealistic because viewers don't typically see these photographic characteristics in other genres of photography. Whether that's a good or bad thing is in the eye of the beholder, but detail-enhanced shots are some of my favorites.

This style accentuates a scene's natural qualities and can even force some textures that are difficult to see with the naked eye.

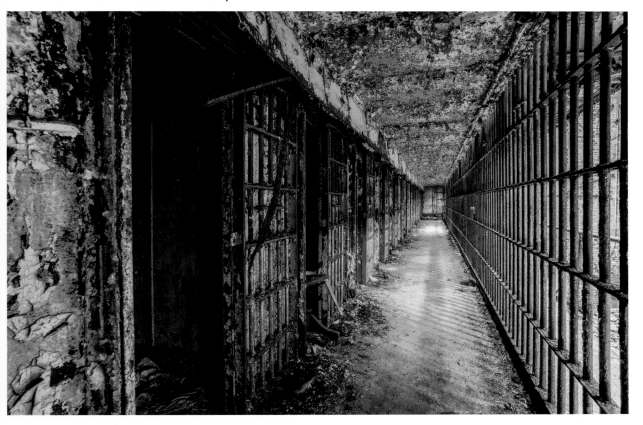

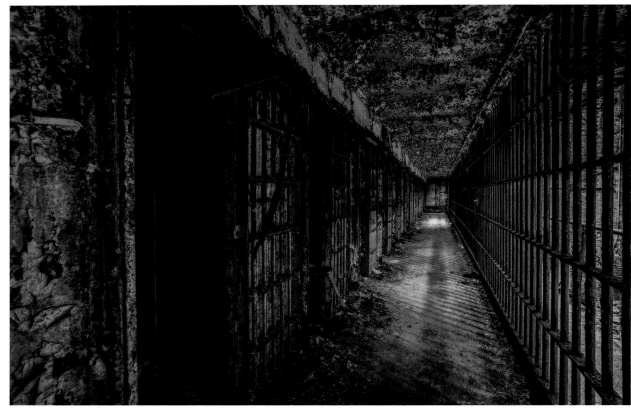

Dark and dirty: This is the essence of grunge.

Grungy

The goal of a lot of abandoned-location photographers is to make their shots look grungy. The term "grunge" rose to popularity in the early 1990s, when it was used to describe a genre of rock music characterized by excessive distortion, fuzz, and feedback effects (see: Nirvana). When applied to photos, a grungy image has over-the-top levels of texture, grit, and contrast.

It's particularly hard to get a good grungy photo without using HDR, because you want to pull all the details out of underexposed areas. (We'll talk more about that later when we dive deeper into post-processing techniques.) Grungy photos are easy to overdo because the textures and moody colors can detract from the subject of the photo. Because it's a fine line between grungy and simply dirty, I try to stay away from this style, but once in a while images just call for it.

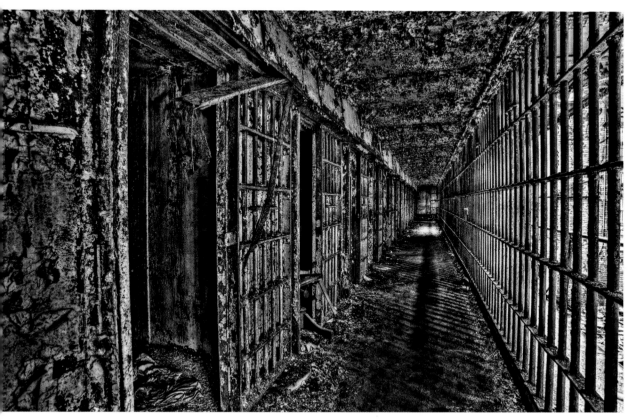

Overcooked

Unfortunately, there are a ton of UrbEx shooters and photos that fall into this category. When I previously noted that "my own photos suffered greatly" because I didn't take the time to find my own style, overcooked is why.

When first starting, I assumed that overcooked photos were the norm, because most of the online shots I saw were overcooked. It took me a solid year of shooting to get out of this pit.

A stereotypically overcooked photo is one that has been improperly processed using HDR programs such as Photomatix. They are characterized by excessive halos around hard edges, excessive saturation, and very little contrast between highlights and shadows. HDR is used to create most of these photos, which has given HDR a bad reputation for producing

I've purposely overcooked this image to show you what an eyesore this style can be. But if this is what you think looks incredible, don't let me stop you. It's your art. Just trust me when I say that you'll grow out of it as you keep shooting.

"crappy photos." I have a plethora of photos that I edited during my first year of shooting that I won't let anyone see because they are both improperly composed and overcooked—a lethal combination.

My Style

So what's my style? I think of myself as a detail-enhanced shooter who borders on the grungy side.

With that said, sometimes I create natural shots, sometimes I (accidentally) overcook my shots, and I've even published SOOC shots. It's always good to have a general stylistic goal, but my editing style really depends on the subject and the shot. You can make any shot look grungy, but does it work? Does it enhance what's already there, or does it look forced? Using post-processing software, you can make a plain white wall look dark and grungy, but why would you want to?

My goal is to stylize my photos in a way that enhances and complements the subject. My goal is *not* to create a scene that wasn't there in the first place. When I'm shooting, I'm always thinking about what tools I can use to bring that scene to life. I don't like to make particularly dark scenes look bright in post-processing, nor do I like to make bright scenes look dark. This is why I prefer to wake up early to capture blue hour and golden hour: so I can build upon the scenes that are given to me.

But my style is always evolving, just as yours is. Don't be afraid to experiment with your shots, because it could lead to some great images that you didn't know you could create.

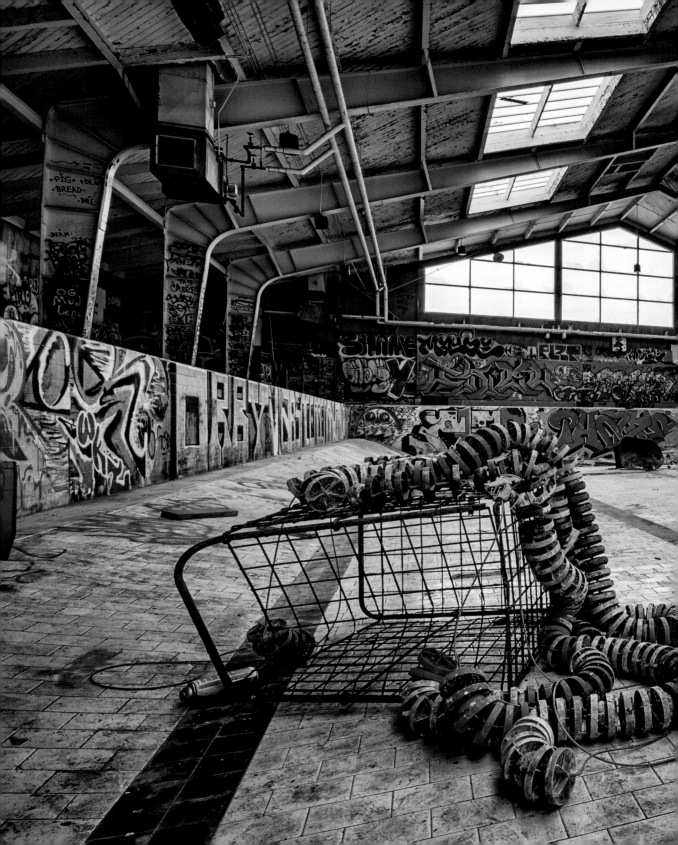

EIGHT
IMPORTING AND EDITING YOUR SHOTS

As soon as I get home from an explore, the first I thing I do is unload my memory cards onto my computer. Actually, the *first* thing I do is put my asbestos-ridden clothes in a garbage bag and then shower. After that, I unload my memory cards. I'm always excited to see my shots, but more than anything, I feel that if I don't do it immediately, I may forget about the memory card and accidentally format it on my next exploration.

Importing your photos is a crucial step in your workflow, not just because you don't have a workflow without it, but because you can save a lot of time by taking care of a few things now instead of waiting until you've processed all your photos. In this chapter, I discuss some importing tricks you can try and how to weed through hundreds of shots to pick the winners.

Lightroom serves as the hub for all your cataloging, editing, basic post-processing, and photo publishing. As soon as you insert a memory card into a computer, Lightroom pops up, ready to import your photos. But before you click Import, you should know about some best practices that will ensure that your catalog is structured to make photo organization and editing easier.

Creating a Folder Structure

TIP Sign up for a cloud-based backup solution immediately. I use Backblaze, and as soon as I start importing photos, the computer starts uploading them to the web. For $5 a month, you'll never need to worry about backing up your backups, and you'll be able to access your photos any time you need them (from anywhere).

Having a good filing system is imperative (I'm slightly obsessive about having clean folders) because it helps Lightroom perform efficiently and enables you to find photos more easily. A friend once told me that he kept his photos on multiple external hard drives with no formal folder-naming convention, and I cringed—especially after he told me that one of his external hard drives failed.

I organize my folders in a pretty simple way so that I can always find my photos when I need them:

- First level: Photography folder

- Second level: year

- Third level: date (location)

In the screen shot to the right, I censored the names of sensitive locations, but you can see some of the concerts I shot that year. Your naming structure doesn't have to be complex; it just has to be consistent.

Setting Import Options

Once your folder structure is set up for your existing photos, you can customize the import options that Lightroom provides. As soon as you pop a memory card into your computer, Lightroom should automatically open (depending on your settings) and the Import dialog should also open by default. Let's examine the options, what they all mean, and the settings I use.

TIP If the Import dialog doesn't open automatically, go to Edit > Preferences, click the General tab, and select the "Show import dialog when a memory card is detected" checkbox.

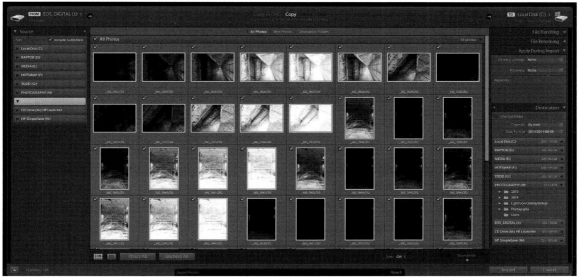

Copy, Move, or Add?

The first thing you're presented with in the Import dialog is a choice of how you want to import your image files:

- Copy as DNG
- Copy
- Move
- Add

You need to decide if you want to just copy over your raw files using Copy, or if you want to Copy as DNG, which is just a raw format that Adobe created. There are pros and cons to using DNG files. A good comparison of those can be found by visiting http://photographylife.com/dng-vs-raw.

I always choose Copy because I don't need the benefits of using DNG files. Move and Add are irrelevant since they are not available for use with memory cards.

Creating Previews

In the Build Previews drop-down, you determine the quality of the thumbnail images that Lightroom creates for your library:

- **Minimal:** This option uses the smallest previews that are embedded in your raw files by your camera. This is the fastest option for importing and will use the least disk space. However, Lightroom will need to create larger previews once you start editing, so this choice may slow you down later.

- **Embedded & Sidecar:** This option uses the largest previews from your camera. This is a slower process and will use more space on your hard drive. Lightroom will still create larger previews with this option chosen.

- **Standard:** Lightroom renders an even larger preview on its own. This process takes longer upon import, but it speeds up working with images later.

- **1:1:** Lightroom creates full-size previews. This option takes the most time during the import process and also uses the most disk storage. But it makes working with images faster when you have to navigate through your library and post-process your photos.

After you've chosen your preview option, three other checkboxes may be useful for you:

- **Build Smart Previews:** New to Lightroom 5, this option allows you to post-process your photos even when the original photos are not directly accessible at the time (such as if you keep your photos on an external hard drive that is not plugged in).

- **Don't Import Suspected Duplicates:** When you select this option, Lightroom avoids importing photos that are already present in your destination folder. This option can be useful when your import process is interrupted or if you can't remember whether you've already imported some of your photos.

- **Make a Second Copy To:** This option is handy if you didn't take my advice for setting up a cloud-based backup service. And even if you did, it lets you duplicate your files to a second folder on your computer as an extra backup source.

These are the options that I choose:

- 1:1 preview, because I hate being slowed down when I'm in the editing process. Importing in this way does take quite a bit of time, but I'm usually ready for some lunch when I get back from exploring anyway, so it's a perfect opportunity to grab a sandwich and a beer while Lightroom is working.

- Don't Import Suspected Duplicates, so if I happen to reuse a memory card in the field, I don't have a bunch of old photos reimporting into Lightroom.

Some of you might be asking, "But what about Smart Previews? They sound awesome!" It's a simple answer for me: all my photos are on internal hard drives, and I don't edit my photos unless I'm at home because I prefer the processing power of my desktop computer. Smart Previews are great for photographers on the move who are using laptops and external hard drives; I just don't need it.

Renaming Files

This option is self-explanatory. It lets you rename your files in a way that distinguishes them from the files in another import session. So if you went to an abandoned hospital named Bluerock Hospital, you could name your files something like "bluerock1.CR2," "bluerock2.CR2," and so on. I don't rename my files, because I never need to identify them outside Lightroom.

Using the Apply During Import Panel

The next feature is one of my Lightroom favorites. The Apply During Import panel lets you visually process your photos and add data during import. You may be asking, "Do I need any of that stuff?" No. Nobody needs any of it, but it might make your life easier down the line.

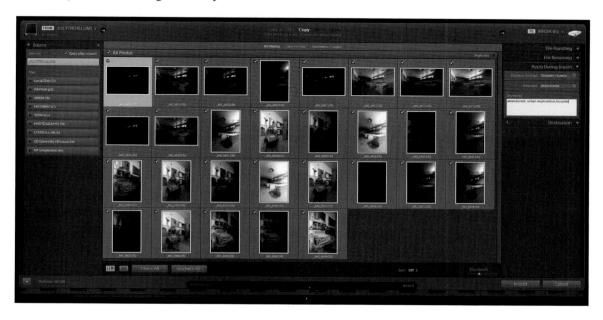

If you don't plan to use HDR for your photos, you can create Develop presets to visually modify your images when they are imported. It's a fantastic tool. I use it primarily for my concert gigs, but it may be useful if you plan to keep post-processing to a minimum. In Lightroom, you can create a Develop preset that applies a group of settings to an image with one click. Using the Develop Settings option, you can apply any Develop preset to all the images being imported.

1. Go to the Develop module.

2. Find the Basic panel on the right side of your screen, and input these values:

- Contrast: +20
- Highlights: –50
- Shadows: +50
- Clarity: +20
- Vibrance: +20

3. In the Tone Curve panel, set the Point Curve menu to Medium Contrast.

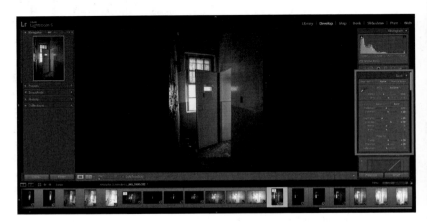

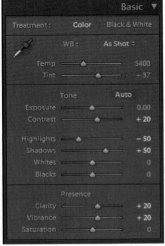

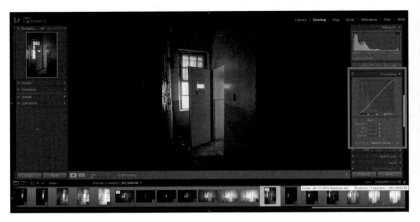

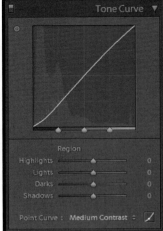

4. Scroll down to the Detail panel, and enter these values under Sharpening:

- Amount: +40
- Radius: 0.8
- Detail: +35

5. In the panel to the left, click the plus sign (+) to create a new preset.

6. Leave everything selected, and name the preset **Basic Adjustments**.

7. Click Create.

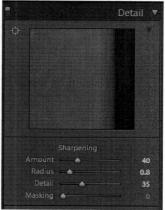

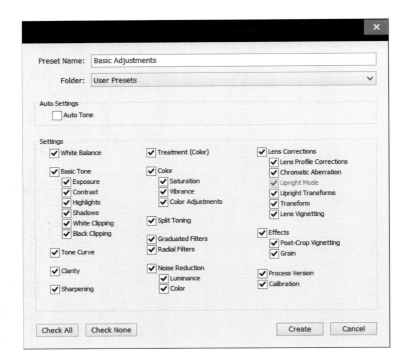

Now when you're importing photos using the Apply During Import option, you can select your Basic Adjustments preset and Lightroom will apply those settings to all your images. Obviously, those settings may not be perfect for every photo, but they're a good starting point for many shots that aren't going to be turned into an HDR image.

Adding Metadata and Keywords

If you don't know what metadata is, don't sweat it. It's just a fancy word for information that is saved within your image file. That information might include your copyright information, your contact information, and keywords associated with the image. In the Metadata drop-down menu, you can create metadata presets that you can apply to your images, just like Develop presets.

My metadata preset for abandoned photos fills in my contact and copyright information, along with basic keywords such as "abandoned" and "urban exploration." Those keywords are embedded into the file, and they will be available as searchable tags on photo-sharing sites such as Flickr when I publish the photos. I tend to use generic terms like "abandoned hospital," rather than the name of the hospital, because vandals scour photo-sharing sites as a way to find abandoned places. They then graffiti them or steal artifacts from inside.

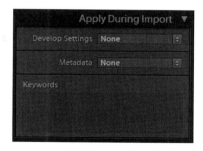

Keywords that you don't add using a metadata preset can be added by typing them in the Keywords field. Not only are keywords valuable for online searches, they are also one of the many ways that you can find your photos within Lightroom.

Destination

The last panel in the import process is the easiest. All you're doing is deciding where you'd like to save all of your raw files. Just pick your top-level folder, and then make sure you choose "By date" in the Organize drop-down menu.

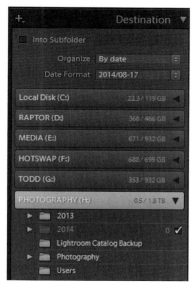

Stacking Shots

When you're bracketing shots, Lightroom has a fantastic tool that enables you to keep those bracketed shots grouped together. Stacking not only helps organize your photos, it also makes navigating through them to separate the good shots from the bad much easier.

Auto-Stacking by Capture Time

Once you've imported your images, you can stack your photos by the time interval between each shot. If you're autobracketing, the length of time between shots should be fairly low, which makes this process even easier.

Here's a quick way to stack shots with just one click:

1. In the Library or Develop module, select all your photos within a folder.

2. Right-click any photo.

3. In the pop-up menu, choose Stacking > Auto-Stack By Capture Time.

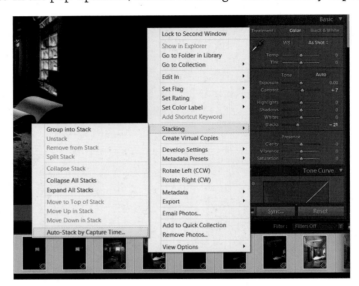

4. Choose the length of time that leaves the most images stacked. You'll have to remember what kind of shooting you were doing in order to get this approximately correct.

5. Click Stack.

6. Right-click your selected images again, and then in the pop-up menu choose Stacking > Collapse All Stacks.

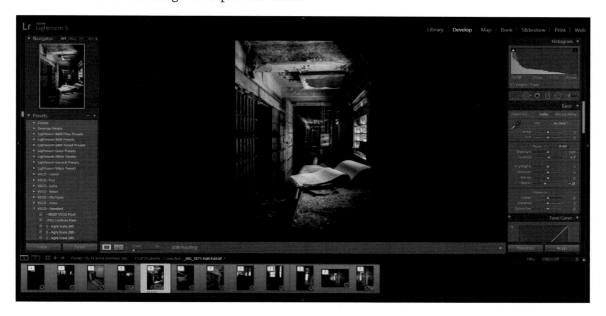

Now you can see all your exposures on a per-photo basis. So if you took seven exposures for one scene, you don't need to navigate through all seven exposures to determine if the image is worth keeping or not. You will need to browse the stacks to make sure the stacking was done correctly. An easy way to determine this is by looking at the little number in the upper-left corner of each image. If you were shooting seven exposures for your entire explore, only the number 7 should appear on each photo.

Again, this process is a lot easier if you remember how you were shooting throughout the day. If you were taking some single exposures between bracketing your shots, there's an easy way to remove those shots from a stack:

1. Select the photos that don't belong in a stack.

2. Right-click, and from the pop-up menu choose Stacking > Remove From Stack.

This method isn't perfect, but if you take as many photos as I do, it can save you a lot of time.

Picking the Winners

Congratulations—you've taken a bunch of pictures and loaded them into Lightroom. I'm sorry to say that those two activities are among the easier steps in this process.

One of the most difficult aspects of being an urban exploration photographer is picking your best shots. It's very hard for me to pick my favorite shots, usually because I have an emotional attachment to a location and I can't necessarily remain objective when reviewing the photos. Additionally, I'm not shooting gorgeous landscapes that make it easier to pick winning shots. I'm looking at dirty, dark scenes where beauty truly is in the eye of the beholder. All I can really do is pick the ones that most strongly evoke some kind of emotion in me.

Performing a First Pass

TIP One of my favorite keyboard shortcuts in the Library or Develop module is Shift-X. It flags a photo for deletion and then advances to the next photo automatically.

After I've stacked all my photos, I advance through them to pick out the bad ones right off the bat. By "bad," I mean the completely unusable shots: out of focus, blurry, underexposed or overexposed, terrible composition, and so on.

When you identify a bad shot, you can press the X key to flag it for deletion. After you've flagged your bad photos, press Ctrl-Backspace to delete all the flagged photos at once. If you're thinking everything through while shooting, however, you won't have too many useless images. But we all have our bad days.

Look at the images in the filmstrip on the bottom. You'll see some dimmed images that have flags with little x's. This indicates that these images have been flagged for deletion.

Using the Star System

Now that you've gotten rid of the absolutely unusable shots, you'll want to mark the images that are ready to be processed. You can certainly create your own system, but the following rating system has worked for me. To mark your shots with star ratings, all you have to do is press 1, 2, 3, 4, or 5 on your keyboard. You can then filter your shots based on these star ratings to make it easier to find the ones you need to process or the ones that are ready to process.

Here's how I rate my photos:

★ ★ ★	Ready to post-process
★ ★ ★ ★	Post-processed, need to decide if I want to publish
★ ★ ★ ★ ★	Ready to publish

I originally used one and two stars to represent bad shots because I was being obsessive about having stars on all my photos. I eventually realized how silly it was to devote any time to bad shots, so I no longer rate them. I just know that if a photo is not rated, I don't need to do anything with it.

Notice that each has five stars. These are images that have been published to my website and social media sites.

Choosing the Best

While I'm rating my photos with stars, I take a step back after I've given a four-star rating. At this point, I've post-processed the photo to my satisfaction. It's a shot that I really enjoy, but I want to make sure it's the best of the bunch. I think I'm a bit pickier than some UrbEx photographers in that I don't like posting 100 photos from the same location.

It all gets back to that whole "documentarian versus artist" decision that everyone has to make. I like to publish three to five shots that I feel best represent the feeling of a place. If I walk away with 60 photos from one day of exploring, I need to be absolutely sure that I'm posting my best shots.

To make sure, I ask myself, "Would I hang this photo on my wall?" If my answer is yes, that shot is ready for publishing to social media and my website. If my answer is no, I can either re-process the photo or just let it live with four stars forever.

Sometimes, I'll review my four-star photos and decide that I like them enough to publish them. But I've also reviewed five-star photos, decided that they weren't good enough to be published, and deleted them from the web. You can rate your photos once and be done with them, but I am always scrutinizing my work, especially because my tastes and preferences are always evolving.

Don't Delete the Rest

One habit I picked up early in my photography career was deleting photos that weren't worthy of being published. I was so steeped in creating HDR photos that I even deleted the original raw files that went into the HDRs.

I deeply regret those poor decisions, because I hate the way I processed photos when I was still a newbie and now I can't re-process them because I don't have the original files. I also had a ton of three- and four-star photos that I deemed unworthy and then deleted to free up hard drive space.

Don't do this. If nothing else, you can always go back and review photos from an abandoned place to remember what that place was like, even if you don't want the public to see them. This falls in line with bracketing your shots. Hard drive space is so cheap these days, there's no reason not to keep all of your shots.

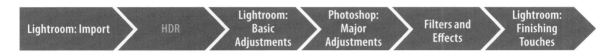

Creating HDR Images

There are many methods for creating HDR photos. Most of them are over-engineered, but I encourage you to find what works best for you. In this section, we look at two pieces of software that I use to create HDR photos: LR/Enfuse and Adobe Photoshop. These are the simplest tools that I've found to create high-quality HDRs without having to deal with 100 output settings.

I've found that the various software options that give you "ultimate control" over your HDR settings only confuse the process and give you unpredictable results. Most of those apps also have a bunch of presets that are largely unusable, and even their "natural" presets look awfully unnatural. Trust me when I say that you don't need them and they won't make your photos better.

Using LR/Enfuse

As you've learned, LR/Enfuse is a Lightroom plug-in that is very bare-bones and a little difficult to install, but it's incredibly easy to use for producing a 16-bit HDR image.

1. Select the exposures you'd like to use. Ctrl-click images to select more than one photo.

2. Choose File > Plug-in Extras.

3. In the Plug-in Extras submenu, choose "Blend exposures using LR/Enfuse."

4. The LR/Enfuse UI displays four tabs. Use these settings:

- **Configuration tab:** Keep the default values.

- **Auto Align:** Leave the "Automatically align images before blending them" checkbox unselected *unless* you didn't use a tripod to take your shots (shame on you!).

- **Enfuse:** Don't change anything. I've experimented with different settings and I've found that the defaults are perfect for this purpose.

- **Output:** Match the settings in the following figure.

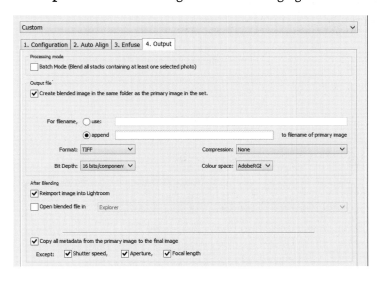

NOTE The "Colour space" option should remain consistent throughout your workflow. Make sure that your camera, Photoshop, and LR/Enfuse are all set to the same option. I use Adobe RGB. All of the options are perfectly fine, you just want to remain consistent.

5. Click Enfuse Images.

 After a little bit of processing, LR/Enfuse spits out a TIFF file named after your main exposure.

You've created an HDR image. It will look colorless and flat (low contrast), but you'll give it some life soon. If you know anything about painting, just consider this your primer coat. This is the base image that you'll perfect using Lightroom and additional plug-ins.

Using Batch Mode

In the Output tab in LR/Enfuse, you'll see the Batch Mode checkbox. The ability to use this feature is why you should stack your images right after you import them into Lightroom. Doing so will let you select multiple stacks of images and instruct LR/Enfuse to create individual HDRs out of them.

So if you've selected your three-star images and they're stacked with their respective exposures, you can select this checkbox and LR/Enfuse will generate HDR files for each stack so that you don't have to repeat the steps in the previous section for each image. If you work with HDR images as much as I do, this will save you hours of work.

Creating a 32-Bit HDR

A 32-bit HDR image includes more exposure and color information than a 16-bit image. It isn't always crucial to have a 32-bit HDR, because 16 bits will suffice for most people. But I've happily been using 32-bit HDRs for almost two years and I haven't found a reason to return to 16-bit. A 32-bit HDR will give you more exposure and color data to play with once you get it into Lightroom. So how do you create one? Let me show you!

1. Select your exposures (just as you did in the LR/Enfuse steps).

2. Right-click any selected exposure(s).

3. In the Edit In submenu, choose Merge to HDR Pro in Photoshop.

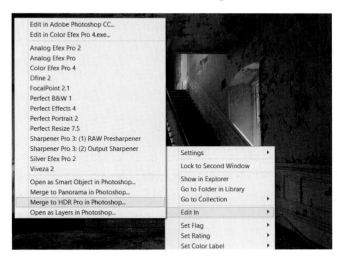

Photoshop will open and start processing. Let it works its magic.

4. In the next screen, leave "Remove ghosts" unselected, and make sure that Mode is set to 32-bit.

5. Select then deselect the Complete Toning in Adobe Camera Raw checkbox.

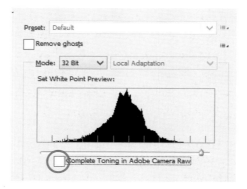

If you leave Complete Toning in Adobe Camera Raw selected, Photoshop will open Adobe Camera Raw, and you can make your edits there within Photoshop. Adobe Camera Raw has the same sliders as Lightroom, and it will apply them with a Smart Filter.

However, if you don't use Adobe Camera Raw and bring the HDR image back into Lightroom, all your changes will be saved within Lightroom and you won't have to reopen the file in Photoshop to make changes later. I know it sounds confusing, but just trust me. Lightroom, not Photoshop, should be the hub that holds all of your nondestructive editing.

6. Click OK.

7. Choose File > Save.

Your HDR image should now appear in your Lightroom library.

Understanding Luminosity Masking

Luminosity masking allows you to work with various channels of brightness in your images. In layman's terms, it allows you to select areas of an image in Photoshop based on how bright or dark those areas are.. This technique is a bit more difficult than performing a few steps in LR/Enfuse

or Photoshop, and I'll admit that I don't use it that often, but it is still worth having in your photography toolbox.

HDR apps can produce very clean images, but luminosity masks don't really merge files, as you do with HDR; you're actually manually blending different exposures using Photoshop layers. As a result, you have much less image degradation during the blending process. Some photographers say that the degradation of creating an HDR is hardly noticeable, but some pros out there swear by luminosity masks and nothing else.

I've found that luminosity masks are excellent when your shots of abandoned buildings include bright windows. If you have a great exposure and your windows are blown out, luminosity masking is a great method to try. It can also be very useful if you've taken an exterior shot but your sky is blown out. You can simply paint in a darker version of the sky without having to make any difficult selections in Photoshop.

NOTE Be warned that this technique is intended for users who are comfortable with Photoshop. If you're still a beginner, I recommend watching some YouTube videos on layers and masking before diving into luminosity masking.

To get started, you'll need to download a Luminosity Action set created by the awesome Jimmy McIntyre. It will save you a bunch of time because you won't have to repeat the setup process for each image. To install this Photoshop Action set, extract the file from JM Luminance Masks Actions.zip (see Introduction), open Photoshop, and perform these steps:

1. Make sure your Actions panel is open. If it's not, choose Window > Actions.

2. In the Actions panel, navigate to the upper-right corner and click the drop-down icon.

3. In the menu, choose Load Actions.

4. Navigate to the JM Luminance Masks.atn file on your computer. Select it and click Load.

You should now see the JM Luminance Masks in your actions list.

You're now ready to do some luminosity masking. For this example, you'll use two exposures, but you can use as many as necessary once you understand how the technique works.

5. In Lightroom, select one underexposed shot and one overexposed shot from a set of exposures. Don't choose your darkest or your lightest shots. Choose ones that were shot around –2 and +2.

I've selected two photos from a chapel in an abandoned psychiatric hospital. Notice that they have much brighter and much darker exposures to choose from. You don't want to use extremes with luminosity masking. In order for them to blend naturally, they shouldn't be too far apart on the exposure scale.

6. Right-click one of the exposures.

7. In the Edit In submenu, choose Open as Layers in Photoshop.

TIP If your layers are slightly misaligned, you can select both layers by holding down the Ctrl key, going to Edit, and clicking Auto-Align Layers.

8. Hide the underexposed layer by deselecting the eye on the layers panel. Doing so will ensure that the luminosity mask action is applied only to the overexposed layer. Also, make sure that your underexposed layer is *on top* of your overexposed layer.

9. In the Actions panel, select the JM Luminance Masks set and click the arrow to the left to reveal the Generate Luminance Masks action. Select it, and then click the Play button in the lower part of the Actions panel.

10. Unhide the underexposed layer by clicking the eye next to that layer.

11. Select the underexposed layer, then Alt-click the Add a Mask button. You should now see a black layer mask on your underexposed layer.

12. Above the Layers panel, click the Channels tab. You'll now see all 18 of the luminosity masks that the action has created. You'll need to use only one to blend your two images.

Because you're trying to blend the information from the darker image into the lighter image, you want to select one of the Brights masks since you'll be painting those parts out to let the darker information stay on top of the lighter exposure. (Confusing, I know. It will all make sense at the end.)

13. Select one of the Brights masks by Ctrl-clicking the *thumbnail* of the Brights mask (not the layer itself or the eye icon). You'll see the "marching ants" appear around your selection. If you feel that this animated border encompasses much more than the bright parts you want to mask out, select a different Brights mask using the same method.

NOTE You won't be restricted to painting within the marching ants.

I selected "Brights 3" as a starting point.

14. Now choose the Brush tool, and make sure your paint color is set to white.

15. Set Opacity to 30%.

16. Make sure that your layer mask is selected on your underexposed layer, not the layer itself.

17. Start painting over the bright parts of the image that you'd like to make darker. Remember that the border won't restrict your painting, so be sure to paint only the parts of the image through which you want the underexposed image to show.

See how the windows now have detail and color where the shot used to be overexposed? This is a simple solution for those not wanting to generate an HDR image using an app. This is technically an HDR image because you have artificially raised the dynamic range, but it's not what most people think of when they hear HDR.

If your painted sections are coming out too dark, you can repeat the technique using a lower Opacity value, or you may need to start with a lighter exposure. Luminosity masks take some trial and error, but once you get used to them, you can do some amazing things that give you full control over editing your image.

No matter which method of HDR creation you choose, you should now have a TIFF file in Lightroom to work with. This will be the foundation of your final photo going forward. If you opted not to create an HDR photo, no big deal, you can just take it from here using a single exposure.

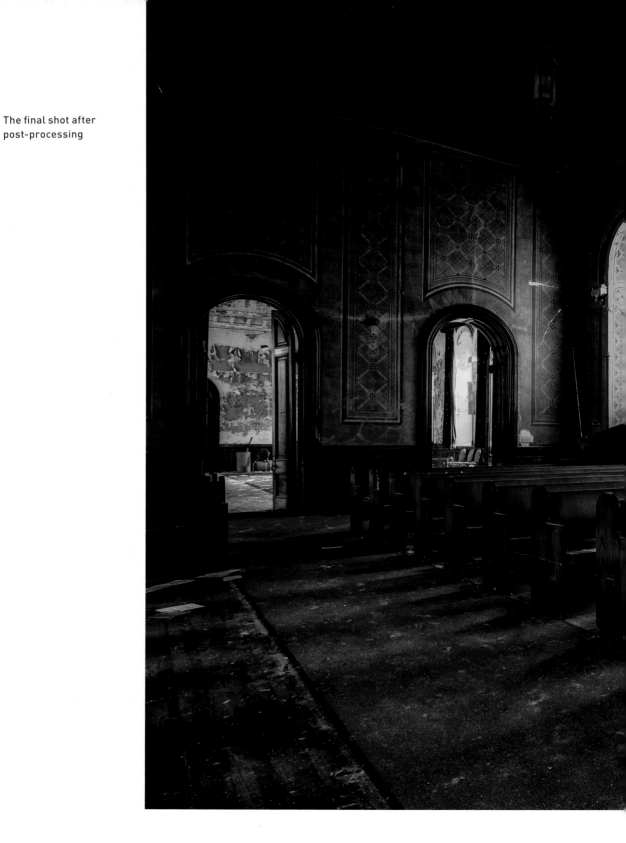

The final shot after
post-processing

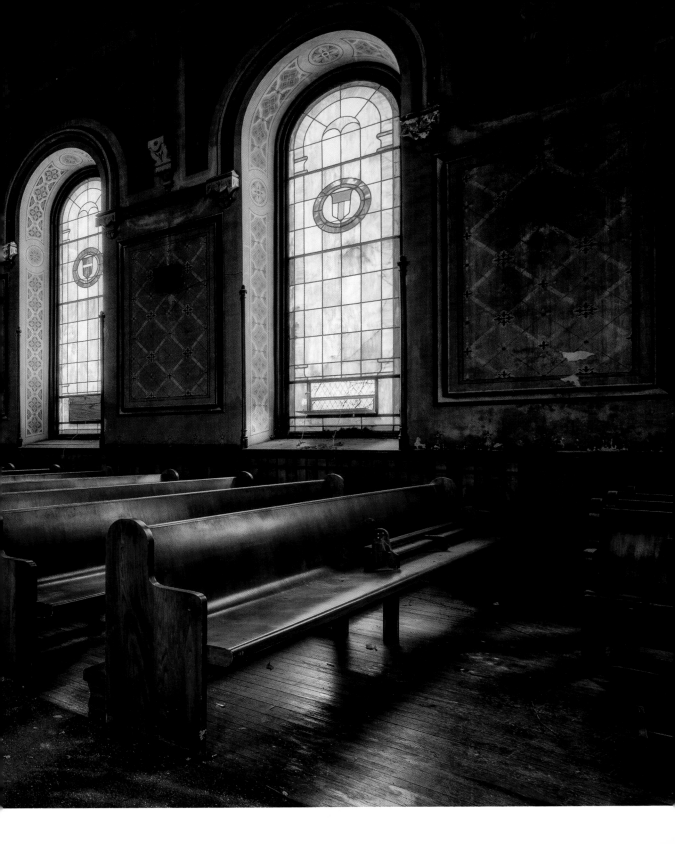

NINE

MAKING ADJUSTMENTS WITH LIGHTROOM

No matter whether you've created an HDR image to start with or you're just going to use a single raw exposure, this chapter describes how to make your image come to life.

If you're using an HDR image or raw file, both images probably look pretty flat and lifeless so far. If you're starting with a JPEG file, it won't need as much post-processing, but you will be limited in your post-processing options since you won't have access to the dynamic range of HDR and raw files. Regardless of your file type, I'm going to walk through all the adjustments, effects, and filters you have to choose from. I'll also give you an overview of my favorites and how I use them.

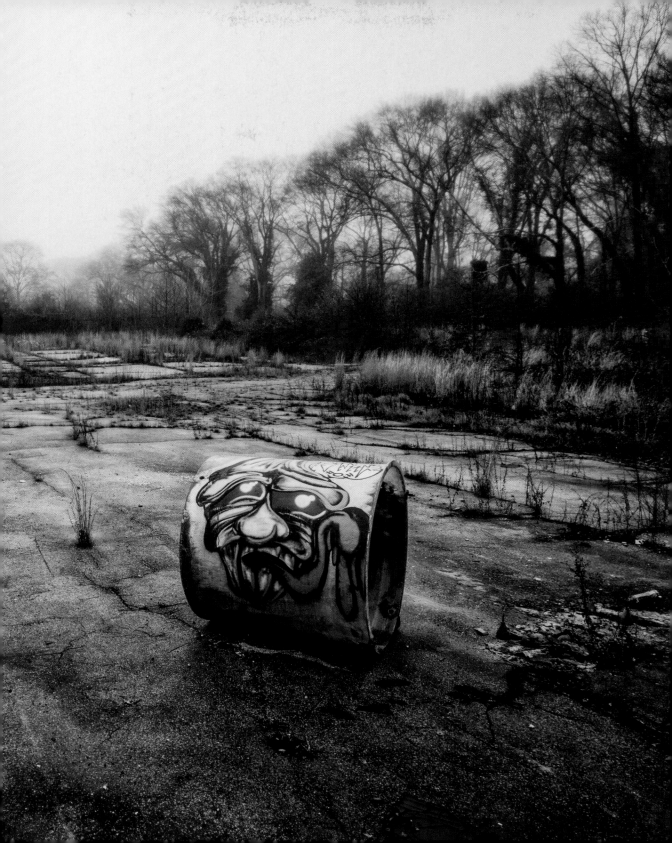

Having a Vision

The best practice initially is to examine your image and envision how you'd like the result to look. Once you become comfortable using these tools, you'll be able to identify what adjustments to make to a photo to get it from point A to point B.

Sometimes I'll get home from exploring and I'll know exactly what I want to do to a photo to create the final image. Other times, photos sit on my hard drive for a month or more so that I can come back to them with fresh eyes. Some photos speak to you and will guide you through the workflow, while others require experimentation to get to a final image.

The guiding mantra I always keep in the back of my mind is "enhance what's already there." I have certainly over-enhanced some photos, but this mantra always keeps me in check when I get wild ideas about drastically altering a photo.

Philosophically, I have no problem changing color tones, texture, or contrast—hell, I'll even use Photoshop to get rid of distracting objects in my photos. But the one thing I try to steer away from is using Photoshop to insert things that weren't in the original scene. We'll look at other things you should avoid later in the book, but for now, let's keep it simple and keep one goal in mind throughout the post-processing workflow: enhance what's already there.

First Pass of Lightroom Edits

Before I dive into the detail of each section, here's where we are in the roadmap of my workflow:

As I've said many times before, Lightroom is the hub for all organization and editing of your photos. The first step for editing your shots is to make use of the amazing tools that Lightroom has given us. You can create an amazing image using Lightroom alone. I like to take it one step further with third-party effects, but you shouldn't feel compelled to take your photos any further than Lightroom if you want your photos to stay on the "natural" side of the spectrum.

I'm going to walk you through each Lightroom adjustment I use frequently, and I'll then show you how it affects a sample image. I won't be going through every available Lightroom adjustment, just the ones I feel will be the most useful to you. I'm starting out with a photo from a beautifully decayed room in an abandoned psychiatric hospital.

The Basic Panel

The Basic panel is perhaps the most important in Lightroom, because its tools can help you refine your image with just a few clicks.

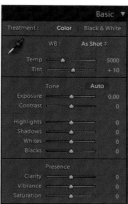

Here's the 32-bit HDR image I'm using as my starting point:

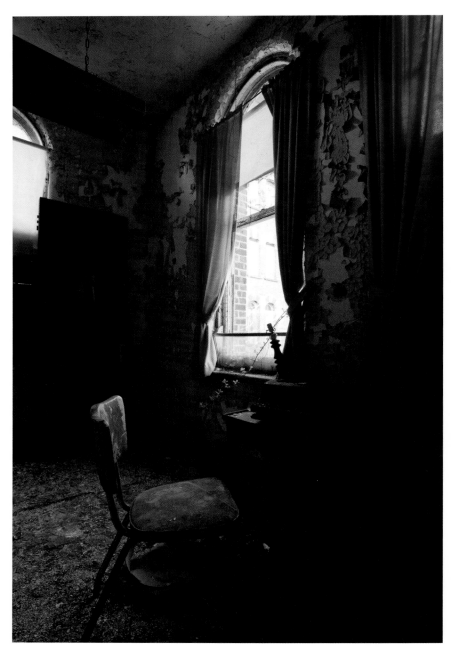

Exposure

This adjustment is self-explanatory: It will make your photo brighter or darker. The Exposure slider is particularly useful to correct your exposure level when you're using a single image instead of an HDR. It is designed to adjust the midtones of the photo and alter the overall brightness of the scene. Using an HDR image will give you even more control when using the Exposure slider.

Using the Exposure slider with the Highlights and Shadows sliders, you have complete control to fine-tune which parts of your image should be brighter or darker. However, the exposure slider won't be as useful when you're using a JPEG file because you will have much less dynamic range available to you.

Temperature and Tint

You can make drastic changes to your image using the Temperature and Tint sliders. These are your white balance (WB) sliders. The combination of these two sliders will convey the mood of your image to your viewer.

A huge advantage of shooting in raw is that you can change your WB to virtually any combination of these sliders. JPEG files have already discarded some color data and therefore don't have the latitude of change of raw files. This is why you can freely shoot scenes using Auto White Balance (AWB) in-camera—because you can always fix it later.

The big question here is: Do you want your image to appear warm or cold? If you didn't wake up early enough for blue hour, sometimes you can make up for that using these sliders. Take a look at how my image changed when I used the WB sliders to give my photo a warm or cold feel compared to the original WB.

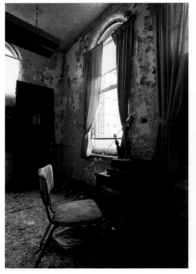 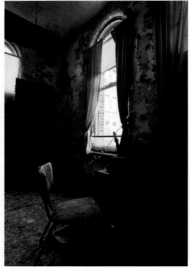 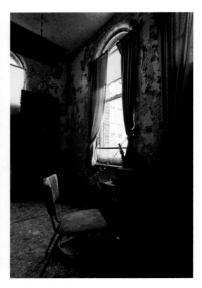

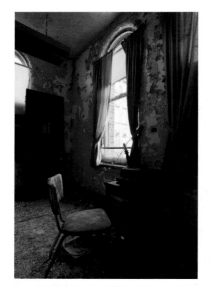

I pushed both of my WB sliders to the left to give my image a greenish sci-fi look—a popular look for some UrbEx shooters. This is a dramatic example, and it would need further adjustments for me to be happy with the final result.

The white balance I choose for my photo really depends on the time of day I shot my image. If I shot it during blue hour, I make sure it's cold. If I shot it during sunset, I make sure it's warm. If I shot it in the middle of the day, I go for whichever WB best complements what's already in the image. The main thing I look for is if the photo still looks natural regardless of the adjustments I make.

Your AWB isn't always correct, so make adjustments based on what looks most natural to you. A plethora of color theory books out there can help you determine what's "correct," but to be perfectly honest, I've found that going with your gut can produce more dramatic results than using the "correct" white balance.

For my sample image, I'm going to continue with a slightly warmer temperature.

Contrast

The Contrast slider can also exert a profound effect on your photo. Contrast is simply the scale of difference between black and white. Push your slider to the left and your darks get darker while your brights get brighter.

I usually save contrast adjustment for a little later in the workflow. This slider can instantly make your photo more dramatic, but don't go overboard. At this particular stage, I'm more focused on getting the details I want in the highlights and shadows. I'll bump it up a little bit and add more later in the process.

Highlights

One of my favorite sliders is the Highlights slider. This slider can either brighten or darken all of the highlights in your image. Here is where all your hard work to create an HDR image pays off.

In my sample photo, the window was completely blown out. Since I created a 32-bit HDR, I had full control to bring all of that detail back into my photo. I don't want to bring the slider all the way down to –100, because then it would just look artificially dark outside. I settled on –70.

The Highlights slider can be fantastically useful, but keep an eye on areas of your image where you might not want the highlights as dark as your window. We can fix specific sections individually later; we're just using these sliders as a starting point.

Shadows

The Shadows slider is the complementary slider to Highlights. Typically, I'll need to lower my Highlights and raise my Shadows. Since UrbEx photography often has an extreme difference between light and dark, you may need to even out those differences to get a balanced image. To keep things simple, I raised my Shadows slider to +70. Again, because the image is a 32-bit HDR, I had much more ability to get the shadow detail as bright as I wanted it to be.

Whites

Whites? How are those different from highlights? The Whites slider just sets the white point for your image. It has a more drastic effect on the bright parts of your image when used in coordination with the Highlights

slider. If I have a bright window (as in this sample image), I'll actually push my Whites slider up while pushing Highlights down. Doing so improves contrast and detail in the bright part of your image.

Before

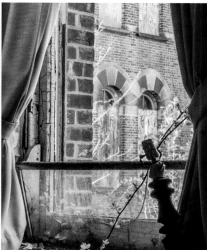

After

See what happened when I pushed the Whites slider up to +50 and the Highlights even farther down to −100? The contrast and color is dramatically improved.

Blacks

The relationship between the Shadows and Blacks sliders is analogous to that between the Highlights and Whites sliders: the Blacks slider adjusts the darkest pixels in your image and can help produce better contrast when used with the Shadows slider. If I have an image that looks particularly flat, a little push to the left in Blacks will fix it quickly.

For this example, I didn't push these values to the extreme, as I did with Whites/Highlights, but you can see how moving the Blacks and Shadows sliders in opposite directions helps enhance the overall contrast.

TIP Hold down the Alt/Option key on your keyboard while moving the Highlights, Shadows, Whites, or Blacks slider to see when you start losing detail in your image. In the sample image on the following page, with my Highlights at 0, you can see that parts of my image are still blown out. I held down Alt until those pixels disappeared (around −60) and then went a little farther because I wanted the image a little darker.

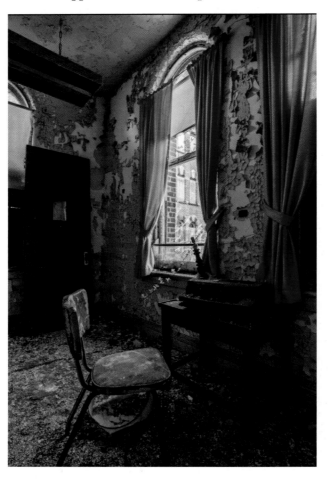

"Couldn't I just do this with the Contrast slider?" Sure, but creating recipes using these four sliders gives you far more control than using just one slider. Using the Contrast slider alone is like using a roller to paint the Mona Lisa. Personally, I prefer using four specific detail brushes to get the job done.

You can see that the window is blown out with Highlights set at 0. Press Alt/Option and you'll see a screen like the following figure, which will indicate how much you need to adjust to ensure that you get all of that detail back.

If you want to ensure that you're not losing detail in any part of your image, keep adjusting your sliders until these pixels disappear.

The Presence Sliders

This group of three sliders can make or break your image. New photographers like to push them to +100 because it gives photos that "wow" factor. Although a combination of these three sliders can be appealing to non-photographers, I'm attempting to teach you how to refine your craft (as opposed to getting Likes on Facebook). Use these adjustments sparingly, because they can be huge pitfalls when you're starting out.

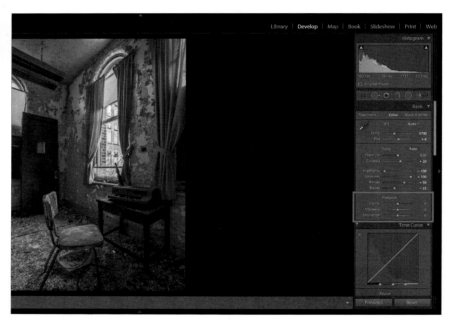

Clarity

Clarity is perhaps the most abused slider in all of Lightroom. It does something wonderful to photos that many photographers just can't get enough of. Increasing Clarity affects the midtone contrast and color of your image to make it "pop." This is certainly the most popular slider among UrbEx photographers because it's the one we use to bring life to those gritty textures (like peeling paint) so the viewer can *feel* the age of those abandoned buildings.

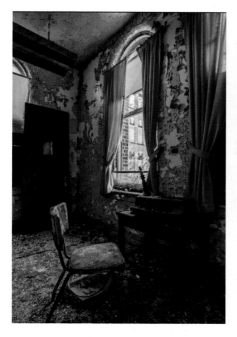

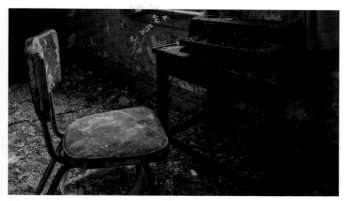

Before introducing +50 of Clarity

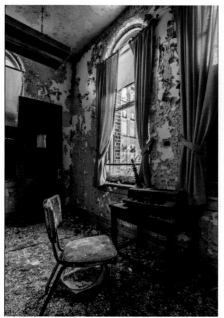

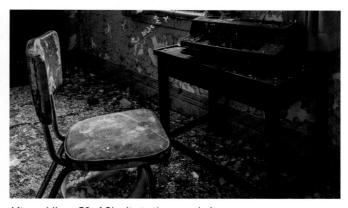

After adding +50 of Clarity to the sample image

You have to be careful using Clarity, though. If you push it too far, it can give you unattractive halos around the edges within your image. It will contribute to that "overcooked" look we're trying to avoid.

Vibrance

Vibrance is fantastic when used in moderation. In short, it boosts the amount of color in an image—but only to the colors that need it. It will not increase the saturation of a color if it's already on the verge of becoming oversaturated. The sample image doesn't really need any Vibrance or Saturation boost, so I left it as it is.

Saturation

Whereas Vibrance boosts only the colors that need boosting, Saturation boosts all colors. Just as Contrast is a paint roller on the Mona Lisa, so is Saturation. It doesn't care about current saturation levels; it will allow you to go overboard. I rarely use this slider, because Vibrance typically does everything I need to do in the color department.

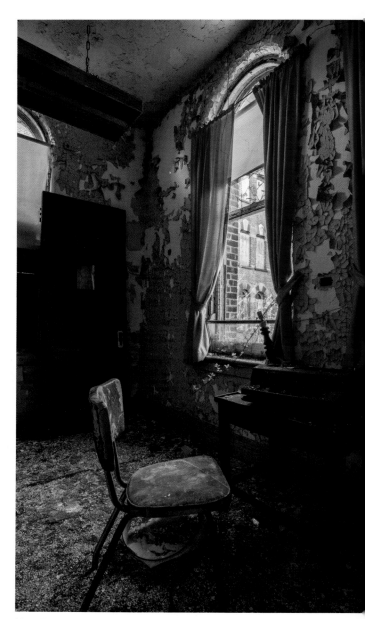

Here is my final image after some additional post-processing.

The Tone Curve Panel

The Tone Curve panel is plucked straight from Photoshop and is quite powerful. It is primarily for power users because it can easily be abused. Much of the functionality overlaps with the sliders in the Basic panel, which some might view as redundant, but they serve a purpose nonetheless. In my eyes, using the Tone Curve panel is completely optional. You can still create a fantastic image without it.

Region

The Region section under Tone Curve lets you alter the brightness and contrast of your image in four specific regions: Highlights, Lights, Darks, and Shadows. You're probably thinking that we already covered this in the Basic panel. We did, sort of.

The sliders in the Basic panel are considered "intelligent" and do their best not to let you ruin your image. Those sliders allow you to make adjustments within limits.

The Tone Curve sliders have no concern for protecting your image. You can ruin it to your heart's content because the Tone Curve sliders are like the big brothers of the Basic sliders. They have no intelligence to them whatsoever, so you can use them to fine-tune your image without Lightroom's built-in protections. I rarely need to use the Region sliders, but I frequently use the Point Curve setting.

Point Curve

Point Curve is a one-click setting designed to give your image a little more contrast using the Tone Curve. As you've learned, the sliders in the Basic panel are restricted so that you don't have full control over your image (that's a good thing). I use the Point Curve setting to give my image a little bit of contrast right off the bat, without the guesswork of using the Contrast slider in the Basic panel. I usually pick Medium Contrast to see if it works well with the image. If it doesn't, I just leave it on Linear.

The Detail Panel

The Detail panel includes another incredible set of sliders I use on almost every one of my images. The panel consists of two main sections: Sharpening and Noise Reduction. Perhaps the most important things to

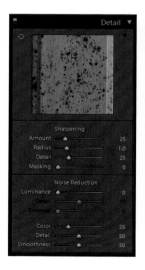

remember about these adjustments are to apply noise reduction early in your workflow (if your image needs it) and to apply sharpening at the end of your workflow (almost all UrbEx images can benefit from a little sharpening). The main reason is that sharpening enhances the details within your photo, so if you have a ton of noise in your image, you'll be sharpening the noise in addition to the details. So get rid of your noise first, and then enhance your details.

Sharpening

Lightroom has two great presets for Sharpening: "Sharpen – Faces" and "Sharpen – Scenic." As an UrbEx photographer, you probably won't be using "Sharpen – Faces" very much.

The goal with sharpening is to make the edges appear crisp while avoiding obvious halos or artifacts. Sharpening works by adding contrast to edges. More specifically, it lightens the light side of an edge, and darkens the dark side. You can play with the sliders within the panel to see how the sliders affect overall sharpness, but I find that applying "Sharpen – Scenic" to my images at the end of my workflow is about all I need for photos being published to the web.

When I'm going to be printing images, I will re-sharpen based upon my output medium and size. For those images, I use Nik Sharpener Pro because I can identify exactly what my output format will be. But if, like me, 95 percent of your images are going to live on the web, using "Sharpen – Scenic" should suffice. Some of you may not be satisfied with that solution, so let me break down each slider so you can start creating your own presets:

TIP You can hold down the Alt/Option key as you drag any of these sliders to see exactly what is affected.

- **Amount:** The degree of sharpening that is applied to your image. Easy, right?

- **Radius:** How far from the edge lightening and darkening occurs. A radius of 3 means that the contrast will occur three pixels from the edge. A radius of 1 is almost always a good starting point.

- **Detail:** How much of the fine detail is used for sharpening. A Detail setting between 20 and 40 should be good for most images.

- **Masking:** The higher the Masking setting, the more sharpening is restricted to obvious edges. In other words: increasing masking reduces the areas that are sharpened.

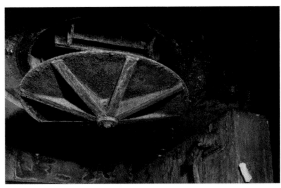

See how grainy this photo looks? Meet luminance noise. It's particularly prevalent when shooting at high ISOs. To minimize the noise in Lightroom, drag the Luminance slider in the Noise Reduction tab to between 25 and 50.

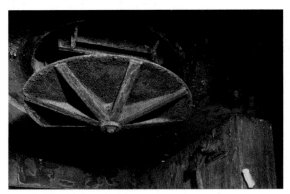

Notice the color blots around the image? That's color noise. To get rid of it, drag the Color slider until those colors disappear. A value between 25 and 50 should do it.

In case I didn't stress this enough earlier: Sharpen your images after you're finished with all other post-processing!

Noise Reduction

For UrbEx photographers, this panel is one of our best friends. As you saw when learning about the various options for shooting long exposures earlier in the book, image noise is our enemy. We do whatever we can to get high-quality images in the least amount of time with the least amount of visual noise. Because we have to make sacrifices given our unique circumstances, the Noise Reduction sliders can save a noise-ridden image as effectively as any third-party plug-in I've tested.

One thing you should understand is that noise appears in two types: luminance noise and color noise. You can infect your image with both by shooting at a high ISO or by shooting long exposures (particularly in warm weather). Luminance noise looks like abundant pixelation, whereas color noise usually looks like magenta and green blots all over the image, particularly in the shadows.

The Lens Corrections Panel

The Lens Corrections panel is often overlooked, but it can be used to dramatically improve your image with only a couple of clicks. This is where Lightroom can fix the perspective of your photo if you didn't get it right at the time of shooting. It can also fix any problems your lens may have caused.

Basic

The Basic tab within the Lens Corrections panel contains a one-click option for the other three tabs (Profile, Color, and Manual). Often, I use only this tab instead of going into each adjustment individually. With four clicks, I can fix any lens distortion, chromatic aberration, and vertical/horizontal perspective issue. These settings can also be applied upon import, but sometimes I shoot with intentional perspective distortions that I don't want Lightroom to autocorrect.

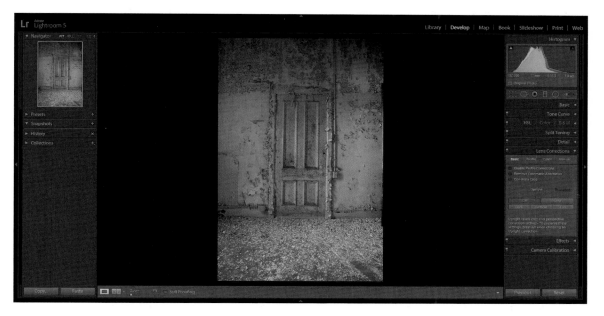

Enable Profile Corrections: The Lightroom team has tested hundreds of lenses and identified how those lenses can affect your final image. Using that data, it has loaded profiles for you to use to correct those issues. Your lens information is stored in the EXIF data in your image, so when you select the Enable Profile Corrections checkbox, Lightroom will identify your lens and apply distortion and vignette corrections. You can also manually adjust those corrections in the Profile tab.

Remove Chromatic Aberration: Chromatic aberrations are purple or green halos that show up around the edges within your image (particularly around windows and other sources of light). I consider this to be an aspect of image correction that most UrbEx photographers don't bother to correct (or simply don't know about). Most times, you can't see these aberrations without zooming in, but as soon as you print an image, they'll show up clear as day. Lightroom can remove most of them; just select the Remove Chromatic Aberration checkbox.

The level of chromatic aberration varies from lens to lens. With my gear, I've found that Remove Chromatic Aberrations doesn't remove *all* the aberrations in my image. This is the one correction that I'll go into the

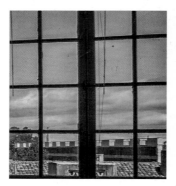

The purple and green outlines in this window aren't always visible to the naked eye, but these chromatic aberrations always catch my eye when I'm post-processing my shots.

Just by selecting the Remove Chromatic Aberration checkbox in the Basic tab, I was able to remove most of the annoying fringe in this window.

Color tab to manually correct. It usually just takes a bump to 5 of either the purple or green Amount sliders (depending on which color is showing up in my image).

Increasing the green slider removes green aberrations, and increasing the purple slider removes purple aberrations. You may have both types of aberration in one image, so you could use both sliders. If your aberrations don't show up as green or purple, you can use the Purple Hue and Green Hue bracket sliders to identify the color range of your aberrations so that Lightroom can remove them.

TIP You can use the Eyedropper tool to identify the color of your aberration so you don't have to guess while using the sliders.

To completely remove the chromatic aberration in this image, I had to raise the purple Amount slider to 5 and the green Amount slider to 10, and I even had to change the Green Hue from 40/60 to 40/80 to fully capture the entire color of the chromatic aberration.

Straightening buttons: The buttons at the bottom of the Basic tab are pretty straightforward. Before clicking any of them, make sure the Constrain Crop checkbox is selected. Doing so will ensure that Lightroom crops the image based on the adjustments you make.

The adjustments are Auto, Level, Vertical, and Full. Auto will make level, aspect ratio, and perspective corrections. Level will make corrections if

your camera was tilted to the left or right while shooting. Vertical will make corrections if your camera was tilted up or down while shooting. Full is a combination of Auto, Level, and Vertical and is usually the most drastic.

I usually use Auto because it will correct 95 percent of my issues. However, sometimes it will correct aspects of a shot I don't want corrected, so before moving on, compare the image with Auto turned on and off to ensure that you're happy with the results. I'm mainly looking for

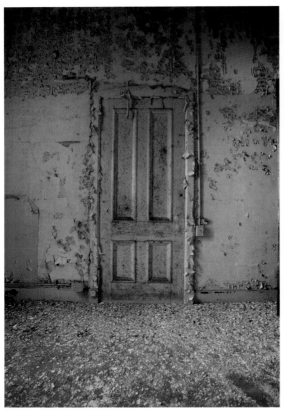

Before corrections

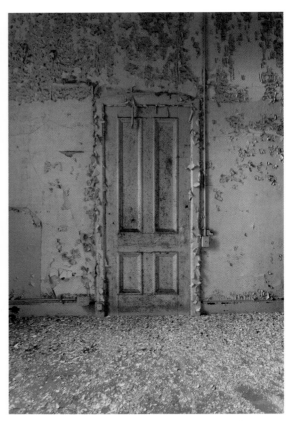

After corrections, the door looks perfectly straight. I apply a combination of Profile Correction and Straightening to almost all my images.

completely straight wall and window edges. You can get this perfect in-camera with a tilt-shift lens if you have $2000 or more lying around.

That's the gamut of Lightroom tools I use on a daily basis. Lightroom has many more features and far more advanced functionality than I've covered, but this is all you need to get started with post-processing. From here, we move on to Photoshop for more advanced editing tools.

TEN

MAKING MAJOR ADJUSTMENTS IN PHOTOSHOP

After you've made basic adjustments in Lightroom, you're ready to break out the big guns and make more serious adjustments using Adobe Photoshop. That is, assuming that your photos actually need major adjustments. I estimate that only about 10 percent of my images require major corrections, but it all depends on the environment you were shooting in and how much time you want to spend on a single image to achieve a particular look. The options for manipulating your photos in Photoshop are endless. Although I've gone overboard in the past, I now focus primarily on one aspect: ensuring that viewers are focusing on the subjects of my photos.

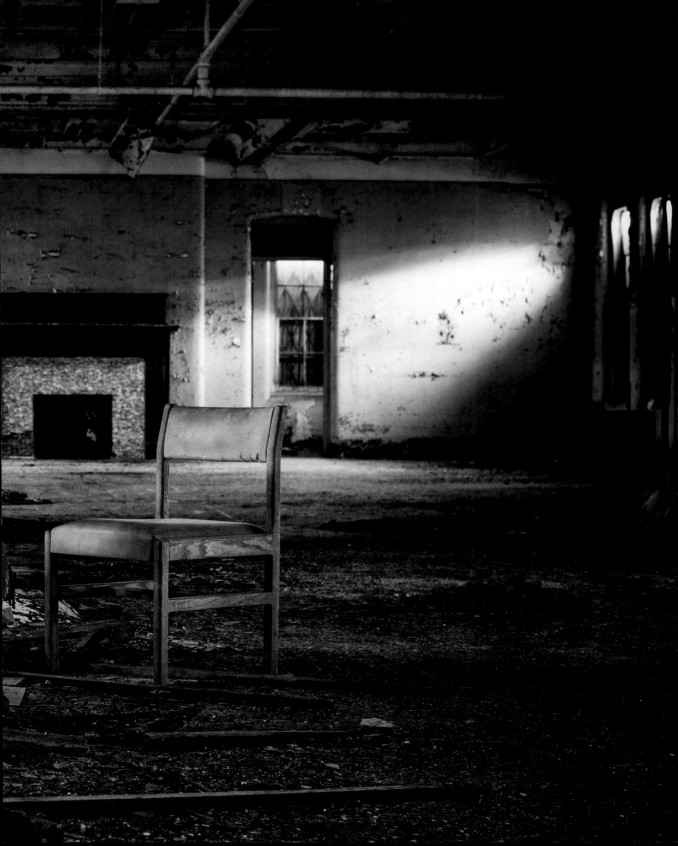

Creating Distraction-Free Shots

The main things I look for in my photos are areas that can distract my viewer from focusing on the subject. If I find something that is genuinely distracting, I'll remove it. Some UrbEx purists may cry foul because I'm not exhibiting the scene as I truly saw it. That may be true, but I don't care. I'm interested in creating visually appealing photographs for people

The walls were plagued with bad graffiti from the 1970s, when this underground missile silo was used as a party house by the local college kids.

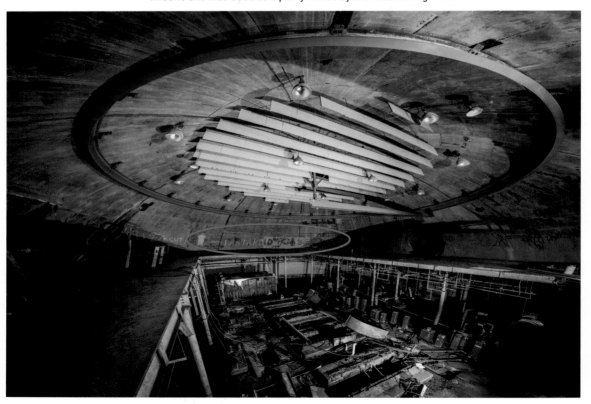

to enjoy; I'm *not* interested in leaving that bright orange Cheetos bag in the foreground to maintain historical accuracy.

As UrbEx photographers, we have one huge truth that works in our favor: most of our scenes are full of destruction and grime, so it's really easy to hide post-production edits. These distractions can be addressed by one-click solutions in Photoshop, or you can spend a couple of hours making sure that each pixel is perfect.

As seen here, one of my favorite photos required a fair amount of time to remove graffiti and correct artifacts left over from the panorama-stitching process.

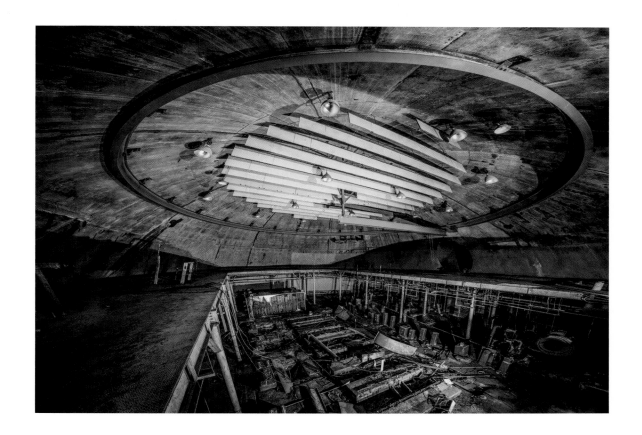

There's a tagger on the East Coast who likes to spraypaint a ridiculous tag on *everything*. It was hard to get a shot in this psychiatric hospital without that tag. I had no qualms about removing it from this chair because it didn't add anything to my photo and served only as a distraction. Some

In this example, you can see an edit that took me about two minutes to do in Photoshop.

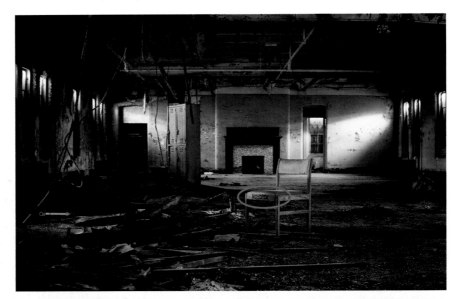

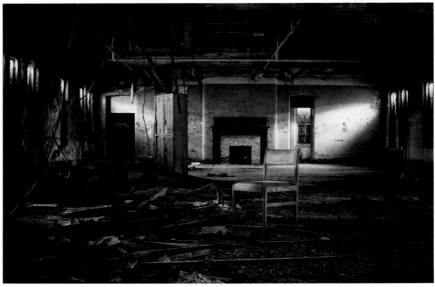

photos will not be made "great" by removing graffiti or other distractions and don't merit the time it will take to do so. It's an artistic preference you have the choice of making. You should have these skills in your toolbox, however, so let's walk through some easy steps to remove distractions.

Comparing Lightroom and Photoshop Tools

I realize I just said that we're moving on to Photoshop for major edits, but it's worth mentioning that Lightroom also has tools that can be used to remove distraction—primarily the Spot Removal tool.

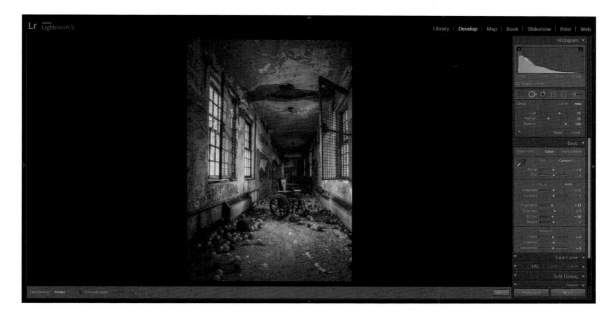

There is one major pro and one major con to using Lightroom instead of Photoshop for this process. The pro is that Lightroom's Spot Removal tool is non-destructive, so just as with every other edit you make in Lightroom, your corrections can be reversed at any time. Photoshop can do this also if you use layers, but that technique can become problematic if you want to perform any further edits in Photoshop or Lightroom, mainly

because you don't have the ability to undo your edits. If you make a mistake in Photoshop and you need to correct that mistake, you have to start from scratch unless you use layers, which can dramatically increase your file sizes. The major con is that the Spot Removal tool isn't nearly as robust as the tools available in Photoshop. Lightroom can easily remove items that have clear outlines and that offer some separation from the background, but I still prefer the power of Photoshop.

Spot Removal tool

If you want to remain within the Lightroom ecosystem, here's a quick tutorial on using the Spot Removal tool. Say that you want to remove the scraps of trash in the foreground of a shot:

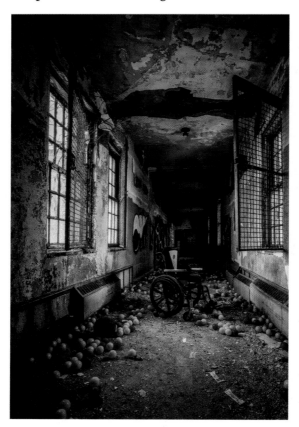

1. Choose the Spot Removal tool. In the Brush option of the panel, make sure you have chosen Heal rather than Clone.

2. Paint over the items within your image that you'd like to get rid of.

3. You'll see a lasso appear near the area you painted. It identifies an area that looks similar to your selection and that Lightroom is using to create an image overlay. It's called a "sampling point." If you have chosen Clone, Lightroom will pull data exactly as it appears from the sampling point. With Heal chosen, the Spot Removal tool paints

new pixels that are used to cover up what's there. I think Heal tends to look more natural, so if I'm using Lightroom, I usually choose that option.

4. Sometimes the tool is confused by your selection and creates a sampling point from an area that looks nothing like what you want. When that happens, simply grab the lasso and drag it to an area that looks similar to the selection you're replacing.

5. Click Done, and you're all set!

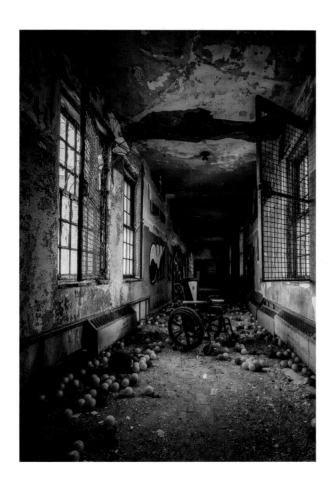

Spot Healing Brush tool

Photoshop has five built-in tools that can assist you in removing items from your image. They are all similar (and somewhat redundant), but they can be used to achieve the same results in different ways.

The first is the Spot Healing Brush, which is almost exactly like the Spot Removal tool in Lightroom; the only difference is that you can't relocate the sampling point. Once you paint over an area, Photoshop essentially says, "This is the best I can do; take it or leave it." If that's not good enough, give the Healing Brush a try.

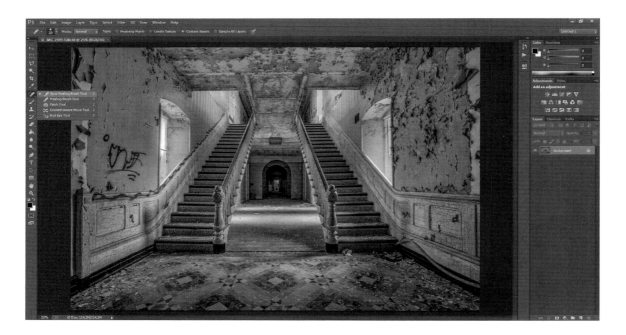

Healing Brush tool

Within the same toolbar button is the Healing Brush tool. (Press and hold down the mouse button to access the other brushes.) It is very similar to the Spot Healing Brush, except that you can define a sampling point prior to painting the selection you want to remove. When you first attempt to use it, you'll click somewhere on the image and get an error message.

The Healing Brush will display this error message on first use.

Photoshop is just saying, "Pick a sampling point, dummy!" To do so, press the Alt/Option key to turn the brush into a crosshair icon, and then click the sampling point of your choice. Now paint over the section you want

to remove. You'll notice that a small plus sign (+) is following your brush near the area you're painting. That indicates where your new image data is coming from as you brush.

Patch tool

The Patch tool also lets you select a sampling point, but you select it *after* you select the area to remove. To use it:

1. Choose the Patch tool (below the Healing Brush)

2. Drag around the section you want to remove. Release the mouse button and you should now see a lasso around your selection.

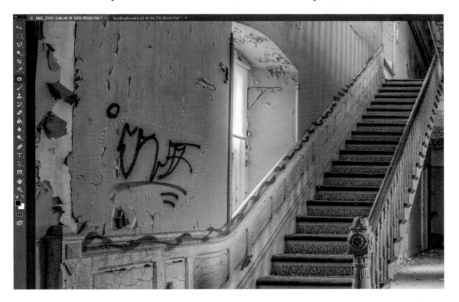

3. Drag that lasso to the area that will serve as your sampling point. You're looking for an area that doesn't have anything terribly unique in it.

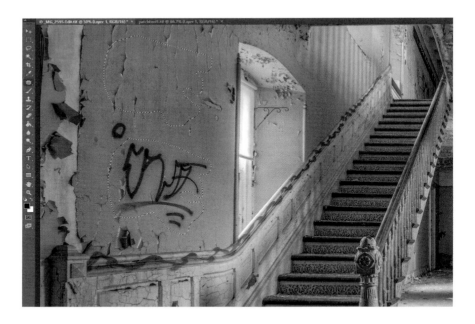

If this wall had had a lamp where I chose my sampling point, the removal process wouldn't work so well. Here's the final result:

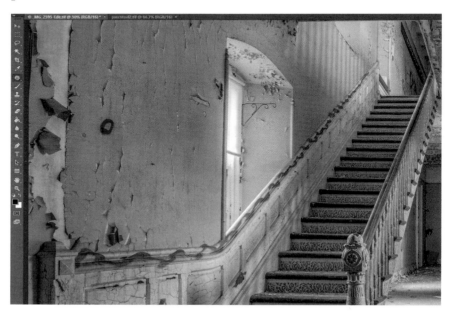

Sometimes the Patch tool leaves blurry edges along the outline of your selection. This usually happens if you accidentally drag your selection to an area with any hard edges that are very different from what you'd like to sample. In this example of removing some graffiti, I didn't have that problem, and it turned out to be a very simple correction because I had a big section of wall to use as my sampling point.

Clone Stamp tool

The Clone Stamp is also similar to the Healing Brush. The difference is that the Healing Brush retains the tonal values of whatever you're replacing and paints only the color of your sampling area. The Clone Stamp paints over your replacement area with the actual contents of the sampling point.

Remember how we picked Heal instead of Clone when using Lightroom's Spot Removal tool? The Clone Stamp tool provides the same functionality as the Clone option. So unless your sampling point and replacement area are identical in terms of shadows and highlights, you may want to stick with the Healing Brush.

I realize that these tools barely scratch the surface of Photoshop's capabilities. The fact is that you don't need every tool in Photoshop to create great photos, because that's what Lightroom is for. Adobe bundled all their essential tools for photographers into Lightroom for a reason. I don't use Lightroom exclusively, but I could certainly get by with it alone.

Feel free to poke around Photoshop and learn as much as you can; it certainly can't hurt. My focus is to teach the tools that I consider essential for Urban Exploration photography. If you want to learn how to add clown cars into your shots, you'll have to wait for my next book.

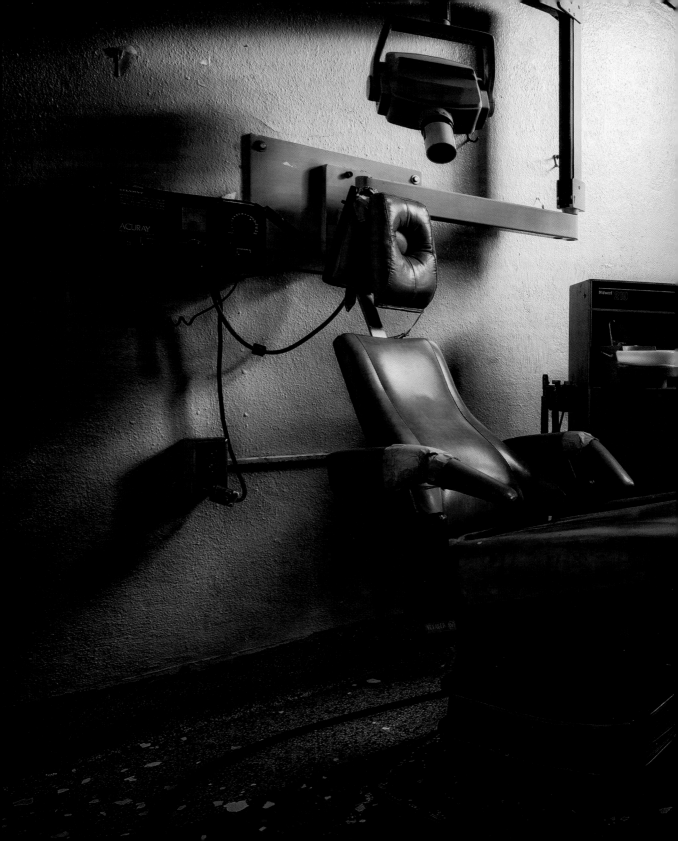

ELEVEN
FILTERS AND EFFECTS

Using filters can be somewhat controversial. Even the term "filters" has gotten a bad reputation due to overuse on services like Instagram. I like to think that serious photographers used them first, and therefore we have the right to claim them as a legitimate device for making photos better—not just for the purpose of attaining likes and followers.

We have the power to make a photo look completely different with filters, but I'm going to stick to one of my previous statements: We should only be trying to enhance what was already there, not create something completely different.

Lightroom: Import > HDR > Lightroom: Basic Adjustments > Photoshop: Major Adjustments > Filters and Effects > Lightroom: Finishing Touches

Manipulation Types

You can manipulate an image in many ways, but the enhancements I think are the most useful for UrbEx photography are glows, detail enhancement, and color alterations. I think these manipulations are the step in my workflow that most other photographers don't perform. I usually use a subtle combination of these to achieve my desired results. When used in moderation, these processing types can turn a good photo into a great photo.

Glows

Adding a glow effect to your image gives it a dreamy feel that helps to accentuate the other-worldly quality of the abandoned places we shoot. It's an effect that is usually seen in glamour and wedding photography to make people and their environments seem romantic. Our scenes of decay have their own romance, so who says we can't use the same effects?

Because glow filters soften your image, they should be used sparingly so as not to lose the sharp textures you're looking for in a final image. Glows created by apps such as Photomatix are often falsely attributed to HDR images.

Detail enhancement

In UrbEx photography, we typically want to accentuate the texture and decay within an image. One of the easiest ways to do this, aside from sharpening, is to increase the tonal contrast of an image. Doing so will increase the differences between lights and darks within your image, and make textures and details pop out from their backgrounds. This is the same effect as Clarity in Lightroom, but Clarity alters only the midtones.

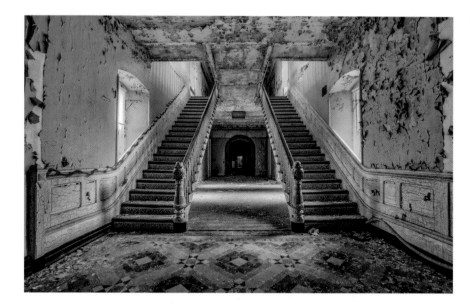

Photo without glow

Photo with extreme glow applied so you can see the effect (never do this to a photo)

With no tonal contrast
added

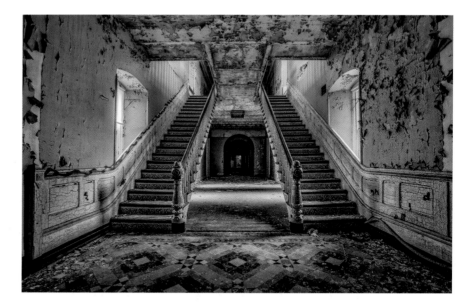

With tonal contrast added

Not all images need this adjustment or even benefit from it, but I find myself applying it to many of my images with positive results. You have to be careful with this one because increasing tonal contrast can also cause small halos around hard edges. You don't want this. So just as with all the other effects we're going to talk about, use it in moderation.

Color alterations

The final manipulation type I typically employ is color alteration. This usually comes in the form of changing the color temperature, but I particularly like using cross-processing to change the look of a photo. Cross-processing originates from the days of film photography, when photographers would develop photos using chemicals intended for a different type of film. Essentially, this throws a curveball at your color and contrast, which can result in really cool effects.

Having gone through the three main manipulation types I use, let's talk about how to apply them.

My method is to apply a combination of these types little by little, layering them so that you're not making one big drastic change. Think of it as applying each filter as you would apply a brush stroke. You could use huge brushstrokes with OK results, or you could make many small brushstrokes to create a precise masterpiece. And just as in painting, the order in which you apply brushstrokes (filters) affects your final image.

No cross-processing

Cross-processed

TIP Lightroom can perform great cross-processing using the Split Toning module. I use it a fair amount, but the plug-ins I'm about to talk about have filters that take the guesswork out of it.

Effect vs. Filter

Before diving further into using effects and filters, do you know the difference between the two? Trick question—there really isn't a difference. In analog photography, you use physical filters on your lens to create a desired effect. In digital processing, the terms are used somewhat interchangeably, because you can apply digital filters to create an effect. Even so, some companies cut to the chase and call all manipulations "effects."

OnOne Perfect Effects

The next step in this workflow is to bring an image into OnOne's Perfect Effects so that we can apply some of the manipulations I just covered. You can open Perfect Effects from within Lightroom or Photoshop. I prefer to open it from Photoshop because Perfect Effects creates a layer I can use to fade the intensity of an effect. A layer is also created when you open the app from Lightroom; but since you have to go to Photoshop to fade that layer either way, I prefer to use Photoshop as my home base for launching all third-party filter apps.

- To open Perfect Effects from Photoshop, with an image open, choose File > Automate > Perfect Effects 8.

- To launch Perfect Effects from Lightroom, right-click an image and choose Edit In > Perfect Effects 8.

Perfect Effects has a wide variety of effects that covers the gamut of glows, detail enhancement, and color manipulations. Perfect Effects has individual effects, but it also has presets that combine effects (some other apps, such as the Nik Collection, call those combinations "recipes").

Let's take a quick look around the Perfect Effects interface so you know how to use the features available to you. After you've opened your image in Perfect Effects, you should see this:

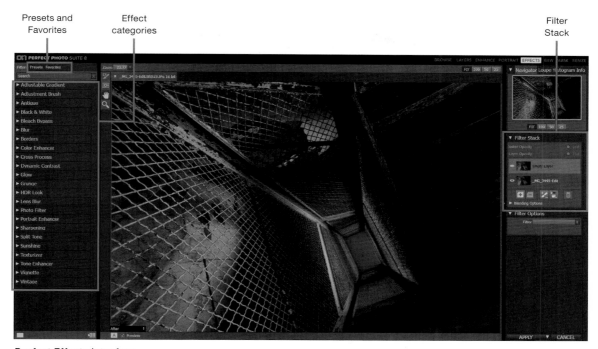

Presets and Favorites | Effect categories | Filter Stack

Perfect Effects interface

On the left side of the interface, you'll see the categories of effects you can apply to your image. You'll also see two tabs above the filter list: Presets and Favorites. Some great presets are in there, but a word of warning: Choosing a preset will overwrite any filters you've already added. I also use the Favorites tab quite a bit so that I don't need to hunt through the categories to find the ones I use most. Anytime you hover the pointer over a filter, you'll see a flag appear in the upper-right corner of the filter's thumbnail. Just click that flag once and it will be permanently placed in your Favorites.

To the right you have the Filter Stack module. Just as in Photoshop, this is where layers are housed. You'll see an eye button ⊙ on each layer, which lets you toggle the filter on and off so you can see what it's doing to your image.

The Layer Opacity slider controls the strength of the layer selected, and the Master Opacity slider controls the strength of all layers in the stack. Just below the layers, you'll see a + (plus sign) button, which adds a new blank layer, and a – (minus sign) button, which deletes the selected layer. You have to click the + button before you want to add a new filter; if you don't, whatever new filter you select will overwrite the filter already in that layer.

Just below the Filter Stack module is the Filter Options module, which gives you finer control over the selected filter, but it also lets you change filters on the fly. Some of this functionality may be a bit redundant, and it often confuses new users.

In the upper-left side of your image, you'll see four buttons that represent the Masking Brush, Masking Bug, Hand tool, and Zoom tool. The Masking Brush and Masking Bug enable you to add filters to only specific parts of your image while leaving the rest unaltered. The Hand tool lets you drag your image when you've zoomed into it using the Zoom tool. I usually don't zoom in, because I want to see how filters affect the image as a whole, but I will zoom in to make sure that a filter isn't creating problems, such as small halos around hard edges.

Those are the basics, so let's add some filters and I'll show you how I use Perfect Effects:

1. Click the Glow category.

2. Find Hollywood Glow, and select it.

This is a pretty intense glow that has brightened up my image considerably. Let's tone it down in the Filter Stack module.

3. Bring the Layer Opacity down from 100 to 30. The effect isn't too drastic, but remember that we're shooting for small brushstrokes rather than big ones.

4. Add a layer by clicking the + button.

5. In the Dynamic Contrast category, click the Natural filter. This filter adds a little bit of pop to your image. I've dialed the Layer Opacity of this one down to 50.

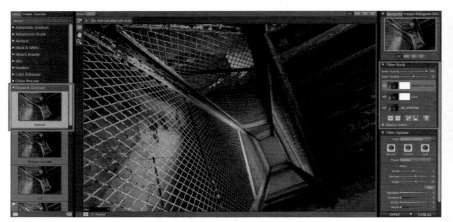 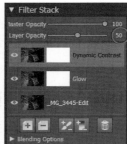

Now let's add some cross-processing.

6. Add a new layer, and then in the Cross Process category, select Urban Sickness.

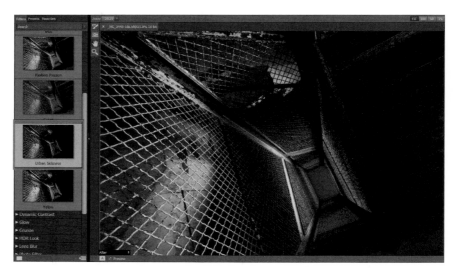

7. The effect of this filter is much too green, so bring the Layer Opacity down to 20.

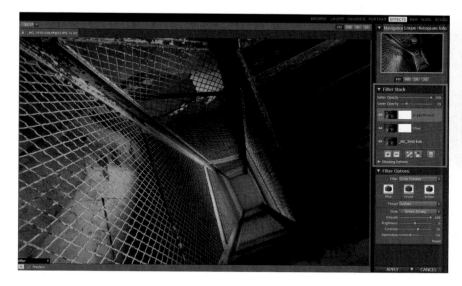

8. This is a good starting point, so click Apply. Perfect Effects returns to Photoshop with a new layer that includes the combined filters.

Notice that we didn't use any filter at 100 or even past 50. These filters are very strong, and there's no need to use one or two effects at 100 and call it a day. Use these in moderation and play around with five or six filters at a time with low opacity. You can reorder them in your filter stack to see how your image changes.

There isn't one correct way to use Perfect Effects. I've found different filters that work well for different types of images through extensive experimentation, and I encourage you to do the same.

FAVORITE EFFECTS

A few of my favorite filters in Perfect Effects are:

- Bleach Bypass—Normal
- Bleach Bypass—High Key Cool
- Color Enhancer—Cool Shadows
- Cross Process—Urban Sickness
- Glow—Hollywood Glow
- Glow—Rich Glow
- Grunge—Arkham
- Sharpening—High Pass Sharpen
- Split Tone—Blue-Yellow
- Sunshine—Sunglow
- Tone Enhancer—Tonal Contrast
- Vintage—Lo-Fi

And here are some of my favorite presets:

- Color Correction—Warm Highlights—Cool Shadows
- Contrast—The Look
- Grunge—Grunge Goddess
- Landscape—Spring
- Movie Looks— Lord of the Rings
- Vintage—Dirty Bird
- Vintage—Honky Tonk

Nik Color Efex

I use Color Efex almost as much as I use Perfect Effects, but I've found that neither one is a one-stop solution for all my filtering needs. Nine times out of ten, I first use Perfect Effects and then bring my image into Color Efex to add one or two more effects. Each app uses different algorithms that I think work well together.

You're obviously welcome to use one or the other (especially if you don't want to drop hundreds of dollars on both), and just one will probably get a look you're going for. If you opt for Nik's Color Efex, here's how to get started.

Just as with Perfect Effects, Color Efex can be launched straight from Lightroom (follow the same steps for Perfect Effects) or from Photoshop. If you're launching from Photoshop, the only difference is that Color Efex sits in the Filter > Nik Collection menu instead of File > Automate.

Once the app is open, you should see this:

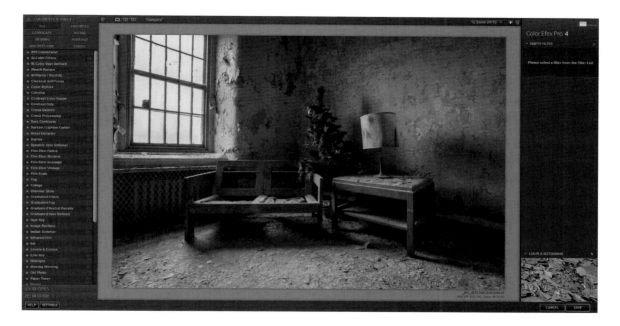

Look familiar? Color Efex has an almost identical layout to Perfect Effects. I think that Nik's interfaces tend to be much easier to use. The only real exception for me is that Color Efex doesn't let you control the strength of each layer, as Perfect Effects does. Some filters let you control the amount of contrast, saturation, and so on, but it would be nice to have one master filter control for every filter.

Let's look at the interface to make sure you know your way around.

To the left is the filter list. Above the filter list are categories. You can click any one of those to filter your list based on what Nik thinks you should be using for each genre of photography. I leave my category set to All because I think we can apply filters from numerous categories to our images.

To the left of each filter is a gray star. When you click the star, that filter is added to your Favorites category. To the right of each filter is a small button of cascading windows. When you click that button, Nik will display presets *within* that filter. I was using Color Efex for about a year before I even noticed this feature.

Below the filter list is a Recipes area, which displays filter combinations you saved as a recipe.

To the right is the filter list. As with the eye button in Perfect Effects, you can check/uncheck a checkbox to see how a specific filter is affecting your image. Click the X to remove a specific filter, and click Add Filter to add a new layer to your filters.

NOTE I think we need to start writing some letters to Nik so they'll add Urban Exploration as a category. Who needs a Wedding category anyway?

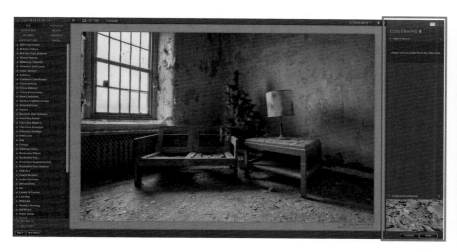

To the right of that button is the Save Recipe button, which you can click to save your filter list for use with other images.

In the options of each filter, you'll see Nik's version of OnOne's Masking Bug: control points. Control points are an integral part of the Nik Collection and are much more powerful than the Masking Bug. A control point is a one-click solution that lets you choose where you do or don't want a specific filter applied within your image. You can also link multiple control points and even copy them to new filters so you can maintain consistency throughout your filter use.

Let's say you want to apply filters to every part of your image except a big window in the corner of the room. You could use a control point to tell Nik that you don't want any of the filters you choose to have an effect on that window.

That's the Color Efex interface in a nutshell. Let's use some filters.

1. Open an image in Color Efex.

2. Find the Tonal Contrast filter in the filter list and click it. In the filter option, change the Contrast Type to Fine.

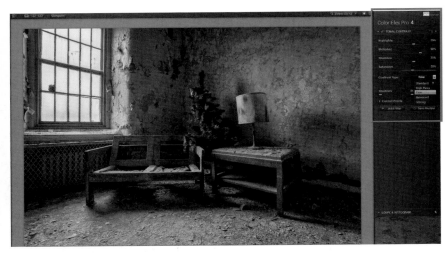

3. Click Add Filter.

4. Add the Sunlight filter to the image, and change these filter settings because it's too intense as is:

 - Light Strength: 10%
 - Brightness: 5%
 - Contrast: 20%

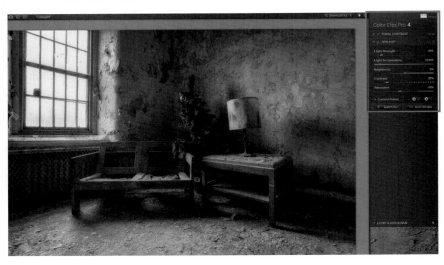

5. Add another filter layer, and then click the Cross Processing filter. In the filter settings, in the Method drop-down, choose C04 because I like that it adds a bit of a colder tone.

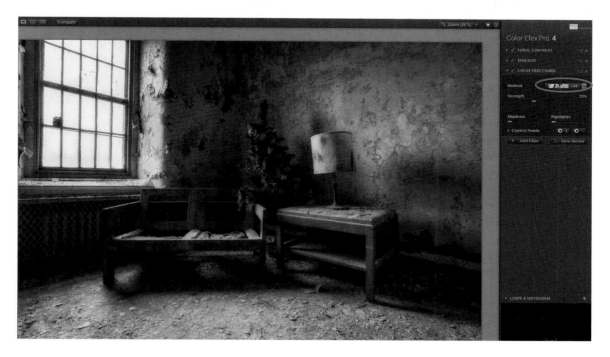

6. I'm pretty happy with the shot now, so I'll click Save. Nik goes through a bunch of processing windows (really annoying), and then returns to Photoshop.

7. Once back in Photoshop, the image still looks a little too intense. Because Nik creates a new image layer with its filters, you can go to the Fill option in the Layers module and change the value from 100% to 70%.

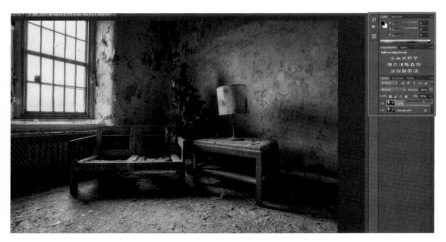

8. Save the file, and all changes will appear in Lightroom, ready for you to make the final adjustments.

Color Efex has only a fraction of the filters that Perfect Effects has, but they are very good. I'm hoping they add some more in the coming years. If you feel as I do and wish Color Efex had more to offer, fear not. Nik also has Analog Efex, which adds a new facet of filtering that specializes in creating vintage looks for your images.

FAVORITE FILTERS

Some of my favorite Color Efex filters are as follows:

- Brilliance/Warmth
- Cross Processing
- Dark Contrasts
- Detail Extractor
- Sunlight
- Tonal Contrast

And a couple of the recipes I enjoy are:

- Soft Landscape
- Super Cross Pop
- Warm Sunset

Analog Efex

Analog Efex was created for the purpose of extreme photo conversion. When applied to your images, Analog Efex give you the choice of having your photos look as if they were shot using vintage cameras or developed using legendary techniques. For you youngsters out there, think of it as Instagram on high-resolution steroids.

I'm not a huge fan of the drastic changes this app offers by default, but it includes numerous sliders that can control (and reduce the effect of) various aspects of each filter. Here are a few of their presets applied to a photo of an old barn in Northern California.

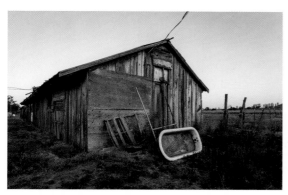

This is the original non-HDR photo with only basic Lightroom adjustments applied.

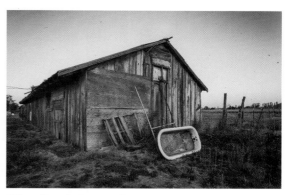

Filter: Classic Camera 3

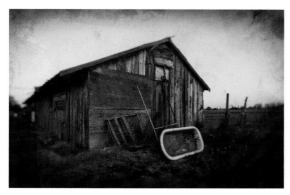

Filter: Wet Plate 2

Filter: Vintage Camera 8

If and when I use Analog Efex, I usually apply the processing and then dial down the intensity of that layer. Here's a quick walkthrough to demonstrate.

1. Here's my original image.

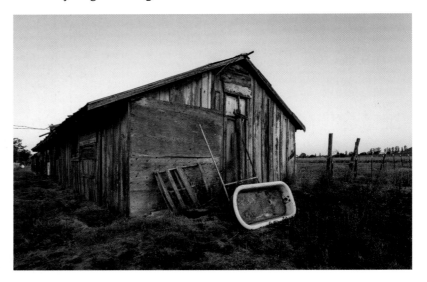

2. I've selected the Color Cast 4 filter and clicked OK.

3. This looks little bit too intense for my liking, so I select the layer.

4. Then I use the Opacity slider to fade the layer to 50%.

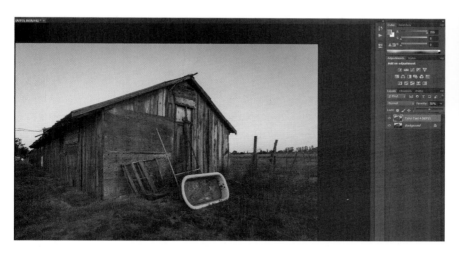

5. Then I click Flatten Image to keep my file size as low as possible.

I certainly wouldn't consider this a final image, but this kind of effect can be applied to your image any time to give it a vintage look.

Viveza

Viveza is another tool within the Nik Collection that is an absolute rock star. I can't tell you how many times Viveza has saved me when Lightroom and Photoshop didn't cut it. Not only is it a powerful tool to create effects, but it can also serve as a basic correction tool.

Remember the control points in Color Efex? Viveza is *only* control points. You can use it to fine-tune select parts of your image and blend its effects uniformly throughout the image so it's hardly noticeable that effects have been applied at all.

Let's look at Viveza's capabilities using a test image.

With this shot of a morgue, I want to darken the shadows behind the door while retaining the visibility of each of those six chambers. I also want to accentuate the highlights pouring through the door so we end up with a high-contrast image.

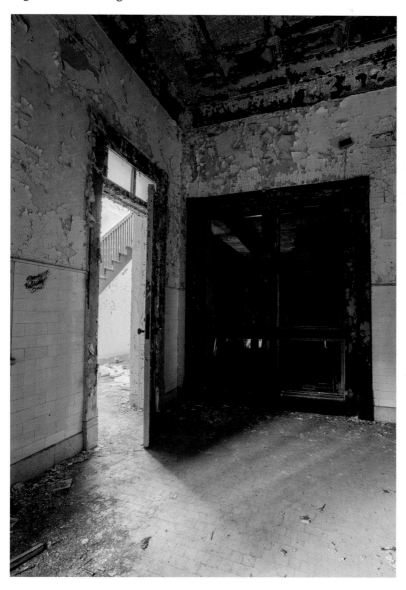

1. Once you open an image in Viveza, click the Add Control Point button.

2. Then click just the section you want to change. You want to be very specific with where you click because Viveza looks at color and tonal values to determine how to change the surrounding areas. In this case I'm going to click the light streaks on the ground—not the light streaks coming from the open door in front of me, the whiter streaks coming from the door behind me—because I want to make that area darker. As soon as I click, a menu appears on my image. You can make any of your adjustments using these sliders, or you can use the sliders in the right toolbar. The slider next to your actual control point controls the size of the area to be adjusted.

3. After adding all the desired control points—each with its own settings—I've darkened the floor, increased the brightness in the door, and lightened the shadows in the six chambers; I think I've gotten it to a point at which I can continue post-processing, so I click OK.

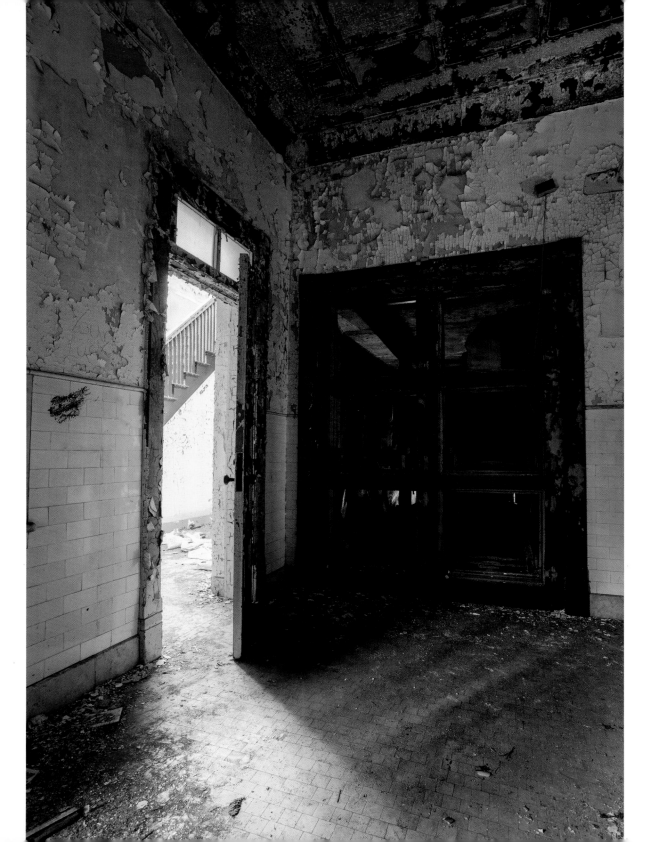

Most people I talk to about photography are unfamiliar with Viveza and how it's used. I consider it to be one of my most valuable tools, so I hope you enjoy it as much as I do.

In terms of filters and effects, Perfect Effects, Color Efex, Analog Efex, and Viveza are the tools I use on almost all my images. You certainly don't have to use all or any of them. I'm a firm believer that these tools have taken my photography to a new level, and I'm pretty excited to see how they improve in the next few years.

Now that we've added all of the effects we could ever want, the next step in our workflow is to return our image to Lightroom for final edits.

TIP If you have multiple control points that you want to have the same settings, Shift-click all the control points, and then click the Group button. This technique will enable you to make all of your changes using just one set of slider adjustments.

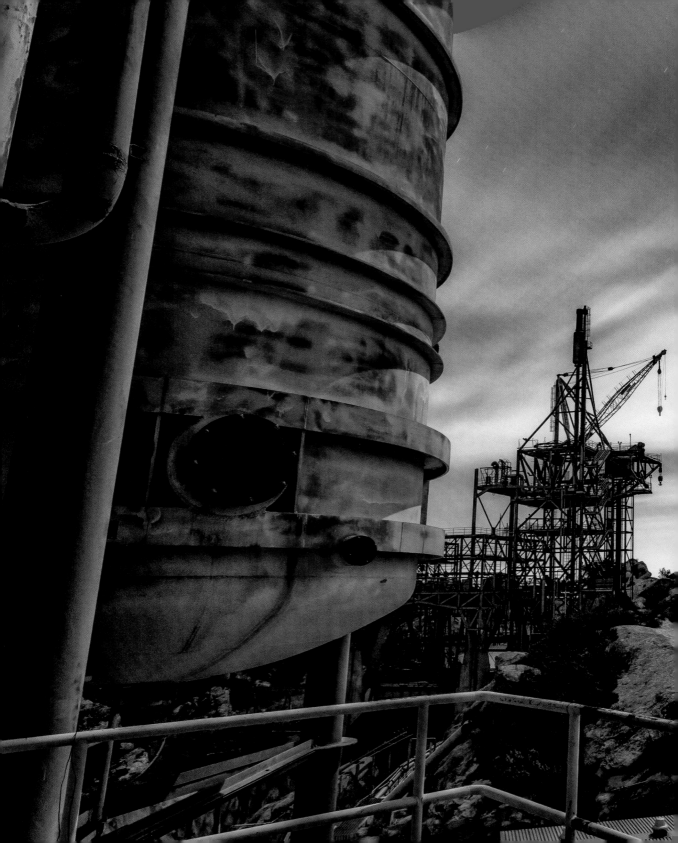

TWELVE
PHOTO FINISHING IN LIGHTROOM

You've imported your shots, created HDRs, made basic adjustments, and added effects, and now here you are: the final stage. Time to return to Lightroom to apply the final touches.

The Final Adjustments

At this point, you may feel that you've spent too much time on a single photo and you may wonder if all this effort is worth it. Over time your eye will improve, you'll become more decisive, and this workflow will naturally get faster. Stick with me for a couple of more tasks and your photo will be the masterpiece you've been hoping for. Here are the final adjustments you need to make.

Adjustment Brush

The Adjustment Brush in Lightroom is a killer tool for making all kinds of localized adjustments. Any adjustment you can make in Lightroom's Basic panel (and more!), you can paint in using the Adjustment Brush. It's very similar to Nik's Viveza, but it works a little differently. Viveza

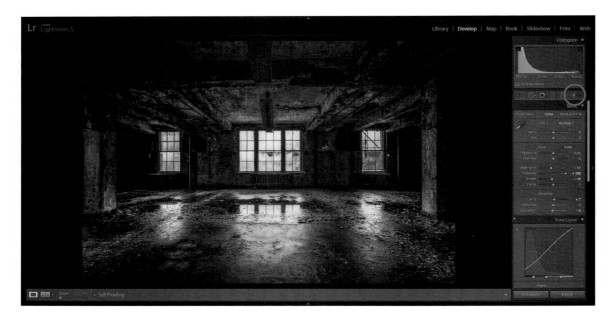

works primarily on control points, whereas the Adjustment Brush can paint exactly where you want to make a change. Viveza does have a brush option, but the Adjustment Brush still has more robust options. As with many other adjustments in Lightroom, you can even save your brush's settings for later use. Here's a quick run-through of the available options.

- **Size:** Brush size (in pixels).

- **Feather:** Create a softer transition between the brushed area and the surrounding pixels. You'll see that the brush itself has a second circle around it, which is the feather amount. You'll want this value to be fairly high so that your adjustments better blend into your photo. I usually leave mine at 70 to 100 unless I'm making very fine adjustments.

- **Flow:** Control how much of the adjustment is applied with each stroke.

- **Auto Mask:** When this is selected, the Adjustment Brush will apply adjustments only to areas of a similar color. This can be useful in some situations, but I've found that I achieve more predictable results by leaving this off.

TIP You can use the wheel on your mouse to quickly change the size of your Adjustment Brush.

- **Density:** Think of the Density slider as setting the maximum amount of change the brush will allow. Although it technically controls the transparency of your adjustment, I consider it to be a safeguard to avoid over-adjusting.

One of the most useful, and most often overlooked, features of the Adjustment Brush is making sure that the mask is visible when you're done painting.

Select the Show Selected Mask Overlay checkbox under your photo, and Lightroom will display in red every place that you painted. I check this only after I've painted on my adjustment. I feel that it gets in my way when I'm actually trying to paint.

When you're finished and you turn the overlay on, you can see where you may have painted outside the area originally targeted for change. To fix this, hold down the Alt/Option key and paint away the unwanted areas. You'll see the red mask disappear as you paint.

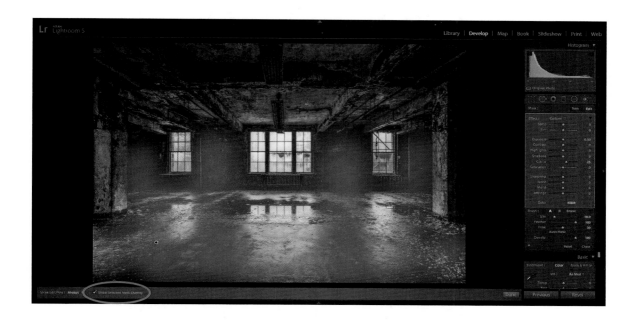

I use the Adjustment Brush for a variety of purposes: to make everything around my subject a little bit darker to help the subject stand out, to increase the clarity by painting only my subject, and to remove annoying highlights that are distracting attention from the subject. Notice a trend? It's all about isolating the subject, even if it's a very light adjustment. I always want to make sure that my viewer knows where they should be focusing.

TIP You can buy a graphics tablet and paint with more precision than with your mouse. This is valuable if you want to make really detailed change, but I've also found that it makes adjustments much faster overall. By now, we're all very proficient with our mice, but I would say that we're all better with a pen in hand. Wacom makes some amazing tablets (although the best ones are upwards of $400). I'm not ashamed to say that I got a graphics tablet for a fraction of that price on Monoprice.com. It doesn't have the fancy bells and whistles of a premium Wacom tablet, but it does what I need it to do.

Cropping

When cropping a photo, you trim away the outer parts of your photo to improve framing or composition. Why crop so late in the finishing process? I'm glad you asked. If I were to crop my photo, apply all these effects and adjustments, and then decide I don't like the crop, I couldn't un-crop it without losing all my effects and adjustments. Because Lightroom is non-destructive, it just makes sense to perform all of your changes and then crop the image at the end. That way you can always change the composition of your photo without losing all your finishing work. Cropping in Lightroom is incredible easy:

1. Find the cropping button above the Basic panel.

2. Drag in any corner or edge until you're happy with the crop.

3. Click Done, in the lower-right corner.

Vignette

Applying a vignette to your photo means making the outer perimeter of your photo a bit darker or lighter than the rest of the image. You don't want to go overboard with vignettes, but I like to apply a small amount for a large portion of my images.

1. Locate the Effects panel to the right. (It's below Lens Corrections.)

2. Drag the Amount slider to between −25 and −50.

3. You're done!

Before vignette

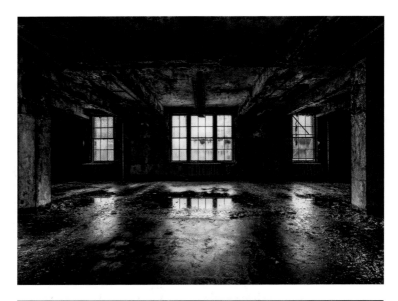

After vignette. I didn't want the detail of the ceiling to detract from the intensity of the windows. Some ceiling detail was OK for this shot, but I certainly didn't want it to become the focal point.

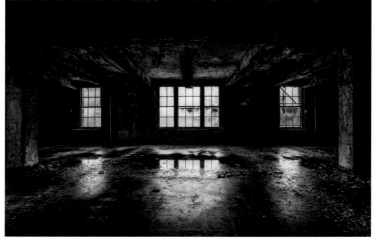

Lightroom has many other settings to choose from, but to be honest, I rarely use them. If you have a burning desire to know about them, here goes:

- **Style:** This setting includes three choices: Highlight Priority, Color Priority, and Paint Overlay. Highlight Priority and Color Priority are very similar and practically indistinguishable from one another, but

their differences are clear-cut. Highlight Priority tries to maintain detail in the highlights but may shift the color. Color Priority focuses on preserving color, sometimes at the expense of tonal values. They both work much like an exposure adjustment. I always use Highlight Priority. Paint Overlay works as if you had overlaid black paint around the edges of your image, with no regard to color or tone.

- **Amount:** This setting sets the degree of vignetting. It works a little counterintuitively because I consider this my Vignette panel rather than my Effects panel. Because I want to increase the amount of vignette, my natural inclination is to increase the Amount slider, when in reality I need to decrease the slider to increase the vignette.

- **Midpoint:** This setting determines where the vignette effect begins. Setting it closer to zero starts the vignette nearer the center of the image. As you increase the midpoint, the vignette begins farther from the center of the image.

- **Roundness:** Drag this slider below zero to make your vignette more square. I don't think I've ever changed this setting, but I guess it could come in handy at some point.

- **Feather:** Just as when you're using the Adjustment Brush, the Feather setting lets you control how hard or soft the vignette's transition is.

- **Highlights:** This slider setting prevents your highlights from becoming too dark around the edges of your photo. This is another setting I don't really have a use for; I'm doing my best to reduce highlights around the edges of my images because they could distract from my subject.

Sharpening

You learned about sharpening in Chapter 9, so this is a reminder that *this is the point in the workflow when you do your sharpening*. It took me a long time to figure this one out, so I'm eager to drive this point home.

Perform sharpening only after you've completed all the other adjustments you intend to make to your photo.

Your post-processing workflow is now complete! Now that we've explored all the tools I use to create images, you're free to explore and experiment on your own.

But before I lose your attention completely, in the next chapter we'll analyze a few of my photos from start to finish for a deeper look into my post-processing thought process.

THIRTEEN
PROCESSING
WALKTHROUGHS

I've described the tools you need to make a great photo. I think it might help you to see how I process a few photos from start to finish in order to find out why I make certain artistic decisions. Sometimes I don't have a better answer than "I think it looks good," but I'll do my best to be as specific as possible. You can download the raw files for these walkthroughs by following the instructions in the Introduction.

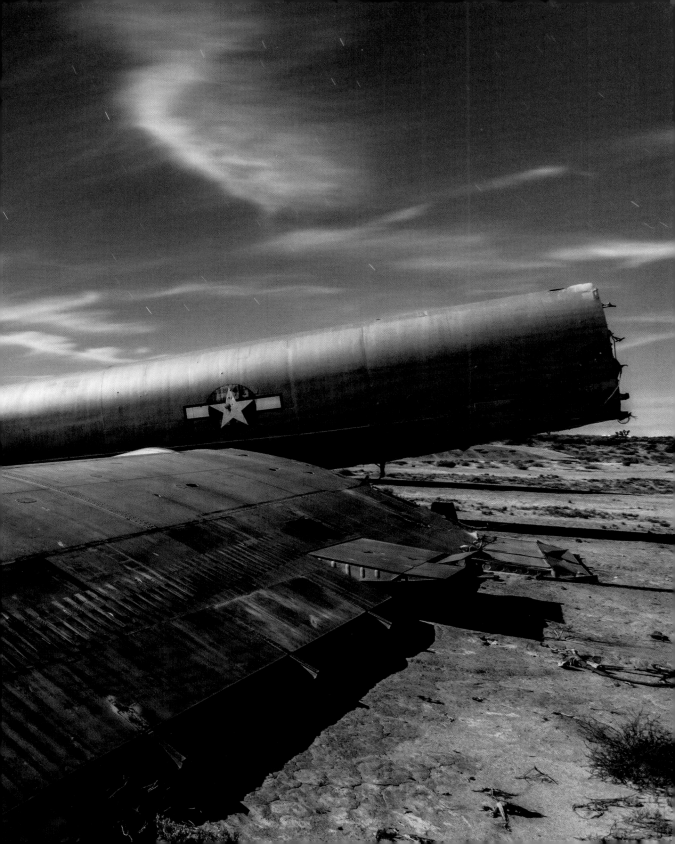

Walkthrough #1:
Chair in a Psychiatric Hospital

This photo was shot on the East Coast of the United States in the spring of 2013. It's got great light pouring in through the windows, and in terms of the subject, who doesn't love a lonely chair?

Unfortunately, it was shot mid-afternoon (not my favorite light, as you'll recall), but UrbEx beggars can't be choosers.

1. I started out with this image, the "normal" exposure, although I bracketed 10 shots.

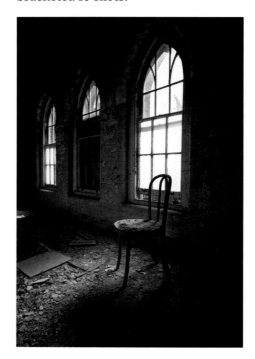

2. I processed it using the 32-bit HDR method and ended up with this.

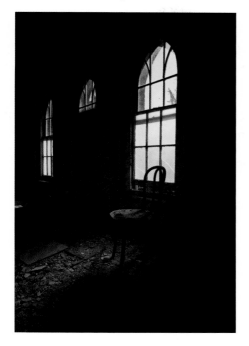

3. For my first pass of basic Lightroom adjustments, I made these changes:

- Exposure: +1.7
- Contrast: +20
- Highlights: –85
- Shadows: +85
- Clarity: +20
- Tone Curve: Medium Contrast
- Enable Profile Corrections: Selected
- Remove Chromatic Aberration: Selected
- Constrain Crop: Selected
- Upright Correction: Auto

Here's a side-by-side comparison after these changes.

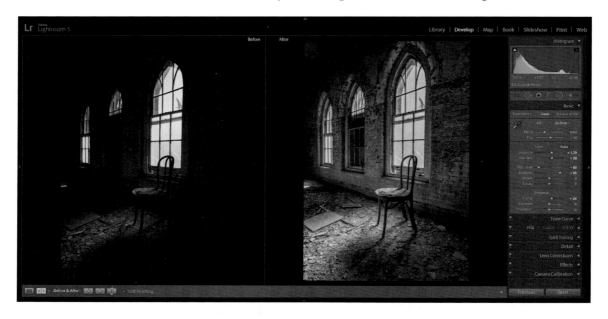

4. I opened the image in Photoshop for major edits and filtering.

5. One area in the window kept catching my eye: the small patch of green trees in the open area behind the chair. I didn't want this to be a distraction, so I made it darker using Viveza.

6. I didn't see any other major distractions, so I proceeded using Perfect Effects with these settings:

 - Warm Highlights – Cool Shadows: Layer Opacity @ 50
 - Dynamic Contrast (Soft): Layer Opacity @ 20
 - Rich Glow: Layer Opacity @ 35
 - Sunglow: Layer Opacity @ 50

The shot looked pretty good to me at this point. I was on the verge of that surreal feel I like to shoot for, but I didn't want to take it too far.

NOTE Remember to use these filters in moderation. Don't just apply one or two at 100 Layer Opacity and call it a day.

7. Bringing the shot into Color Efex Pro, I made the following adjustments:

- Tonal Contrast: Fine; Saturation set to 0%
- Brilliance/Warmth: Perpetual Saturation set to 20%

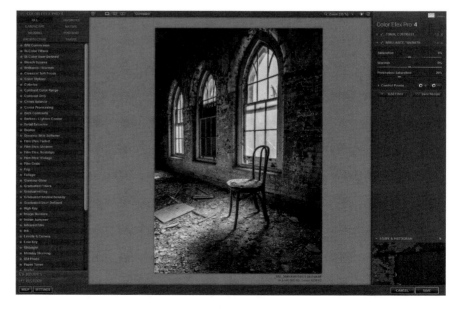

I typically hate clear blue skies in images like this, but I thought the blue complemented the warm color tone of the room nicely, and Perpetual Saturation helped the blue cut through a bit more strongly.

That's all I did with the effects. Some UrbEx photographers might gasp at how many filters I applied, but this was the style I enjoyed in this phase of my career, so I ran with it and then headed back to Lightroom for finishing touches.

8. The final adjustments I made in Lightroom were sharpening, applying a vignette, and a very small correction using the Adjustment Brush:

Sharpening (Lightroom's Sharpen - Scenic preset)

- Amount: 40
- Radius: 0.8
- Detail: 35

Post-crop vignetting

- Amount: −25
- Midpoint: 40
- Feather: 65

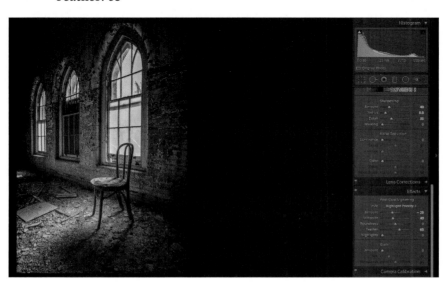

9. Finally, the right edge of the chair was really dark, and I wanted to bring back some of that detail. So I used the Adjustment Brush to raise the Shadows to 30 for just that dark edge of the chair and seat.

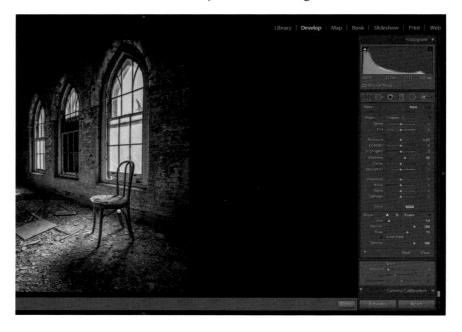

Here's my final image (next page):

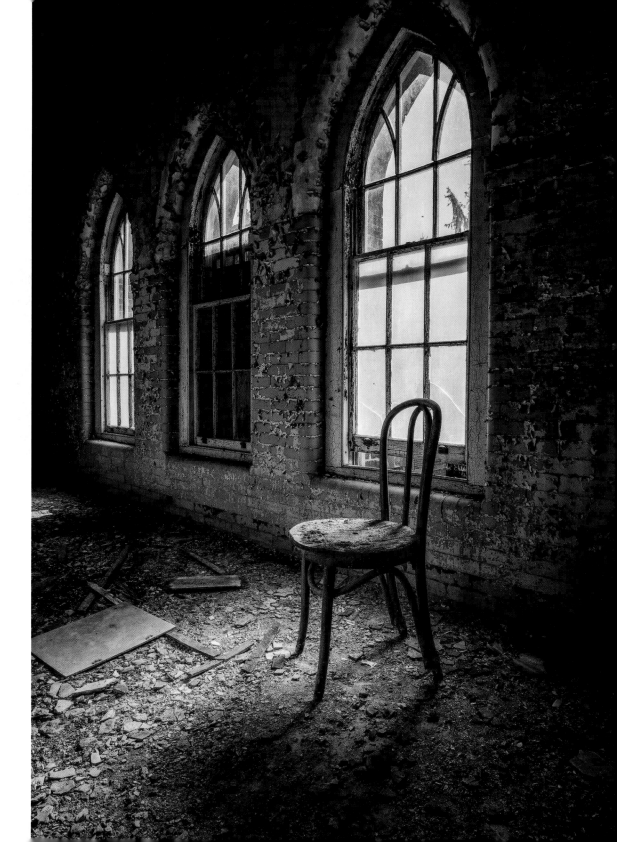

Walkthrough #2:
The Hospital Classroom

I took a few different angles of this room because I was feeling indecisive. I thought this angle was the best, although it certainly needed a little cropping.

1. Here's the proper exposure.

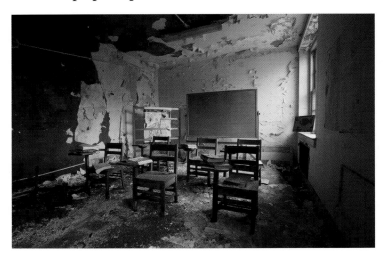

2. First I used the 32-bit HDR method to bring out the shadows in the foreground without causing significant quality loss. The resulting image was almost identical to the proper exposure, but when I raised the shadows, the quality degradation was much lower on the HDR image.

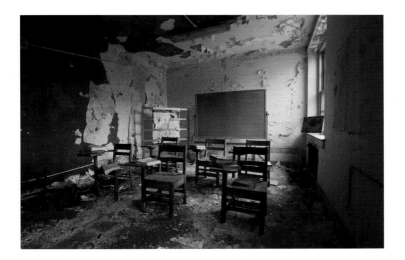

3. Now for some basic Lightroom adjustments. The shot was a little dark and I really wanted to get the detail of the closest desk, so I was primarily concerned with raising the exposure and shadows. I didn't need to do much else except add some contrast and lens correction. Here are my final settings:

- Exposure: +0.5
- Contrast: +20
- Shadows: +80
- Clarity: +25
- Vibrance: +10
- Enable Profile Corrections: Selected
- Remove Chromatic Aberration: Selected
- Constrain Crop: Selected
- Upright Correction: Auto

I then opened the photo in Photoshop to add some effects.

4. First step was to use Viveza to bring down the color of that poster in the back of the room. I wanted my viewer to focus on the desks and books, not on the "Regional Anesthesia in Obstetrics" poster. I raised the brightness of the closest desk and brought down the brightness near the window.

And here's what it looked like after my Viveza edits.

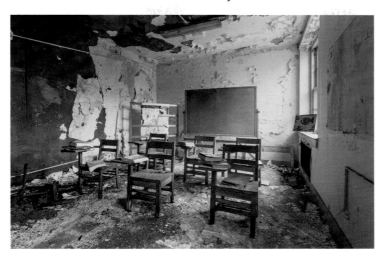

5. I then brought the photo into Perfect Effects and added these filters to the mix:

 - Dynamic Contrast (Natural): Layer Opacity @ 30
 - Blue-Yellow: Layer Opacity @ 50
 - Urban Sickness: Layer Opacity @ 30
 - Earth & Sky: Layer Opacity @ 30

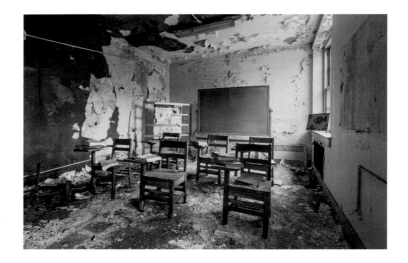

6. I really liked the cold color tone and overall muted feel because it reminded me of the feeling I had being stuck sitting at desks all day during high school. But I still thought the shot needed a little more, so I opened it into Color Efex Pro. I went into this phase a bit indecisive, so I experimented a little. Here's what I came up with:

- Brilliance/Warmth: Perpetual Saturation set to 10%
- Classical Soft Focus: Method set to Diffusion-1; Strength set to 10%

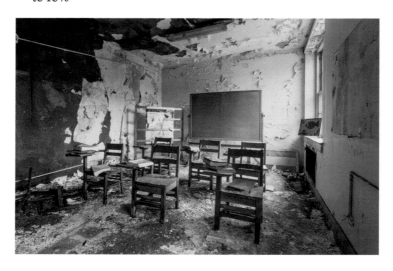

Then it was back to Lightroom for the final cleanup.

7. I cropped the photo to get rid of the empty wall space that was bothering me in the beginning and then applied the following settings:

Basic

- Clarity: +20

Sharpening (Lightroom's Sharpen – Scenic preset)

- Amount: 40
- Radius: 0.8
- Detail: 35

Post-Crop vignetting

- Amount: –20
- Midpoint: 45
- Roundness: +15
- Feather: 65

I was pretty happy with it at this point, so I gave it my seal of approval and marked it Complete.

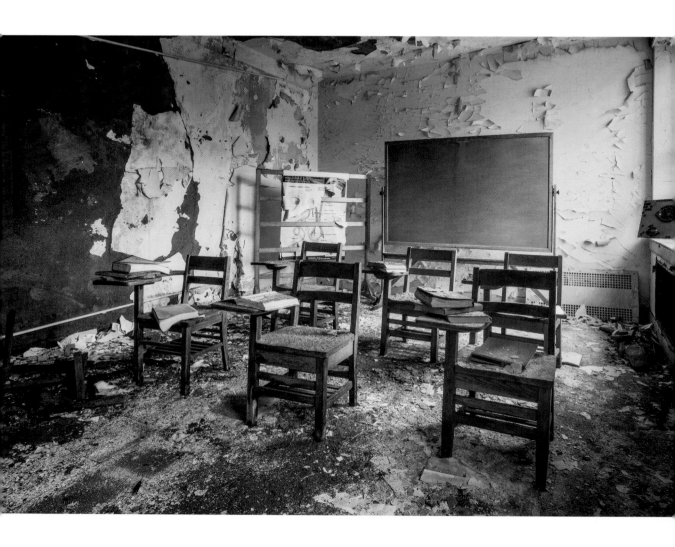

Walkthrough #3: Psych Ward Hallway

For my final walkthrough, I'm going to edit this photo of a psych ward that I've kept on the back burner for quite a while. I haven't post-processed it because I wanted to use it specifically for this book. This shot is a little different from the previous two walkthrough examples.

I shot it with my 50mm lens at f/5 because I wanted the closest door to be very sharp and the rest of the hallway to fade away with bokeh. Having said that, I'm not going to process it the same way I would process a wide-angle photo shot at f/11. Let's get started.

1. Here's our proper exposure.

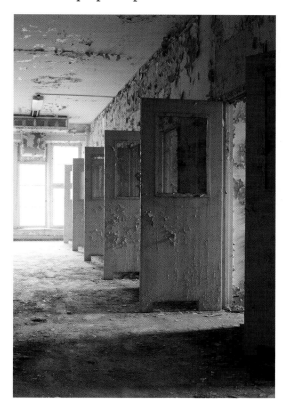

2. As with the previous examples, I'm going to process this shot using the 32-bit HDR method, but I'm not using HDR to pull the detail out of the windows. (It was an overcast day so there weren't many details to get anyway.) Instead, I'm using HDR to make sure that I have full tonal control over details such as the peeling paint on the closest door and the shadows on the ground.

3. As you can see, the image is very dark, but because I processed it in 32-bit, it's very easy to bring up the exposure in Lightroom without quality loss. Here are the settings for my preliminary adjustments in Lightroom:

 - Exposure: +3.5
 - Contrast: +20
 - Highlights: −50
 - Shadows: +30
 - Clarity: +20
 - Vibrance: +50
 - Enable Profile Corrections: Selected
 - Remove Chromatic Aberration: Selected

- Constrain Crop: Selected
- Upright Correction: Auto

4. Here is what we end up with after initial Lightroom adjustments:

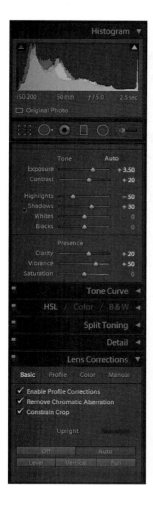

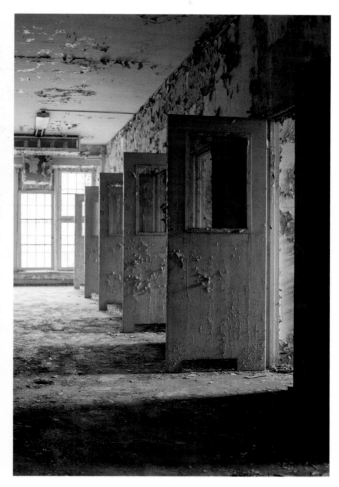

5. Now I'm ready to add the following filters with Perfect Effects:

- Dynamic Contrast (Texture Enhancer): Layer Opacity @ 15
- Sunglow: Layer Opacity @ 50
- Fall Enhancer: Layer Opacity @ 30
- Cool Shadows: Layer Opacity @ 30

That's all for Perfect Effects. It's worth noting that I'm not trying to lower the intensity of the light coming through the window, although I typically would. In this shot, however, the window is positioned in a way that enhances the composition, so I'm actually going to accentuate it so that viewers' eyes will naturally gravitate toward it.

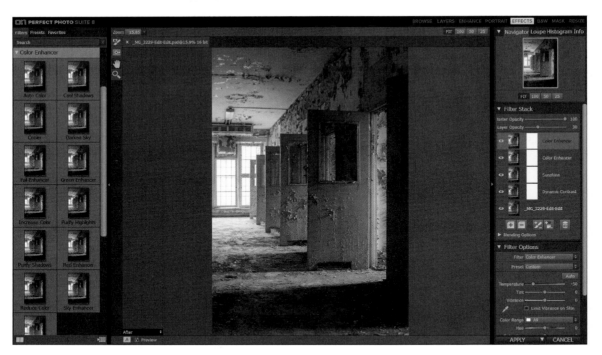

6. Here's what the image looks like now.

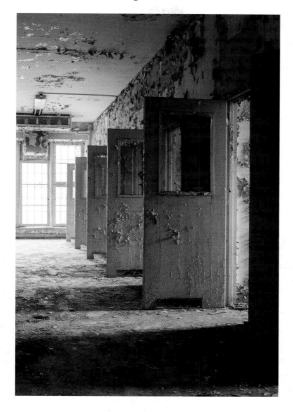

7. Let's open it up in Color Efex Pro to make other adjustments that will improve this photo.

 Sunlight

 - Light Strength: 20%
 - Light Temperature: 5100k
 - Brightness: 0%
 - Contrast: 20%
 - Saturation: 0%

8. I'm using a control point to exclude the closest door and the foreground, and I'm applying this filter only to accentuate the sunlight coming through the windows.

- Cross Processing: Method set to L02; Strength set to 15%
- Detail Extractor: 15%; Contrast and Saturation left at 6%

9. Let's employ a control point for the Detail Extractor, too. I'll use the Control Point button with the + icon and place it on the closest door so that the Detail Extractor adds the effect only to the door and leaves everything else unchanged.

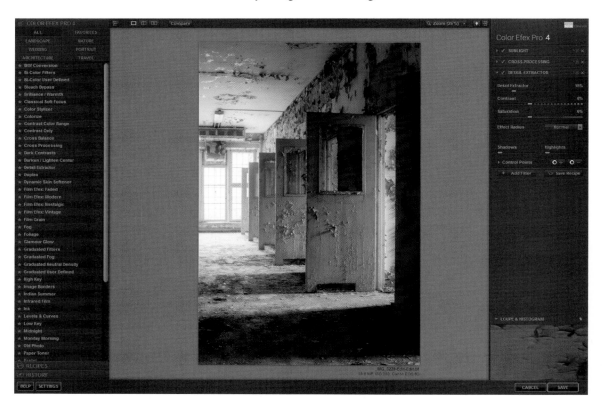

That's all I think we need in Color Efex Pro. Here's what we end up with.

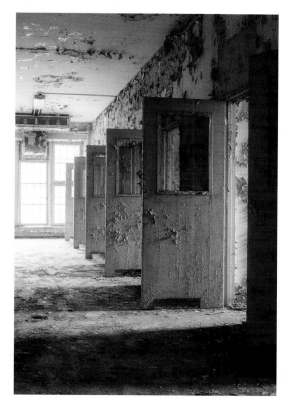

10. Back in Lightroom, I have just a few final adjustments to perform:

Basic

- Clarity: +10

Sharpening (Lightroom's Sharpen – Scenic preset)

- Amount: 40
- Radius: 0.8
- Detail: 35

Post-Crop vignetting

- Amount: –25
- Midpoint: 37
- Roundness: +25
- Feather: 62

11. The final adjustment is to get rid of the strip of light at the lower edge of the image. This is a tough call to make because I like that it suggests more doors in this hallway. But I think that I need to stick to my guns: It detracts from my subject as the focal point. So along with the vignette that I applied to the image, I'm going to use the Adjustment Brush to lower its intensity, using these settings:

- Temp: –54
- Tint: –56
- Exposure: –2.44
- Contrast: +100
- Highlights: –100
- Saturation: –35

This adjustment is a little tricky because I have to match the color of the light strip to the shadows above it. That's where those Temp and Tint adjustments come in handy.

12. Here's the final image.

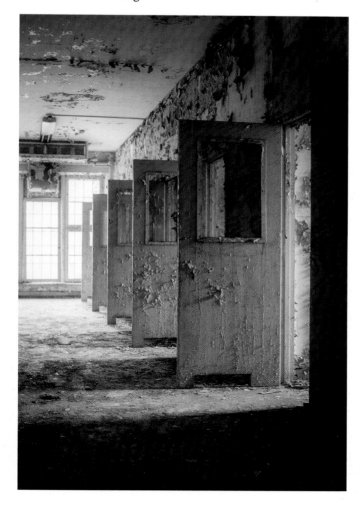

I hope you've enjoyed and gotten useful tips out of these walkthroughs. I encourage you to try adjusting these examples yourself using the original raw files. If you experiment with them and come up with your own processing, post them online—I'd love to see what you come up with!

FOURTEEN
10 THINGS TO AVOID

Throughout the book, I've warned against most of the common post-processing mistakes and judgment errors, but I think the warnings are all worth repeating. Whether you're a beginner or a seasoned photographer, I think you can benefit from this summary. I see some of these issues even in the shots of UrbEx photographers who have been shooting longer than I have.

As with everything in this book, feel free to ignore all 10 of these suggestions if you see fit. This whole book is dedicated to showing you the elements I think make for a strong photograph; if you completely disagree with any of them, keep doing what you think looks good.

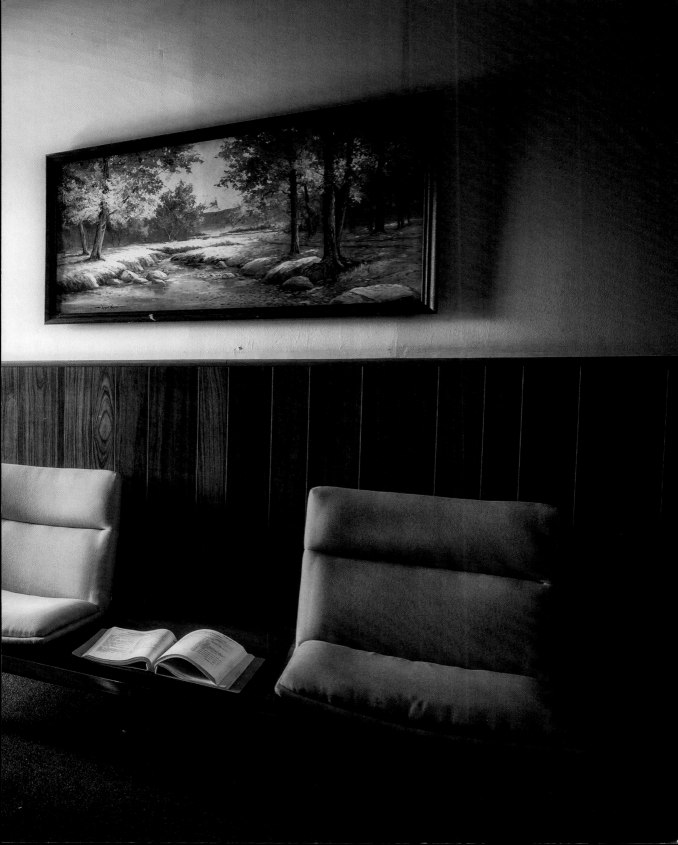

1. Fake Lens Flare

One of the most common misuses of Photoshop for newbies is to add fake lens flare to photos. This is especially rampant in wedding photography, but I've also seen it used quite a bit in UrbEx photography. Not only does a flare distract your viewers from your subject, it just looks incredibly artificial and silly. Most professional photographers try to avoid lens flare, so I can't fathom why people would want to add it back in.

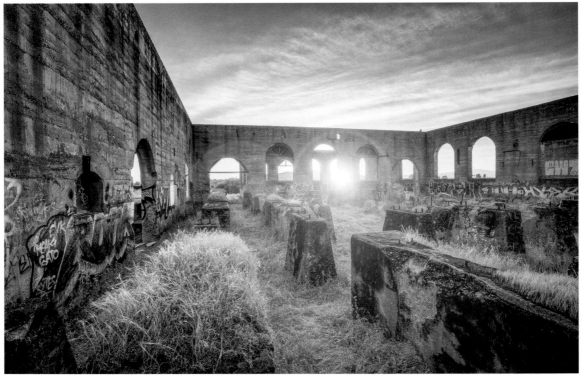

Why?!

2. HDR Fever

Know that there is a threshold for what good HDR looks like, and surpassing it is very easy. If you're ever in doubt, err on the side of caution and dial it back a bit.

Shoot for this:

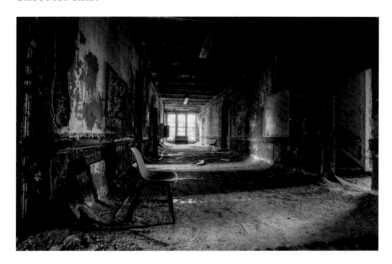

Not this:

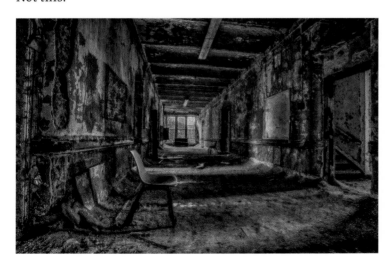

3. Oversaturation

This goes hand-in-hand with HDR fever because many HDRs are oversaturated; but that certainly doesn't mean you can't oversaturate on a single exposure. This gaffe is a little less common in the UrbEx community, because most beginners are going for a dark and creepy look that vibrant colors usually don't convey. That doesn't stop some people from trying.

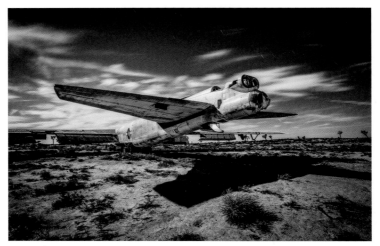

Good

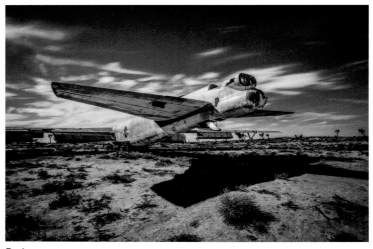

Bad

4. Too Sharp

Too much sharpening can easily be overlooked by the naked eye, but as soon as you zoom in or print your images, it becomes very clear very quickly. I often compare oversharpening to music that has the treble cranked up all the way so you can hear the cymbals sizzling in your ears at all times. We like our photos to be clear and sharp, but not everything needs to be cranked to 11 for your viewers to see what's in your photo.

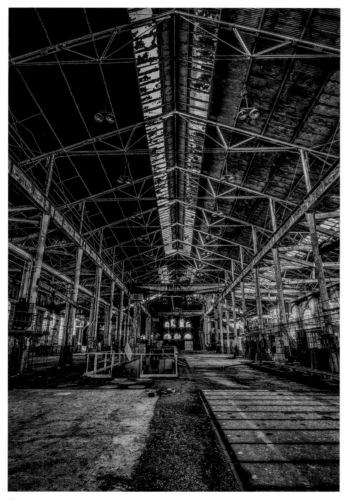

Good sharpening

You don't need to go overboard with sharpening for your viewers to understand what you've taken a picture of.

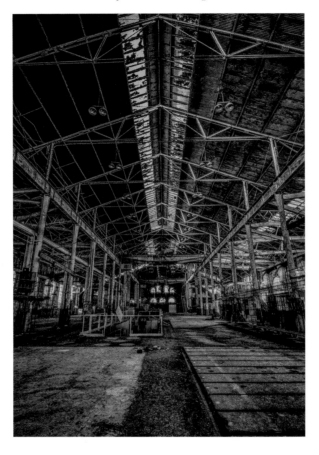

Too much sharpening. Making the elements in this photo extra sharp isn't doing it any favors.

When you look at a detail of the previous photo, you can see the artificial texture that oversharpening creates in your photos.

This texture looks like little worms. If you see the worms in your photos, take it down a notch.

5. Gray Highlights

Unless it was overcast when you shot your photo, highlights should not be gray. This happens most often when people shoot in broad daylight and then try to lower the brightness too much.

For a single exposure, and even some HDR images, there simply isn't any information in those highlights to display, but Lightroom will certainly keep trying if you force it. To avoid this, make sure to bracket your shots with dark enough exposures so that you can see the detail in the window. And it doesn't hurt to wake up earlier so you can get shots before the harsh midday sun.

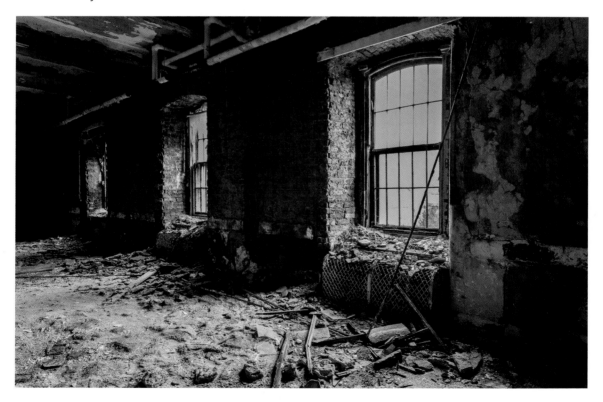

6. Chromatic Aberrations

This is another fault we've talked about, and it still blows me away when people either are oblivious to chromatic aberrations or don't know that with one click in Lightroom you can get rid of that pesky purple fringe. You can even build it into a preset so that Lightroom will remove these problems during import.

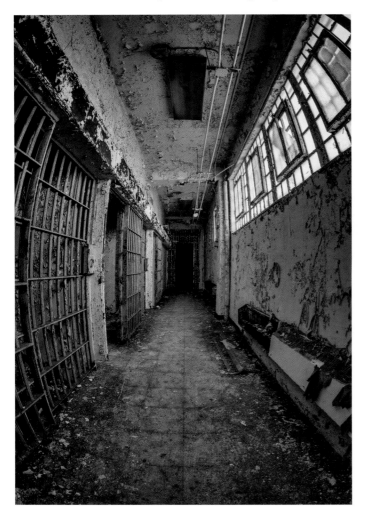

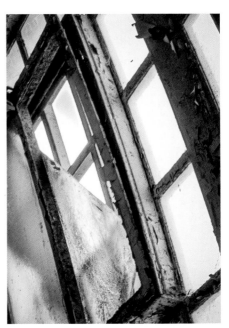

Without a closer look at this fisheye shot of an abandoned jail, you'd never know that it's riddled with chromatic aberrations.

7. Halos

Halos are usually the result of poorly executed HDR, but they can also pop up when you've applied too much contrast or clarity. I created this image for the sole purpose of this example, and it is an overcooked HDR that was actually pretty difficult to make. It's amazing how these problems occur only when you don't want them to and not when you need them to.

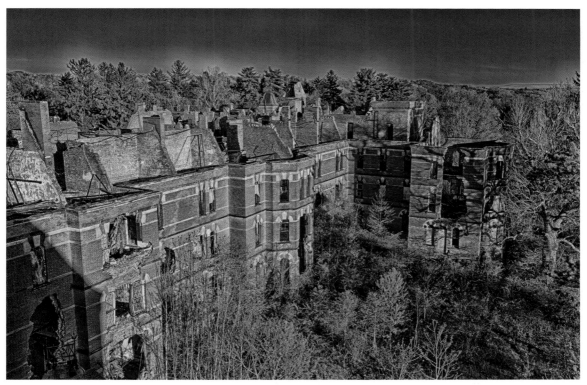

Look at the treeline. That brightness between the treeline and the blue sky is a halo. Halos are bad.

8. Artificial Light Beams

This one is becoming more and more prevalent among UrbEx photographers—even really good photographers for whom I have a great deal of respect. I've gone over how to create light beams in real life before you take your shot. If your environment or shooting conditions don't allow you to create light beams in-camera, don't use Photoshop to add them into your shot. I think it looks cheap and makes it clear that you needed to compensate for an otherwise boring photo.

At the end of the day, this is still just a dresser drawer in a hallway. There's no need to make it look as if God is calling upon it from heaven.

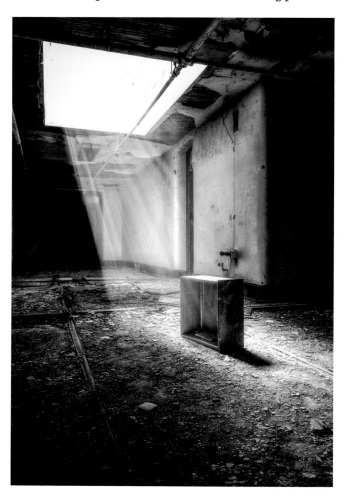

9. Selective Color

This is one trend that simply needs to die. Selective color is used by people who don't know composition and who therefore can't attract viewers to the subjects of their photos without making everything else in the photo black and white. This may sound a bit harsh, but sometimes the truth hurts. This is another fad popularized by wedding photographers that has unfortunately leaked into UrbEx photography. Work with the color you have and manipulate it however you choose, but don't get rid of all but one color.

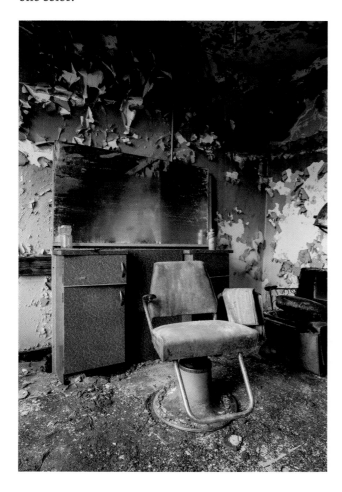

10. Textures

The use of textures is another topic that may get me into hot water, but it needs to be said. Within UrbEx photography, I've yet to see a texture that actually makes a photo better. There are some non-UrbEx photographers who make pretty cool photos using textures, but they are very few. Both Nik and OnOne provide tons of textures for people to use with their photos, but within the UrbEx realm, I would stay away from using them, as they are yet another way to distract your viewers from your subject.

This photo already has cracked paint in it. There's no need to overlay cracked paint on top of the entire photo.

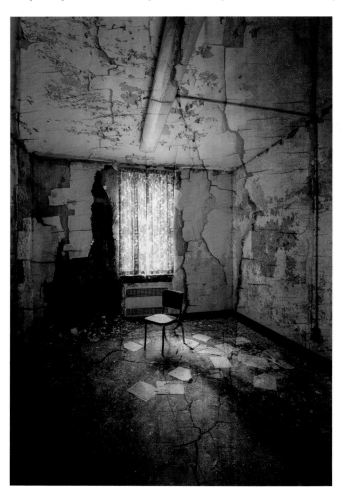